IMAGES

JACK DYKINGA'S GRAND CANYON

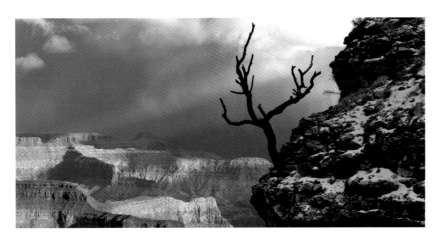

WITH CHARLES BOWDEN AND WAYNE RANNEY

Arizona Highways

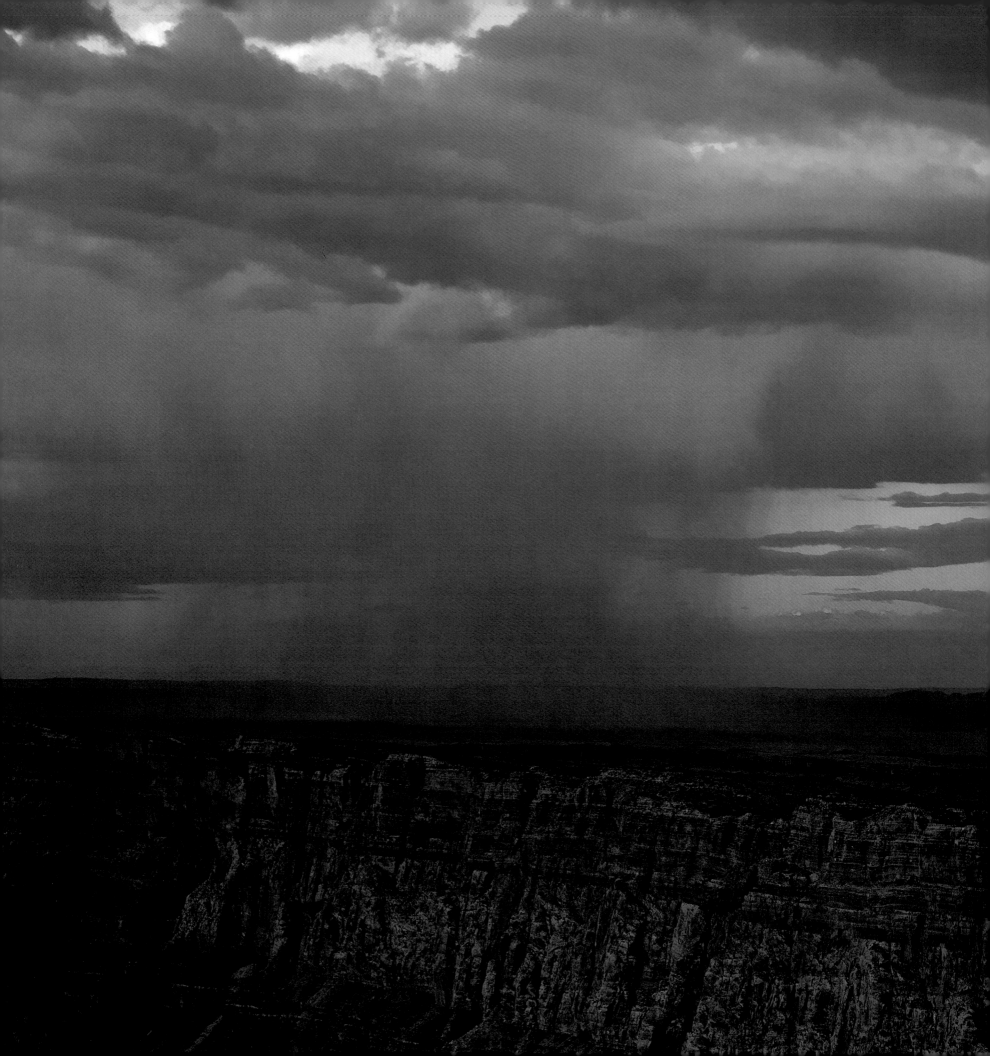

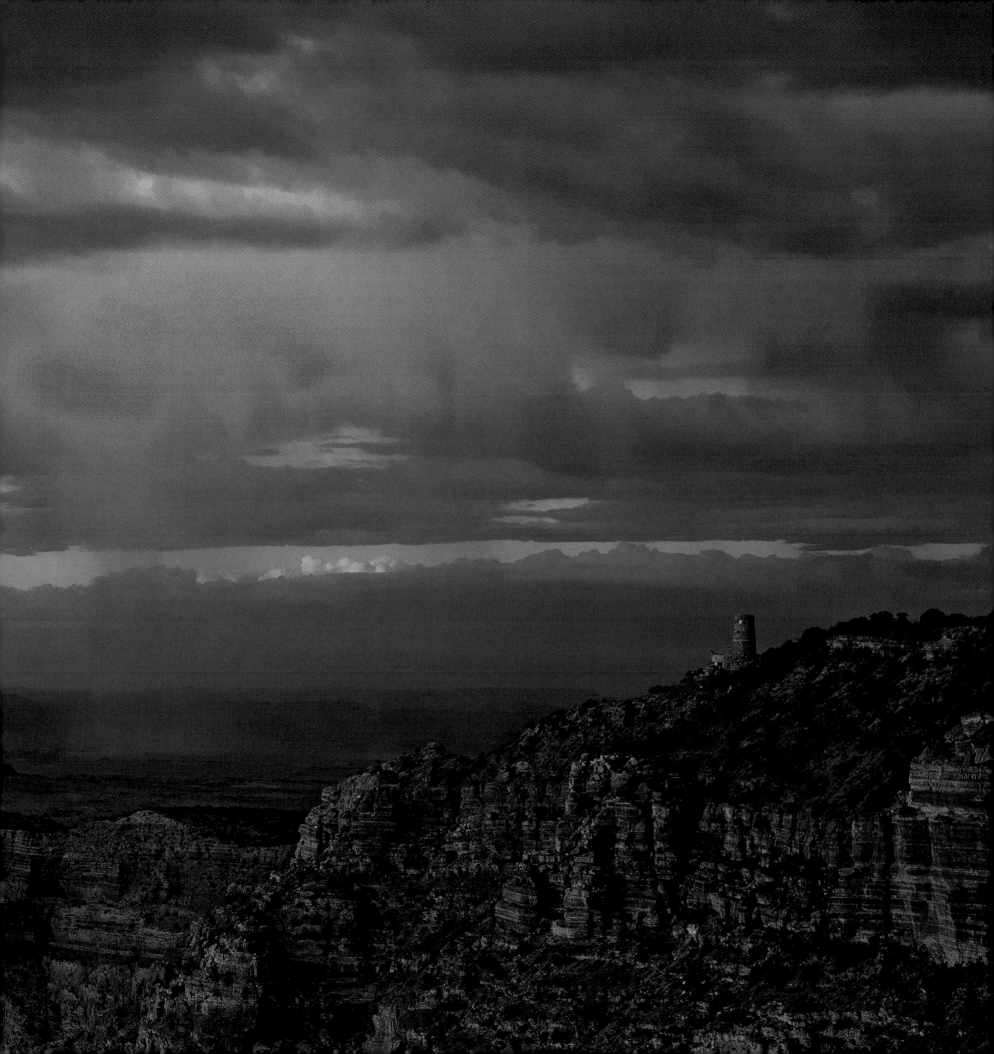

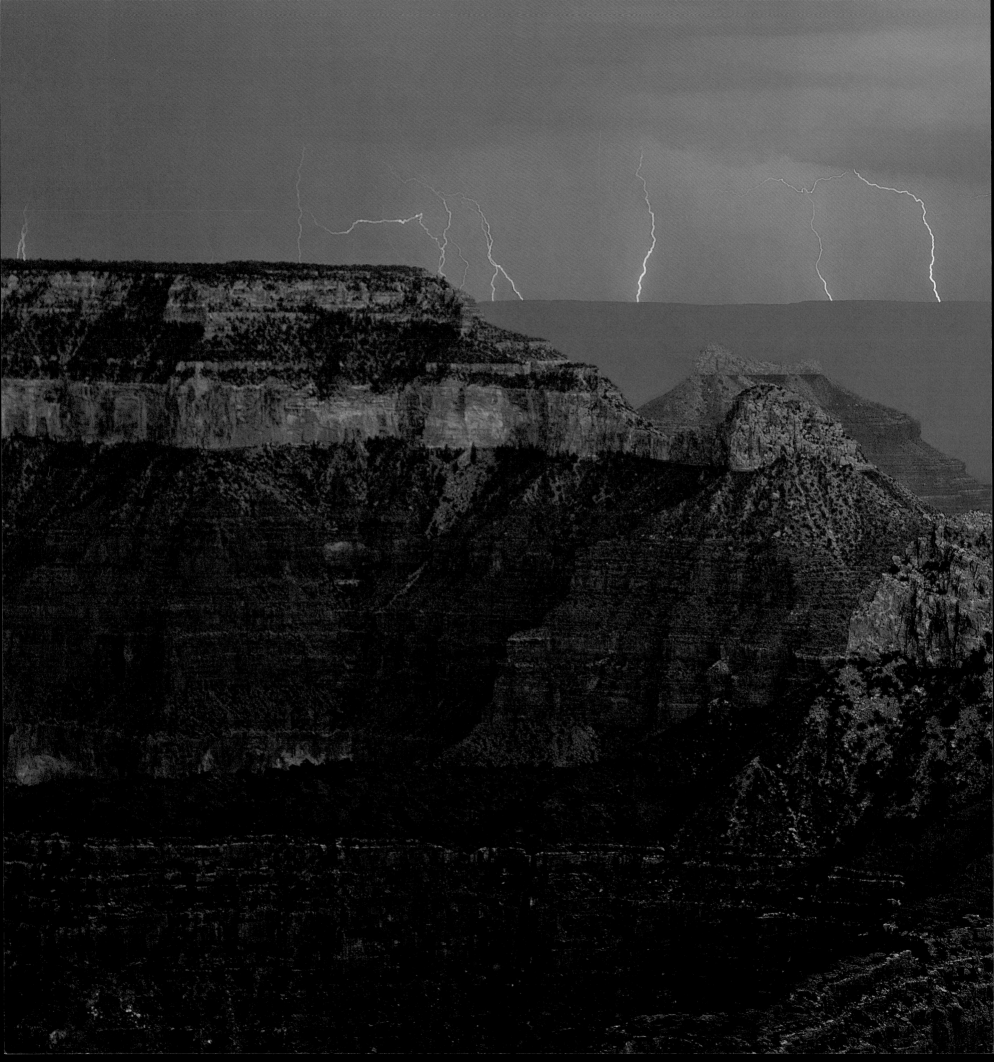

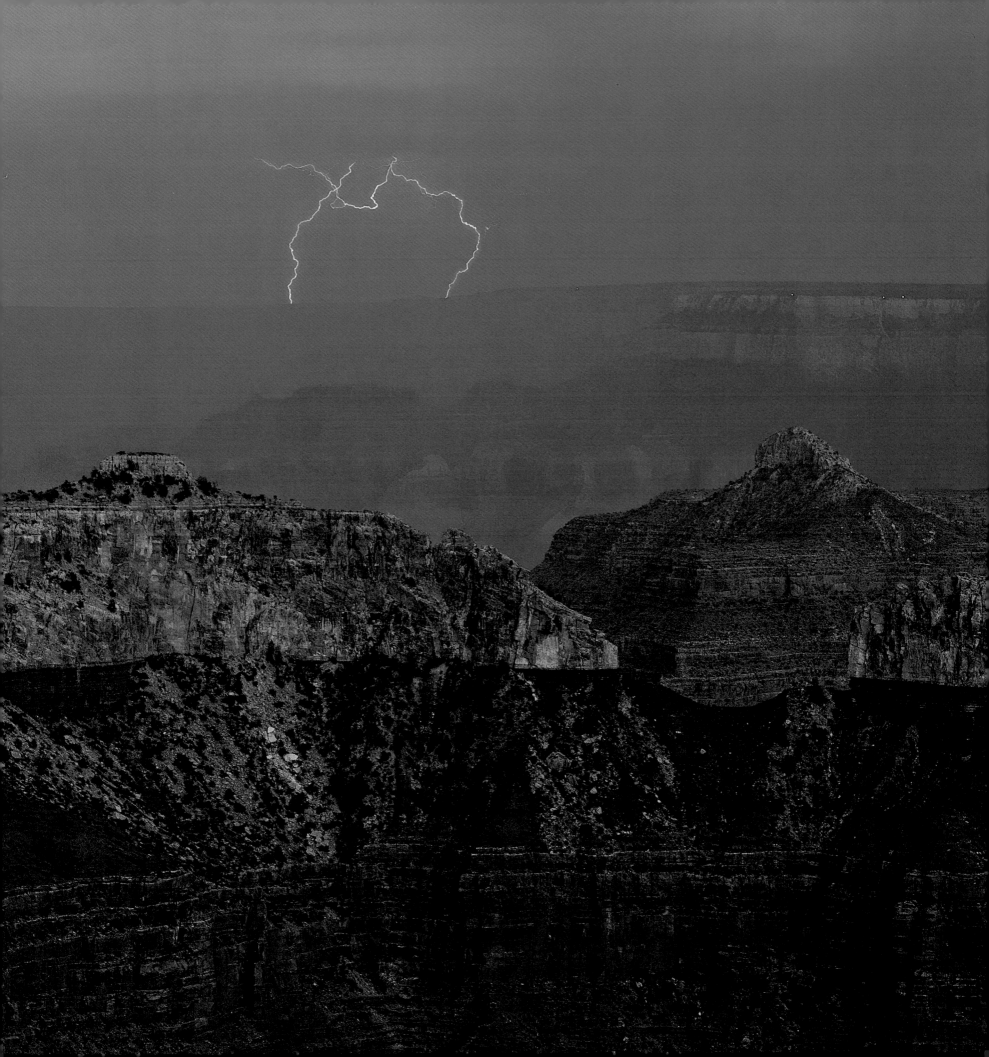

IMAGES JACK DYKINGA'S GRAND CANYON

TEXT **Charles Bowden and Wayne Ranney**

PHOTOGRAPHY **Jack Dykinga**

COPY EDITOR **Evelyn Howell**

PHOTOGRAPHY EDITOR **Peter Ensenberger**

MAP DESIGN **Mapping Specialists, Ltd.**

MAP TYPOGRAPHY **Kevin Kibsey**

ART DIRECTOR **Barbara Glynn Denney**

Library of Congress Control Number: 2007940140
ISBN 978-1-932082-87-6

First printing, 2008. Printed in China

Published by the Books Division of *Arizona Highways*® magazine, a monthly publication of the Arizona Department of Transportation, 2039 West Lewis Avenue, Phoenix, Arizona 85009. Telephone: (602) 712-2200. Web site: www.arizonahighways.com

PUBLISHER: Win Holden
EDITOR: Robert Stieve
MANAGING EDITOR: Bob Albano
ASSOCIATE EDITOR: Evelyn Howell
DIRECTOR OF PHOTOGRAPHY: Peter Ensenberger
PRODUCTION DIRECTOR: Michael Bianchi
PRODUCTION COORDINATOR: Annette Phares

Front and back endsheets: As it slips below a blanket of clouds, a setting sun pours golden hues over a storm passing over the North Rim's Cape Royal, turning the ridges into silhouettes.

The watchtower at Desert View, pages 2-3, catches evening light as rain blurs the distant horizon. Architect Mary Elizabeth Jane Colter designed the 70-foot-high tower in 1904.

Looking east from Point Sublime, preceding spread, one sees lightning ravage the sky above the formations of Shiva, Isis, and Confucius temples.

Following page, left to right: Bright orange lichen, an elemental life form, clings to a rock next to a weathered sage trunk at the end of its life; Yaki Point on the South Rim glows under the last light of day; and the Desert View Watchtower commands a sweeping view.

CONTENTS

 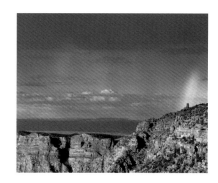

Jack Dykinga's GRAND CANYON

NORTH

MOHAVE DESERT

Lake Mead

GRAND WASH CLIFFS

SHIVWITS PLATEAU

Toroweap Point

Vulcan's Throne

THE ESPLANADE

Skywalk

Quartermaster Canyon

HUALAPAI PLATEAU

LOWER GRANITE GORGE

Kelly Point

Colorado River

HUALAPAI INDIAN RESERVATION

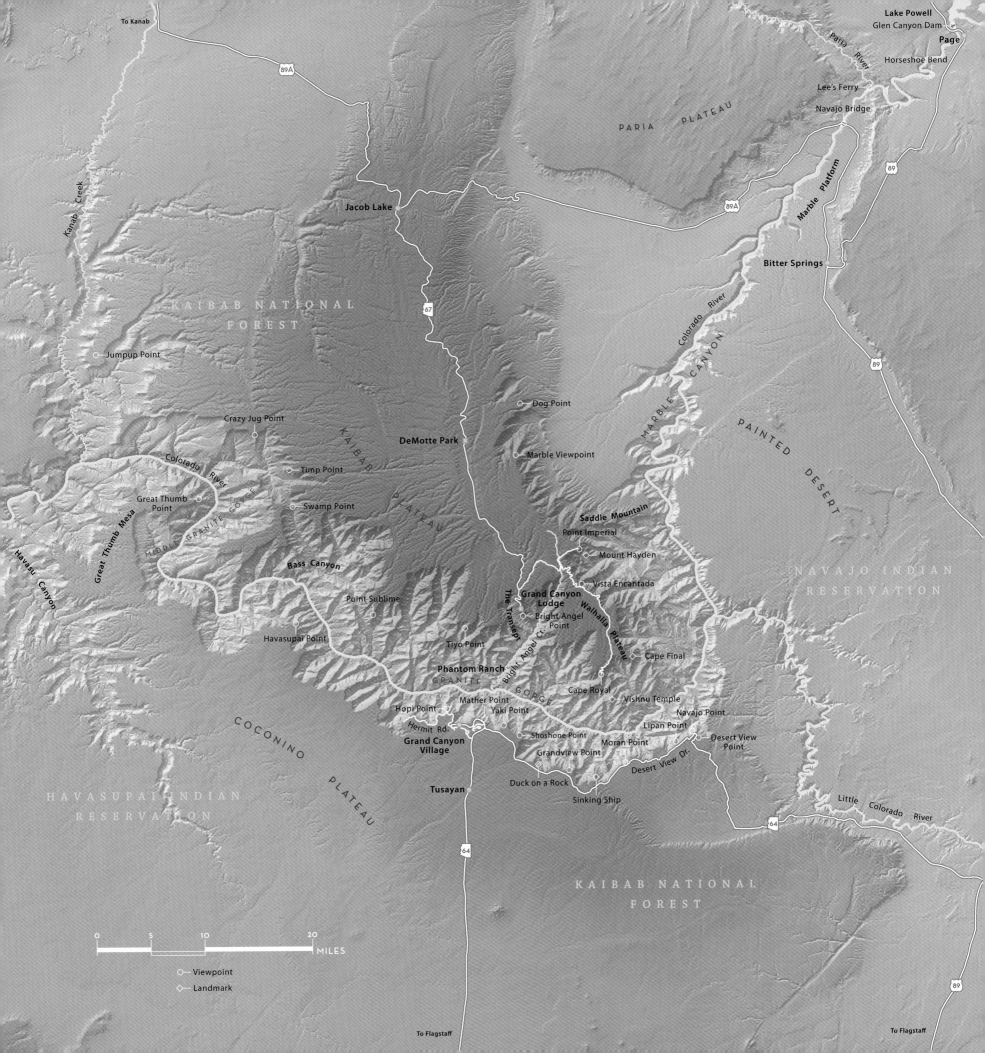

Writers and photographers who set out to describe the Grand Canyon unabashedly acknowledge that conveying all of the great gorge's traits lies beyond the power of words and photographs. Nonetheless, they undertake the task of guiding others in connecting with this place, the result of nature's eternal forces and artistic flourishes.

For IMAGES, *Arizona Highways* assembled a photographer and two writers, asking each to apply his specialty in relating the Canyon's physical and metaphysical qualities. Their encounters with the Canyon embody decades of experience, and their previous works have garnered numerous awards. The result— IMAGES—combines journalistic and impressionistic descriptions, both in words and in photographs.

First, Charles Bowden reflects on how the Canyon bears on the human psyche. Then, Jack Dykinga lays out a portfolio he assembled by venturing into all parts of the Canyon, from the rims to the surrounding terrains to the inner depths. Explaining some of the Canyon's natural history, geologist Wayne Ranney describes the Canyon as it progresses from what he terms its humble beginnings to its classic stretch and to wilderness section.

Bowden observes:

"As a species, we tend to walk to the edge of the Grand Canyon, look, and then not know what to do…. Numbers hardly help at those places we call vistas because the numbers are too big. The mind must try to encompass a gouge in the earth 277 river miles long and up to 18 miles wide and a mile deep. There's one number I keep repeating like a prayer and yet can never comprehend: In the Grand Canyon one river has moved 800 cubic miles of material in creating this big hole."

Later, he writes: "Because the Canyon is like great music, within the reach of everyone and beyond the comprehension of anyone. We can feel it, but we can never say it."

Discussing his portfolio, Dykinga draws on his artistic instincts and tells us:

"To truly 'see' the wonder, one needs to be there when the sun is low on the horizon and crimson rays create a sense of magic."

And, he confides: "The amazing thing is, though I have been inside the Canyon, I never really made it 'around' the Canyon … until now. I decided to visit the more remote viewpoints that surround this amazing place. Of course there's the promontories in Grand Canyon National Park, both on the North and South Rim. They're a great place to start. But, I also explored the points of the Kaibab National Forest, the Glen Canyon National Recreation Area, the Bureau of Land Management, the Navajo Nation, the Hualapai Reservation, the Havasupai Reservation and the Grand Canyon National Monument."

Ranney shares a concept of the Canyon he developed for this book:

"In trying to grasp the enormity of the Grand Canyon, I consider it useful to separate it into three distinct sections, each marked by striking differences in appearance—locally imperceptible but quite dramatic throughout its length. I call these parts Beginning, Classic, and Wilderness."

If you, the reader, have seen only a little portion of the Grand Canyon, or much of it, we hope that this combination of three perspectives in IMAGES enhances your appreciation of that wondrous place. ⁄⁄⁄

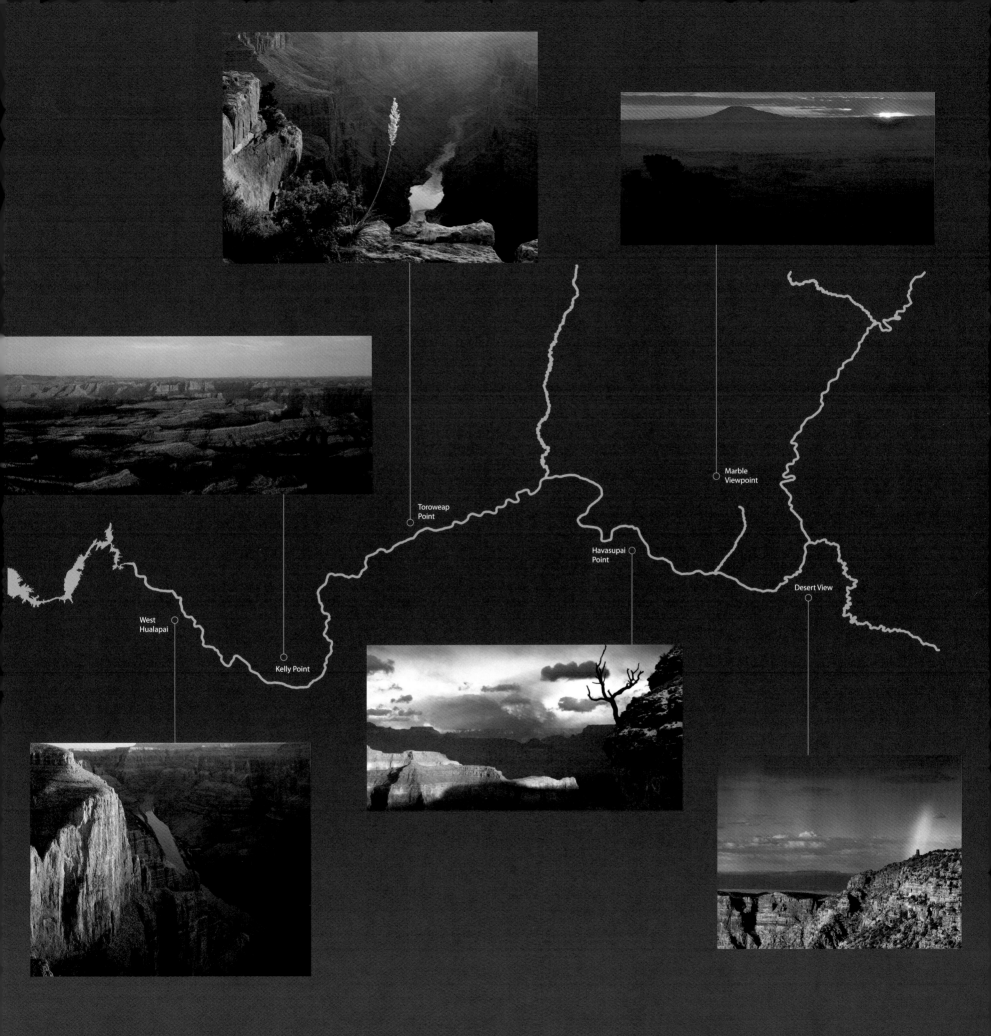

Toroweap
Point

Marble
Viewpoint

Havasupai
Point

Desert View

West
Hualapai

Kelly Point

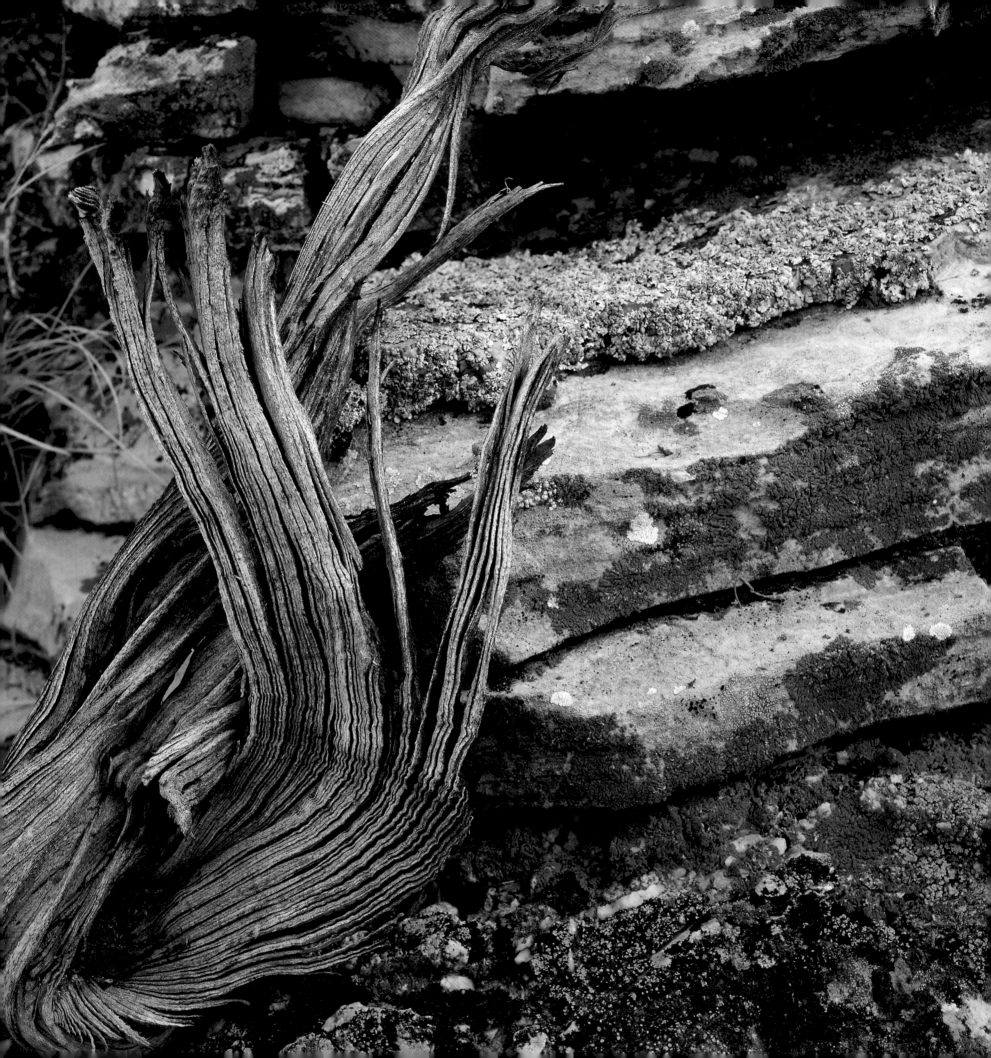

Piñon pine and juniper stand black in the gray light as the first, feeble licks of dawn seep into the eastern sky. The road is more rock than anything else, the air clear and silent. Yesterday, at the South Entrance to the Grand Canyon National Park, the line of cars reached back more than 2 miles. Now, I'm 20 miles west of there and alone, except for the three cow elk that stand by the track and one spike bull that seems like a giant statue as I grind past. The ravens slowly emerge from the darkness and fill the beginnings of the day with their croaks.

South Bass Point suddenly snaps into view. That is the enduring quirk of the Canyon, the thing that has stunned people for centuries—one never sees it coming. There is rock, old grayed limbs and trunks of fallen juniper and pine, a maze of forest and blue sky, and suddenly the world ends and there is this huge hole in the skin of the planet. Every approach to the Canyon means rolling through tablelands, flat ground with

scrub or trees— nothing that would suggest some chasm waits nearby.

At South Bass, the stone remnants of a cabin stare me in the face. The trailhead down to the river slips off the Rim. William Wallace Bass came here in 1884 to cure an illness. He stayed, had a family, raised kids, carved a trail to the river, put in a cableway across the Colorado, carved a trail on the north side up to that Rim, worked mines. He even got a strata in the Canyon named after him and was part of the beginning of the tourist industry in this area. Now his home ground is silence and, for me, a trigger to memory as I stare down at the Inner Gorge where the Colorado River churns at Bass Rapid.

Once, I clambered off the North Rim and went down to Bass Rapid. Now I stand on the South Rim and look into my past and the past of everything else that has ever lived. It's all in the strata, there right in front of me, hundreds of millions of years of life and finally, that dark rock called Precambrian, stone that hails from

the beginning of planet time itself and is almost 2 billion years old. Color indicates time here—cream, grayish white, yellow, white, rust-red, red, tan, purple, a procession of tints and pigments—a clock made like a rainbow.

As a species, we tend to walk to the edge of the Grand Canyon, look, and then not know what to do. The names of formations roll off the lips in close order drill, Kaibab, Toroweap, Coconino, Hermit, Supai, Redwall, Muav, Bright Angel, Tapeats, on and on as the mind spins ever deeper into time. And then a jay clatters in the nearby piñon and the mind returns to the immediate moment as the eye floats over the canyon. Numbers hardly help at those places we call vistas because the numbers are too big. The mind must try to encompass a gouge in the earth 277 river miles long and up to 18 miles wide and a mile deep. There's one number I keep repeating like a prayer and yet can never comprehend: In the Grand Canyon one river has moved 800 cubic miles of material in creating this big hole.

We can never know the start of this trench. About 80 million years

ago, the sea moved off. When we look at the strata of the canyon and of the surrounding Colorado Plateau, we're seeing the exposed floors of ancient oceans. Somehow this notion is easier to say than to believe. To stand on solid rock and imagine it as the bottom of the deep blue sea with creatures gliding past over our heads—well, this seems absolutely certain and almost impossible to feel. Then, about 55 million years ago, the climate was much wetter, a time when we can think heavy rains aided in carving drainage patterns of various rivers and creeks on the slab that forms the flat ground bordering the Canyon. And the earth rises, a matter geologists call uplift.

But here is the rub: Simple steady erosion cannot fully explain the big hole we call the Grand Canyon. Of course, there is bafflement among geologists because the early evidence, those top layers of strata that witnessed the beginning of the Canyon, are all worn away and now probably litter the floor of the Sea of Cortés. The Grand Canyon has devoured its own birth certificate, and geologists argue that it is 80 million

This scene along the South Bass Trail features new life, the orange lichen, and life in its final stage, the snag.

IMAGES *JACK DYKINGA'S GRAND CANYON* | 13

years old or maybe 6 million years old.

The current guess is that the Canyon experienced short bursts of serious cutting and these episodes were framed by long periods of calm. Once again, we are dealing with notions of time that seem to roll off our lips but barely touch our minds. In the last 630,000 years, geologists figure at least 13 lava flows have dammed the Grand Canyon and at times these barriers dwarf our own efforts such as Hoover and Glen Canyon dams. At least one of these dams was 2,000 feet high and 84 miles long. And now it is gone as if it never happened. Hoover and Glen will have their time—maybe a few centuries—and then they will silt in and eventually be cut away by the river.

We tend to go to that viewpoint, take in a vista, and feel we are seeing eternity, some permanent stone sense of time. But what we are really seeing is a giant clock that periodically devastates its own gears and springs, a constantly self-devouring kind of timepiece. Here the words forever and eternal had a short shelf life.

Of course, the Canyon does not care. It simply is—a vast gouge that we have given an identity by calling it the Grand Canyon. There is no evidence that one end of the Canyon knows the other end even exists. Nor is there is any reason to believe that the Canyon feels either young or old, believes itself a monument to time or a creature of the moment. To visit the Canyon is to be burdened by huge trunks of belief and memory that one drags along in the trek. We see not simply some sweep of deep time but also our own lives when we stand on the edge and look into a kind of stone mirror where our own faces and a legion of others spring into our minds much the same way as the finger moves across an ancient stump and pauses on rings and wonders who was in power then, who was in love, and what the world felt like on some distant dawn as the sun cleared a now vanished forest.

There is a compulsiveness to the various vista points of the Canyon, a quickening of the pace as the edge draws near, and then that pause on the Rim as a person takes in a new perspective on a place that one tries to believe is changeless. And always, the Canyon is too big, too wide, and too deep for any easy language. We are struck dumb at the Rim and then later, after our retreat, we fashion language and images to fight this moment of silence, to whittle down the bigness into some size we can handle.

Maj. John Wesley Powell and his crew made the first successful run of the Canyon in 1869. A one-armed veteran of the Civil War after tasting the violence of Shiloh, he was not a man to gush, but even the major strained to rein in with words the thing before his eyes.

He wrote, "The glories and the beauties of form, color, and sound unite in the Grand Canyon—forms unrivaled even by the mountains, colors that vie with sunsets, and sounds that span the diapason from tempest to tinkling raindrop, from cataract to bubbling fountain."

Emery and Ellsworth Kolb replicated Powell's river run in 1911 using a movie camera and producing a film that ran daily at the Rim for 65 years. They represented the rest of us, the multitudes that would come to look. As Ellsworth noted, "We were there as scenic photographers in love with their work, and determined to reproduce the marvels of the Colorado's canyons."

Glen and Bessie Hyde shot the waters in 1928 on their honeymoon and have never surfaced from the Canyon. Their boat was later found, but they remain still out there. But Bessie did leave a poem from her mid-journey:

> My church
> Is made of
> Rocks and sand
> With clear, blue sky
> And pounding waves
> Broken dreams hurt me so,
> I sometimes pause to wonder
> If dreaming is worthwhile
> And not a foolish blunder?

Naturally, this puzzle palace of stone has captivated educated minds for over a century. We tend to mock one early visitor, Lt. Joseph Christmas Ives, who stared into the Canyon and concluded in an 1858 report, "The region . . . is, of course, altogether valueless. . . . After entering it there is nothing to do but leave." But Ives had a sound point—the Grand Canyon is not so much a place to make money as to enchant and at the same time threaten

"The glories and the beauties of form, color, and sound unite in the Grand Canyon—forms unrivaled even by the mountains, colors that vie with sunsets, and sounds that span the diapason from tempest to tinkling raindrop, from cataract to bubbling fountain." – *Maj. John Wesley Powell*

the human mind. Ives was followed by Major Powell, who speculated the river had slowly cut the Canyon like a saw grinding through the plateau.

Then came Clarence Dutton, who dotted the Canyon with place names from ancient history and created the theater of jolting scale that now dominates how we see the Grand Canyon. He noted in his late-19th-century report, "The lover of nature whose perceptions had been trained in the Alps . . . would enter this strange region with a shock, and dwell there for a time with a sense of oppression, and perhaps horror." And it rolls on like that for a century, geologists fine-tuning notions of how the Canyon came into existence and all the while being mesmerized by its sheer size.

So, we arrive at today, when we walk to the edge and our minds rattle with various theories of origin, and then we look and the stone slams our calm and yet, at the same moment, gives us a sense of serenity. The Grand Canyon by slicing the earth so deeply makes us both face time and our tiny slice of this long march, and yet abandon time and feel the endless breadth of this place we call Earth.

Nothing ever happens because the place is eternal. And everything that ever happens takes place in the blink of an eye. I am walking down the canyon that feeds into the Colorado at Lee's Ferry, the origin point for the Canyon we call "grand." I round a bend and there is a rock the size of a garage that has fallen from the canyon wall and everything—shrubs, ground, other rocks—is covered in a fine pink dust from this sudden flight of stone. My fingers run through the fine dust and I wonder when it happened. Just how long can fine pink dust lie undisturbed in a wild canyon feeding into the Colorado River? Or I'm wandering a narrow defile called the Dive of the Buckskin and see huge logs jammed far above my head from some earlier flood and I look at them with disbelief as I walk the cool shadows and my feet glide over the dry sand floor.

So we come to this place to remind ourselves of timelessness and then find these clues of the rush and turmoil of life itself.

What we see at these viewpoints lining the Grand Canyon depends on what we bring to the Rim. And we see more if we go to those obscure places, the ones with primitive roads and no facilities, because then we face this warp and woof of time alone and in silence, with only the bubbling of love and memory to keep us company. The camera stays in the case. There is no guardrail, or signs. Nothing protects us from ourselves or this wound in the earth that harbors the bones of all our ancestors, plant and animal, and their ways and dreams. Time stops, literally. The sun seems to move across the sky but this is little noticed. Birds sweep through the trees, a blue mist hangs over the Canyon, and the slot of the Inner Gorge winds its way far below. At some points the actual river can be seen and without exception I always think I can hear the water moving a mile below.

Sometimes I bring a book. At Bass Rapid I once knocked off a scientific study of passenger pigeons. At Lee's Ferry, the starting point of the Canyon where Paria Creek ripples into the Colorado, I finished Carl Sandburg's massive study of Abraham Lincoln. But eventually, the book is set aside. That is the moment I crave, when time stops, when the world as I know it falls away, and when I think but do not think, that state of mind I imagine Zen monks savor in those manicured rock gardens where they contemplate the depths of life. There is no machine noise, no car doors clunking shut, no engines turning over, no radio, no speech save the song of birds. And the breeze boiling up out of the Canyon itself. At Toroweap on the North Rim, hours of bad road lead to groves of trees and then a 3,000-foot cliff where the earth seems cut as if by a knife.

I have a tiny camp stove for making coffee and I am always stunned by the roar it makes and blessed by the curtain of silence that rolls out the instant I turn it off. Each time I use it I am appalled, as if the mayhem of modern life had followed me as a stowaway disguised in this piddling stove. Maybe that's the reason I bring it—so that the roar of the burner will make the silence all that much more delicious when I turn it off.

Viewpoints are a curious product of the human mind. We insist there are promontories that enable us to see more. I doubt this very much. Every

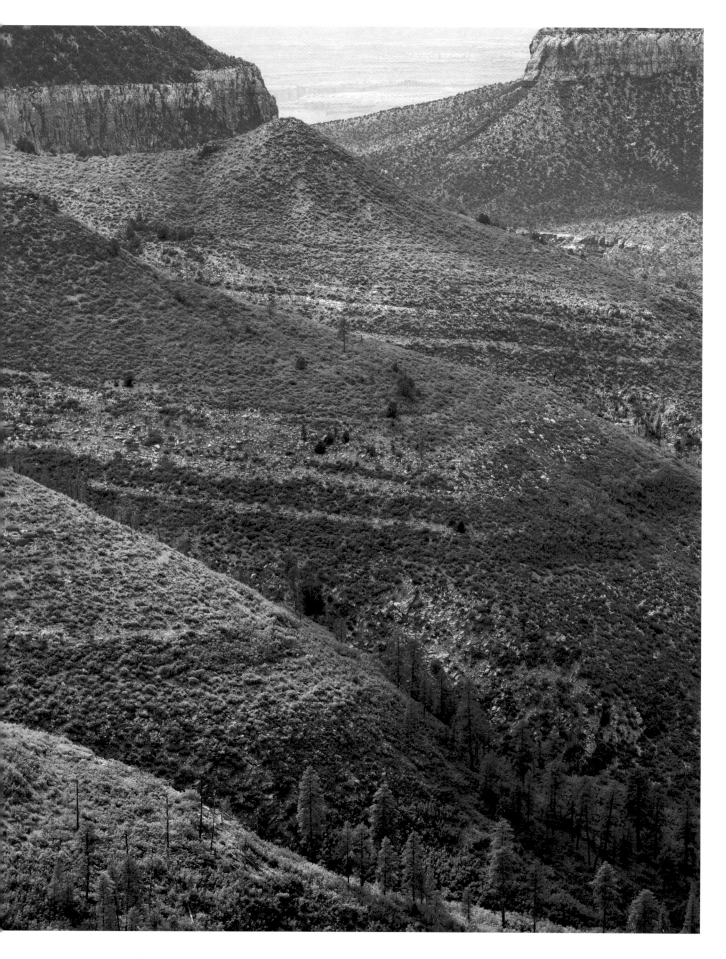

inch of the Rim brings to our eyes more than we will ever understand and yet, at the same instant, everything we see we understand at some deep level within ourselves, and this understanding is beyond our ability with words. There is a part of me that thinks that no one should write a word about the Canyon, or take a photograph, or paint a picture. And I believe this—even though at this very instant I am violating this belief as I write—because the Canyon is like great music, within the reach of everyone and beyond the comprehension of anyone. We can feel it, but we can never say it.

A string of names attached to jagged fingers of rock reach out into the blinding space of the Canyon. That is what we mean by vista points. Crazy Jug Point, piñon pine in the early morning light, rounded columns of stone lining the Rim, and then, off there, that void that beckons and

The emerald green hillsides of the Powell Plateau and the bluish Steamboat Mountain, rising to nearly 7,000 feet, unfold from Swamp Point on the North Rim.

yet frightens at the same time.

Swamp Point, the stone gently curving on the bajada below, and rampantly green with scrub against the dry earth below the North Rim. This was the spot where years before after days skiing through the woods, I dropped down to North Bass. Marble Point, a finger reaching out of the Kaibab. Behind stands Douglas fir, below Marble Canyon slices the plateau, and past this tear in the earth stand the Echo Cliffs and then, behind them, Navajo Mountain looms in the dawn. At dusk, the ground goes blue and melts finally into black. Near Point Sublime, the spires of stone stand adorned with caprock that bristles with fossils, and these prisoners in the rock seem to still writhe with desires. A storm rolls in, the lightning strikes on the horizon, the monoliths dubbed temples—Shiva, Isis, Confucius, O'Neill, Mencius—brood in the seep of evening. Saddle Mountain where pools of water dot the rim rock. Going to Dog Point on the North Rim in spring, you cruise through meadows of white daisies. The trip to Tiyo Point lances

across brown meadow framed by dark spruce. The sun sets at Navajo Point on the South Rim. At Angel's Gate, Isis, Shiva, and Zoroaster temples stand in a series next to Wotan's Throne. Jumpup Point, on the North Rim, is a finger of trees reaching deep into the silence of the canyon. At Moran Point, the river seems so near and so far as it glides below in plain view.

We keep going to the edge and staring out and then we have so much to say and yet the words seldom come.

The road spins through scrub, then hits stands of big ponderosa, and finally slips into Prospect Canyon, a place named by two 19th-century men looking for a bonanza. I'm on the Hualapai reservation, a long ways west of South Bass Point. The dirt track goes on and on for more than 20 miles and I see no one. Five spike mule deer bound out of the way, groups of juvenile ravens explode before my eyes. A column of stone glows yellow by the road, the Canyon walls narrow and then widen. Mile after mile I follow a lane amid the trees, then the Canyon opens and sage brush takes part of the

landscape. I climb up onto a ridge to the left, the stone slab that leads to the promontory. Now the road is rock and winds on the edge of a burned over area, the blackened skeletons of trees standing like scarecrows across the landscape. Suddenly on the left, the world falls away. I park and walk over through the pine and stand on the Rim. The earth below feels remote and everything is buttes, plateaus, and wind. I'm miles from Prospect Point, but I linger. The stone is cool, to the west the air hangs blue, an enchanted mist hanging over the benches and spires of the Canyon.

I roll on and enter the forest clotting the promontory. Walk to the Rim, and below is Bass Rapid, a place I once sat for days and days. The trail on the North Rim leading down to the river is a jumble of boulders and then the chaos of a streambed. It was winter that time and ice formed on the water. The Canyon from Prospect Point becomes a well of memory for me. I stand in the sun and yet feel the fresh flakes of snow from that long ago winter trek. At my feet are

gnarled silver limbs of piñon, some almost seem to twirl as if a giant hand warped them into sinuous curves.

I'm alone. But that is the point of seeking isolated places on the Rim of the Canyon, to find that aloneness and when you do, then you realize you are never alone, because these ribbons of time, those captured in the strata and those embedded in your own life, these soft ribbons of life wrap around you and suddenly you have no schedule, you are not on the way to somewhere, you are where you began and where you end and where all the places in between are found. Sometimes they call the place South Bass Point, or Prospect Point, or North Bass, or Toroweap, or a dozen other off-the-beaten-path fingers of stone reaching into the big chasm.

The view can be huge like here. Or the view can be little like at Lee's Ferry, where you glance downstream and suddenly realize the earth is opening itself up to human eyes for close to 300 miles.

But the view is always the same as you finally look into yourself and find you can live with what you see. ▥

My relationship with the Grand Canyon began inauspiciously as a typical, motorized tourist in a long line of cars driving from viewpoint to viewpoint. I rolled down the window, peered into the bright, midday light, and kept going. Tragically, that was not an unusual approach for tourists arriving for the first time. Since then, I have realized, the Canyon requires more from its visitors. To truly "see" the wonder, one needs to be there when the sun is low on the horizon and crimson rays create a sense of magic.

Subsequent trips led me deeper into remote places, both along the rims and in deep grottos of hanging gardens far below. Yet, I only scratched the surface. I never really made it "around" the Canyon ... until now.

To create this portfolio, I visited popular and more remote viewpoints surrounding this amazing place. I have included promontories in Grand Canyon National Park, both on the South Rim and the North. But, this portfolio also ventures into the Kaibab National Forest, the Glen Canyon National Recreation Area, areas managed by the Bureau of Land Management, the Navajo Nation, the Hualapai Indian Reservation, the Havasupai Indian Reservation, and the Grand Canyon National Monument.

Described in terms of natural, not man-made, boundaries, the portfolio focuses on scenes ranging from the high, lush coniferous forest of the Kaibab Plateau to the Mohave Desert's barren rock, to the blood-ed Colorado Plateau of the Great Basin Desert.

A word of caution: Not all of these places are reachable in a passenger automobile. Many locations lie along steep, narrow, winding, boulder-strewn, deeply rutted routes that require permits and current weather reports before venturing onto them. For these, a four-wheel-drive, high-clearance vehicle is essential—not just to get there, but to get back home!

My hope is that you'll enjoy this visual journey and come to appreciate the amazing and complex ecosystem that is our nation's most precious treasure. It's future, depends on all of us.

Jack Dykinga

From near the South Kaibab Trail's beginning at Yaki Point on the South Rim, a viewer sees ridge after ridge after ridge.

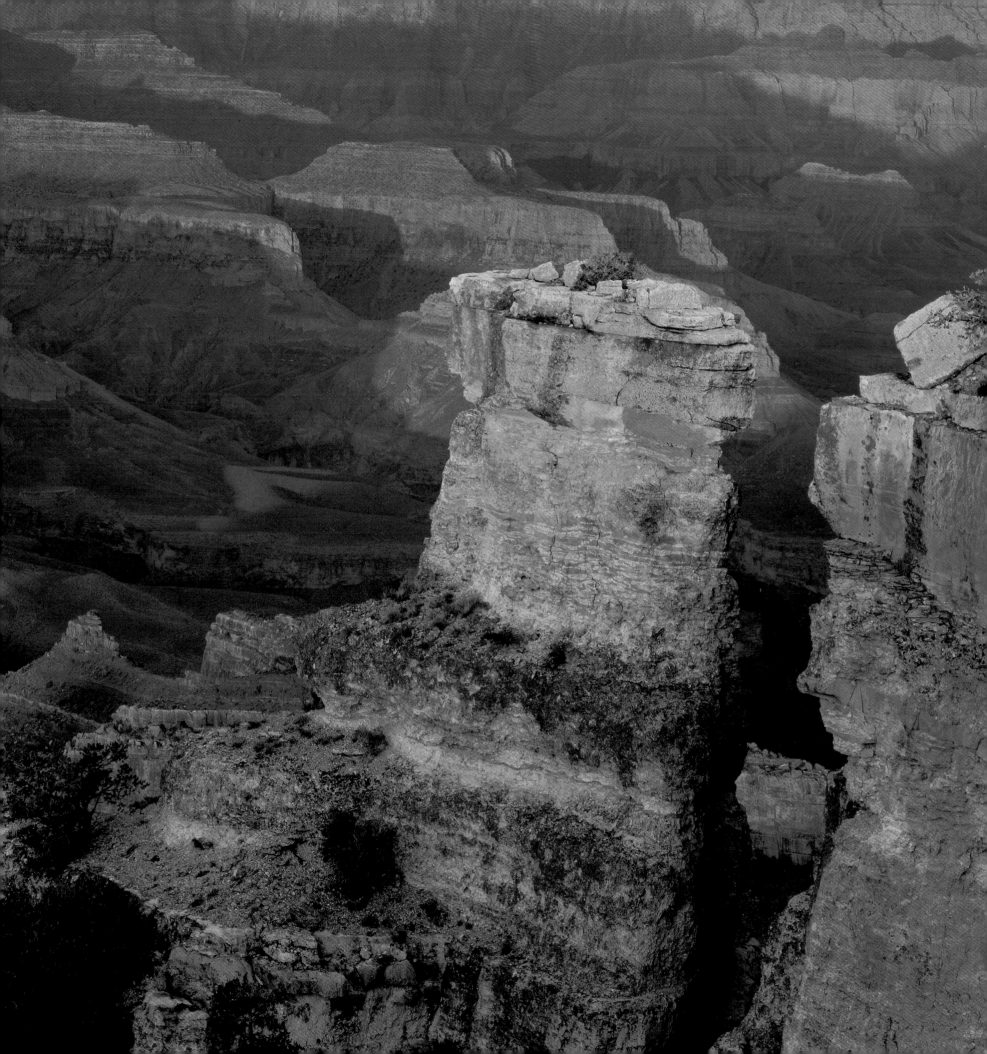

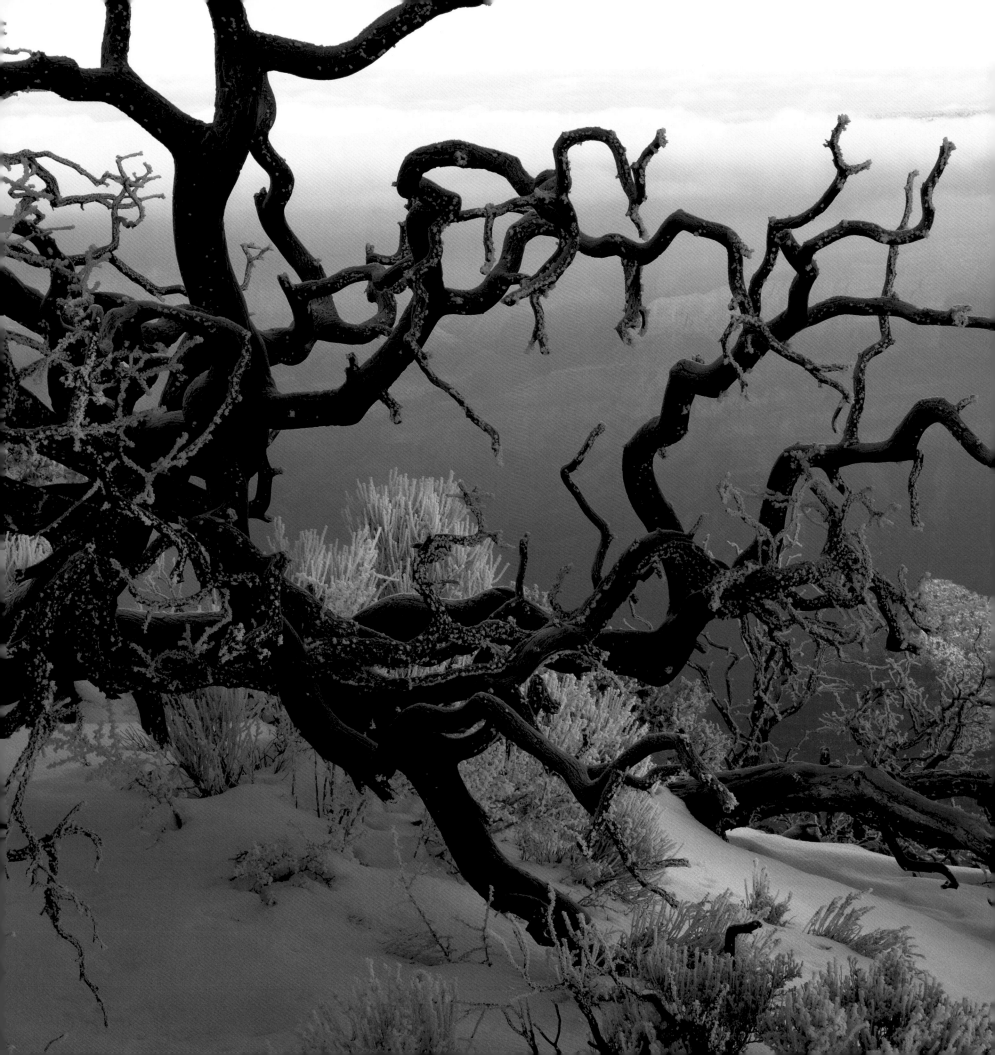

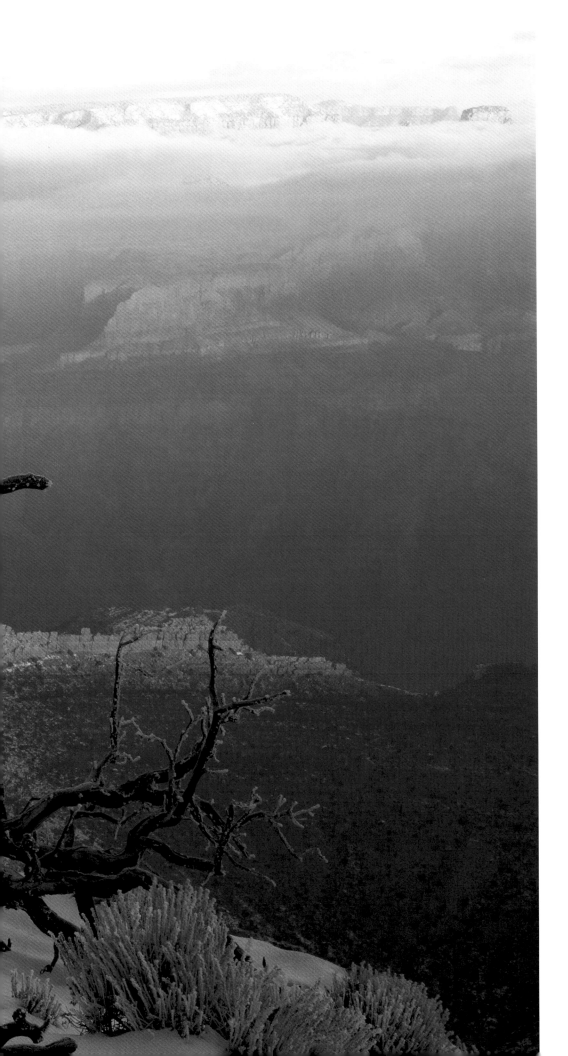

DESERT VIEW | A beam of first light highlights a ridge while the surrounding terrain remains shrouded in a hoary frost at Desert View, the easternmost viewpoint along the East Rim Drive.

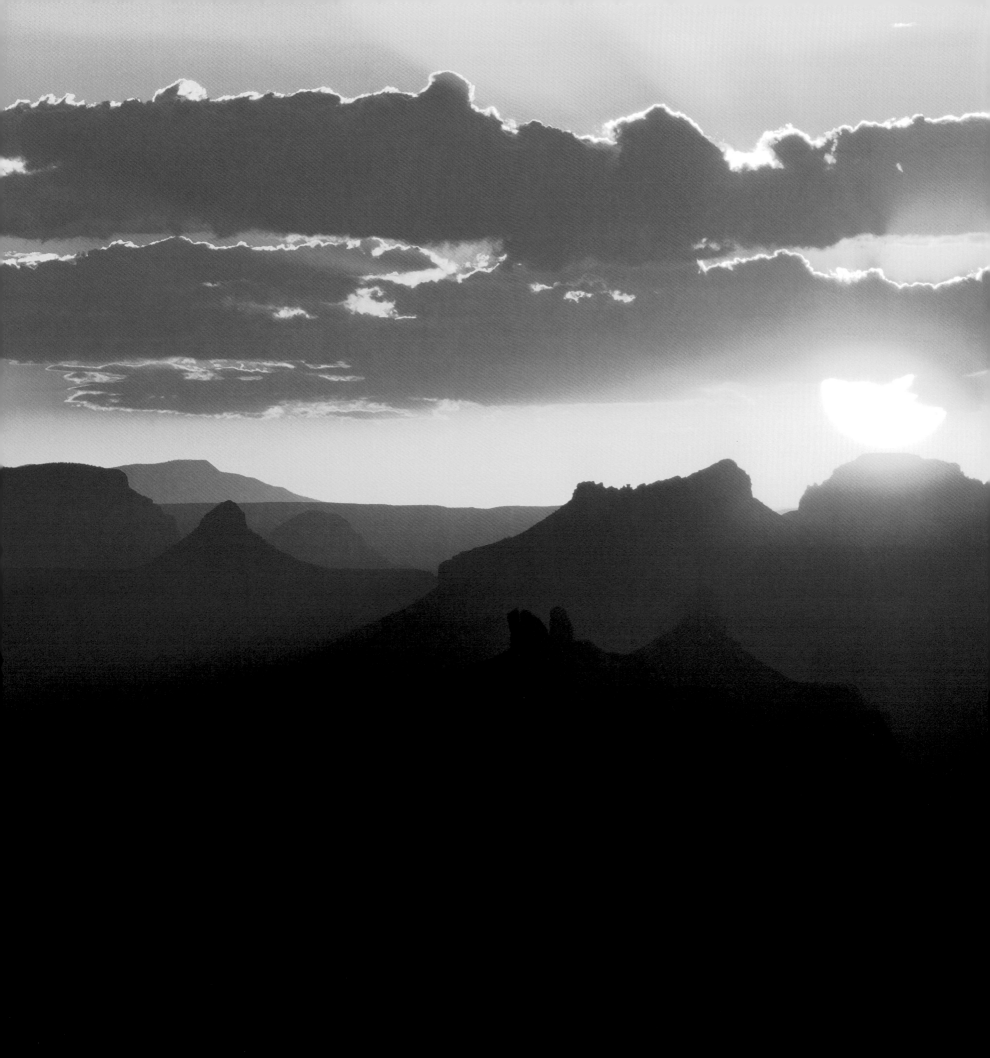

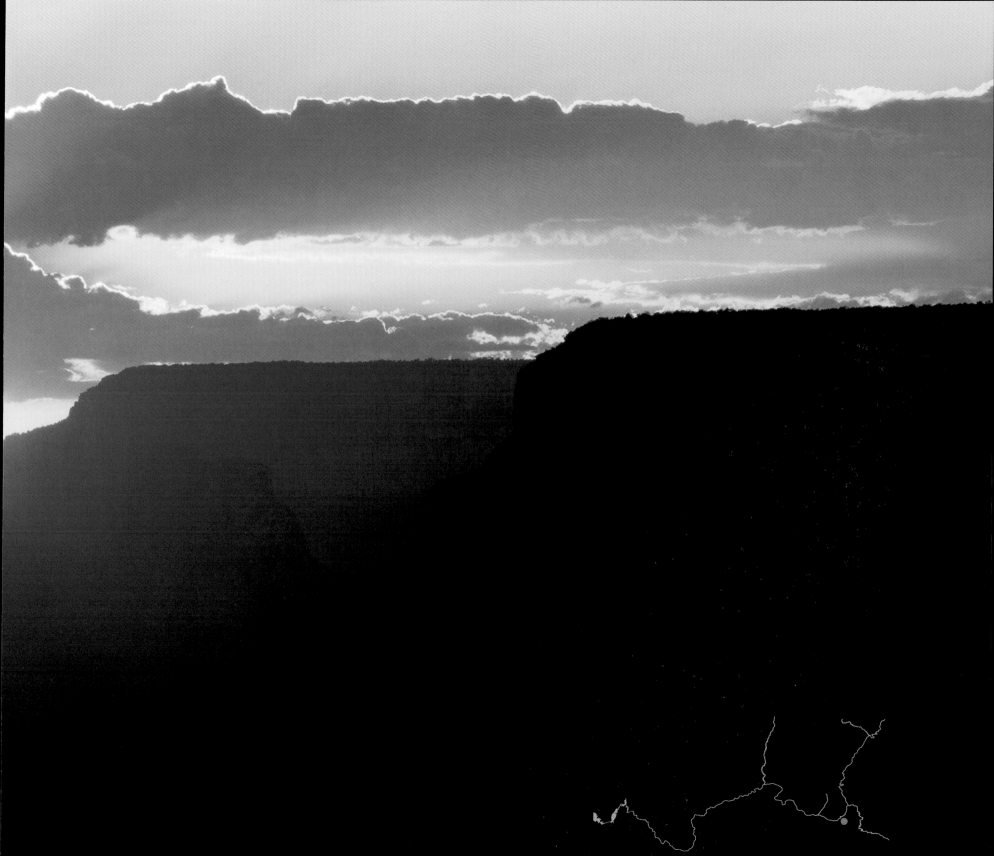

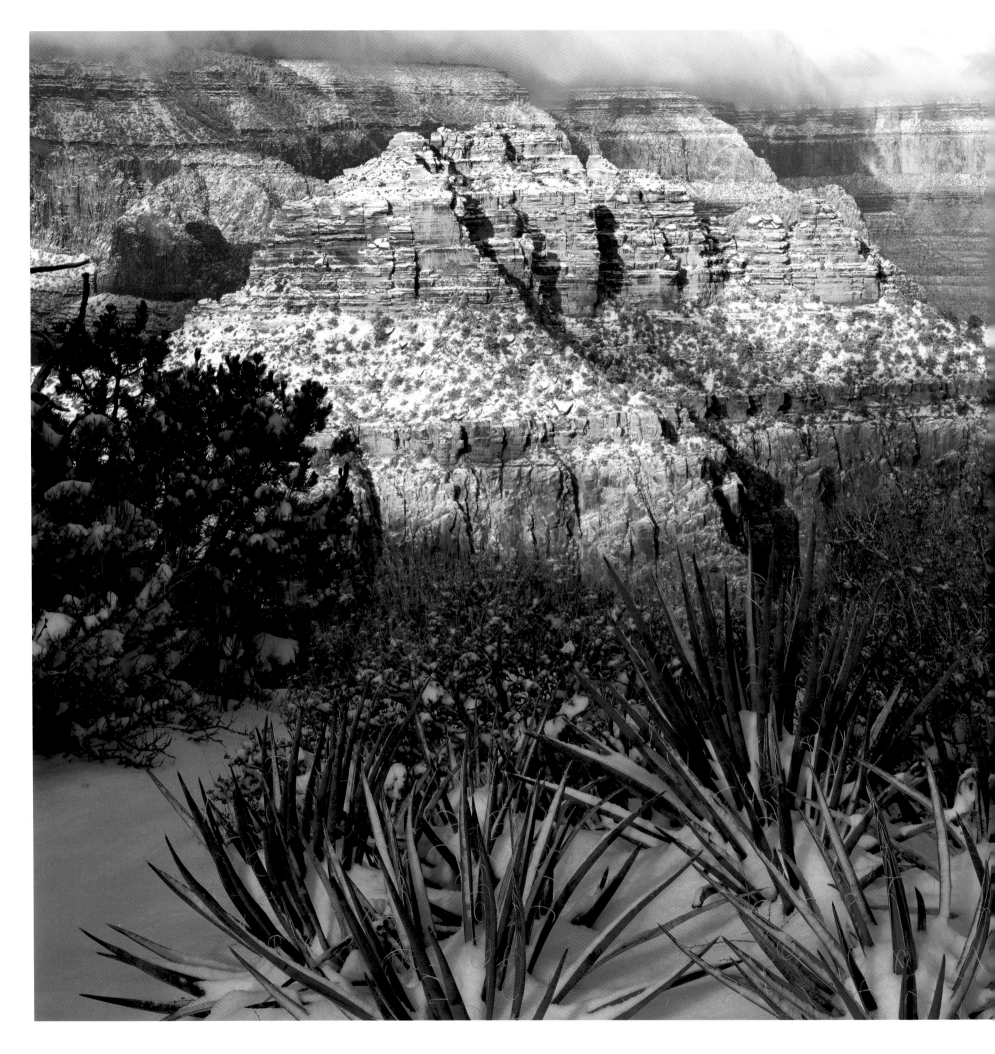

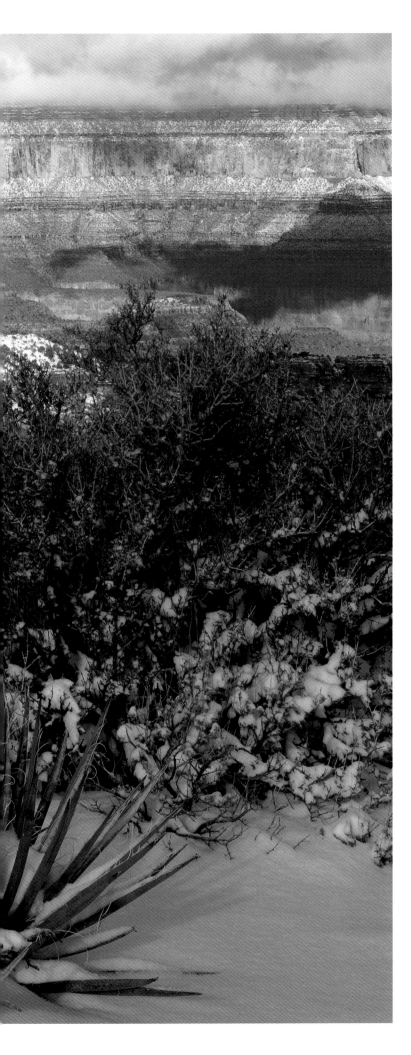

The Grand Canyon, in winter, is a place of solitude where sound is buried under a blanket of snow. Warm golden colors of stone are juxtaposed against winter's cool blues and whites. Combine that with high desert yuccas poking through the new snow and you begin to appreciate the contrasts and diversity of life in the American Southwest. I feel real magic standing on Moran Point with my camera pointed west, in the frigid early morning hours as Coronado Butte receives the first kiss of sunlight. —*JD*

MORAN POINT | At Moran Point, shadow and snow muffle the sharp leaves of yucca, while sunlight catches the ridges of Coronado Butte.

MORAN POINT | Named for 19th-century painter Thomas Moran, whose work captured the Grand Canyon's beauty before landscape photography, Moran Point may be where Spanish explorers first saw the Canyon. The point is an ideal location for viewing the Sinking Ship formation (see pages 28-29). At right, snakeweed (bottom) and yucca poke through the snow.

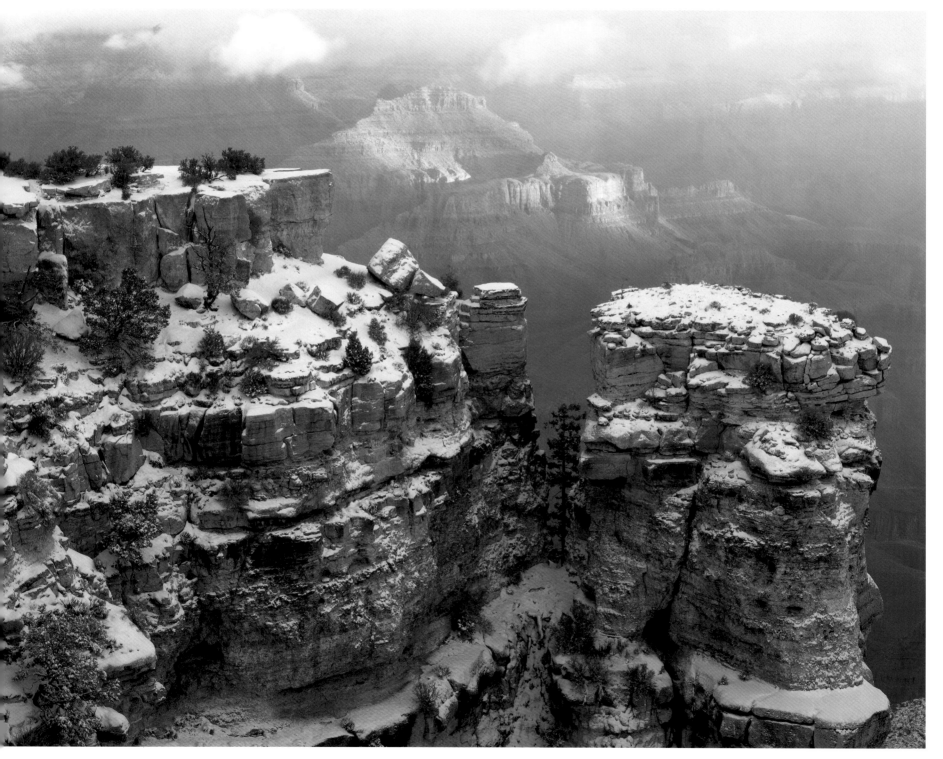

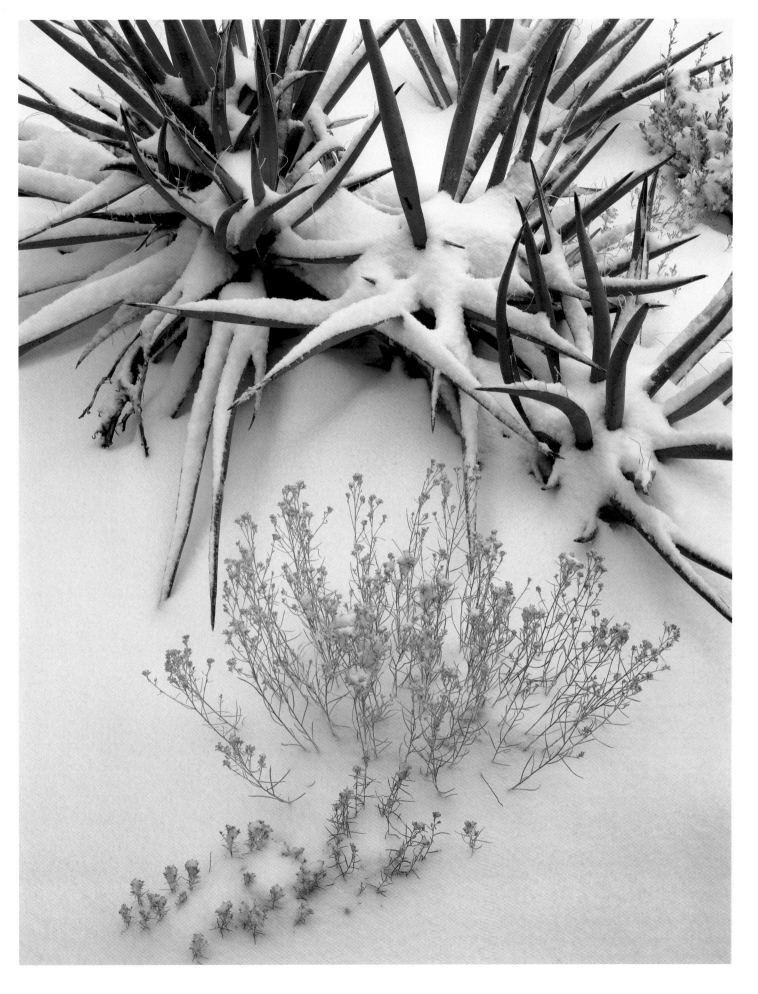

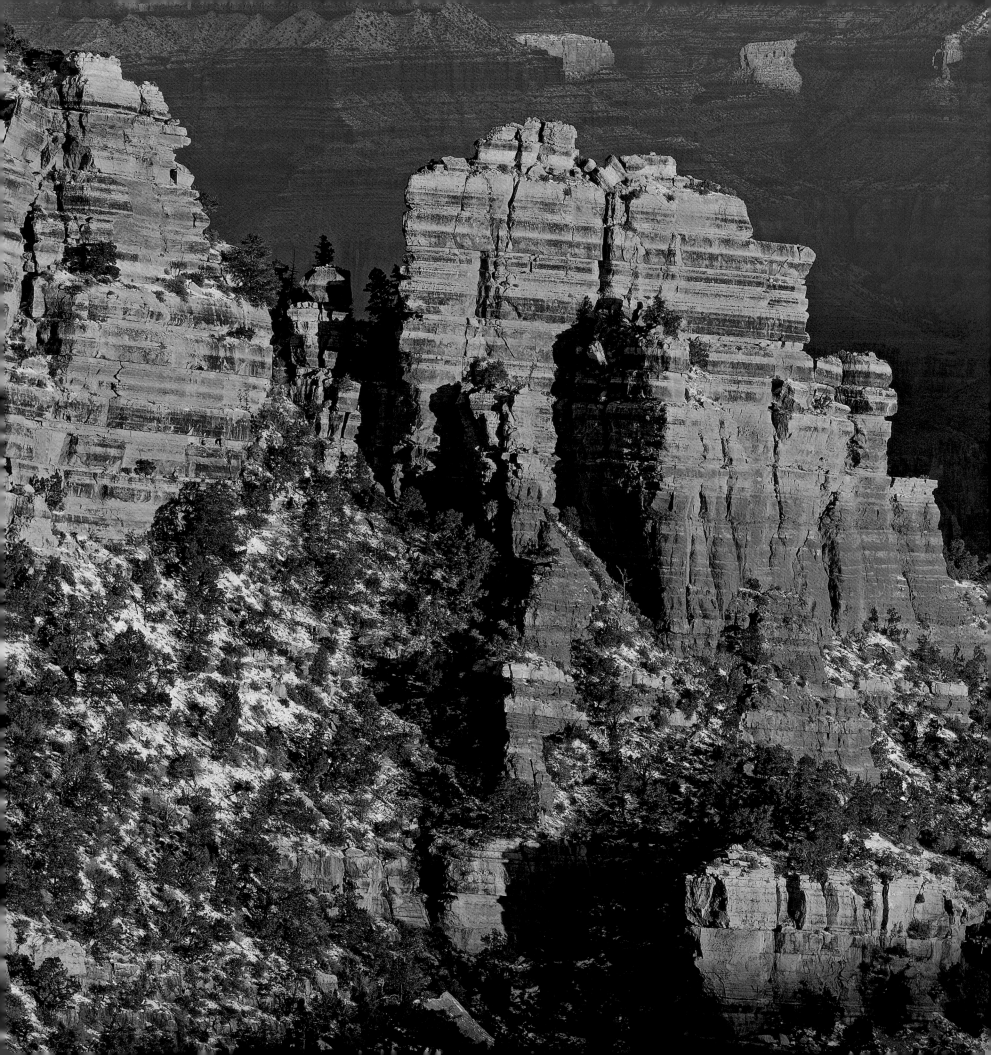

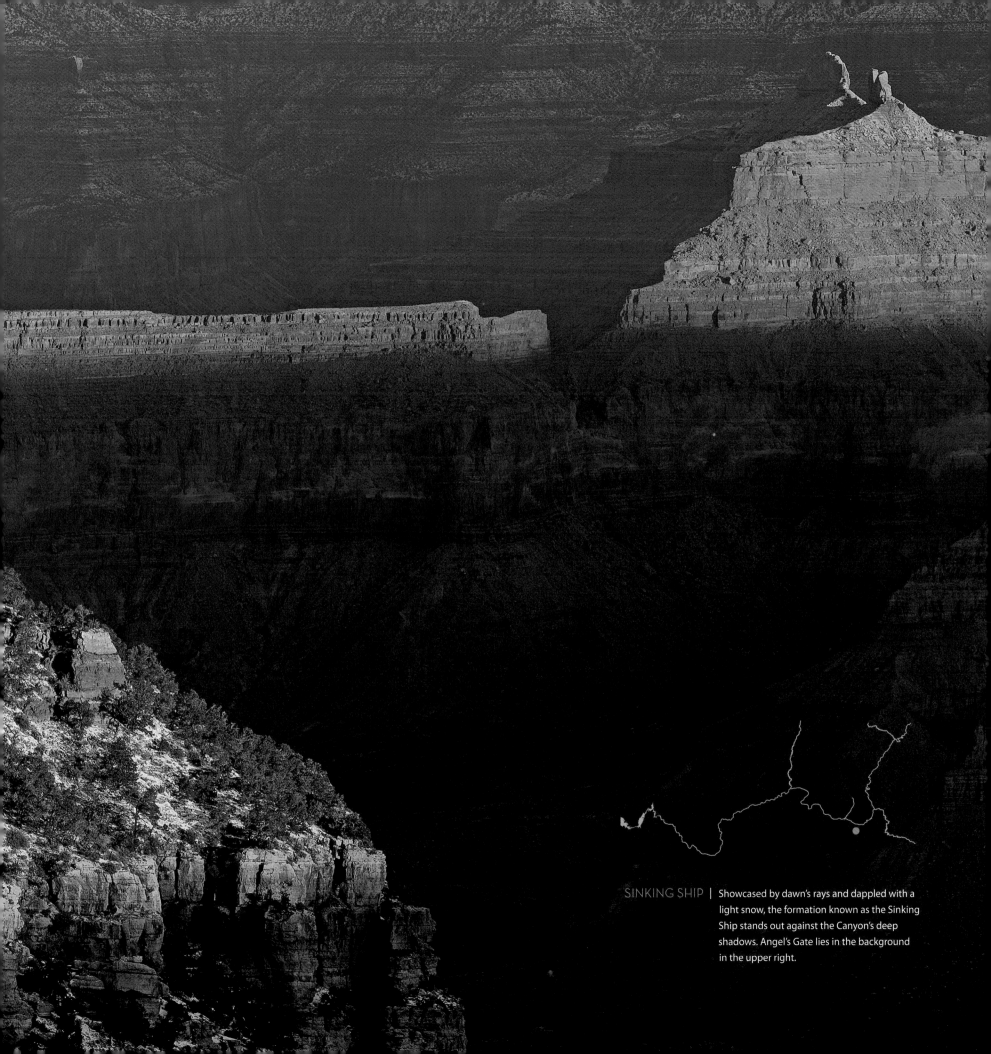

SINKING SHIP | Showcased by dawn's rays and dappled with a light snow, the formation known as the Sinking Ship stands out against the Canyon's deep shadows. Angel's Gate lies in the background in the upper right.

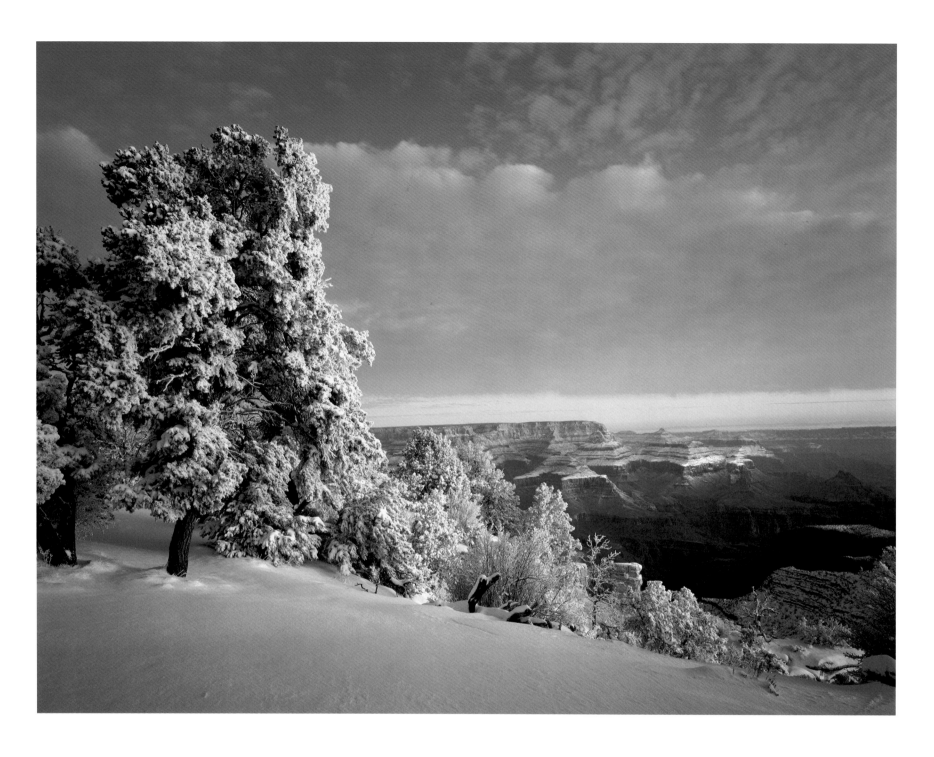

GRANDVIEW POINT | Wintry piñon pines at the South Rim's Grandview Point box a distant vista of the West Rim.

At right, a view from Grandview Point shows the jagged buttes above Hance Creek as they appear in the final rays of sunset.

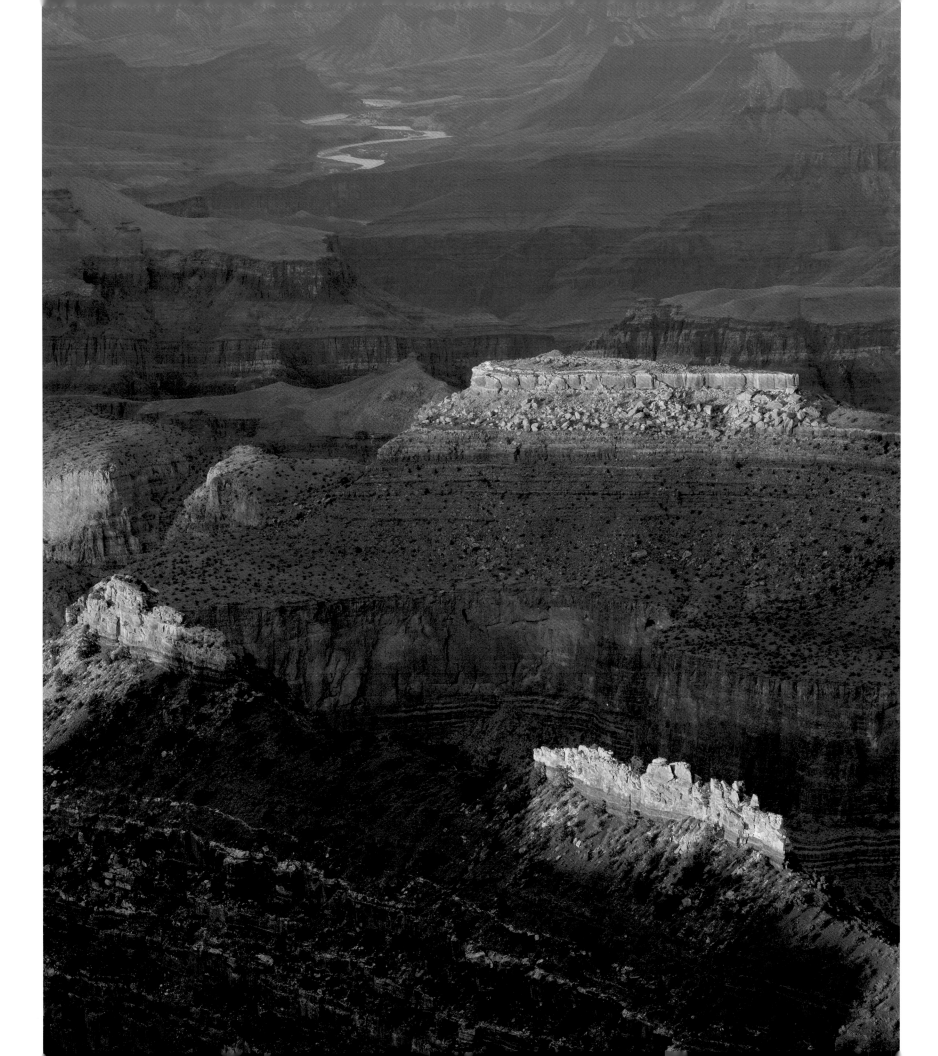

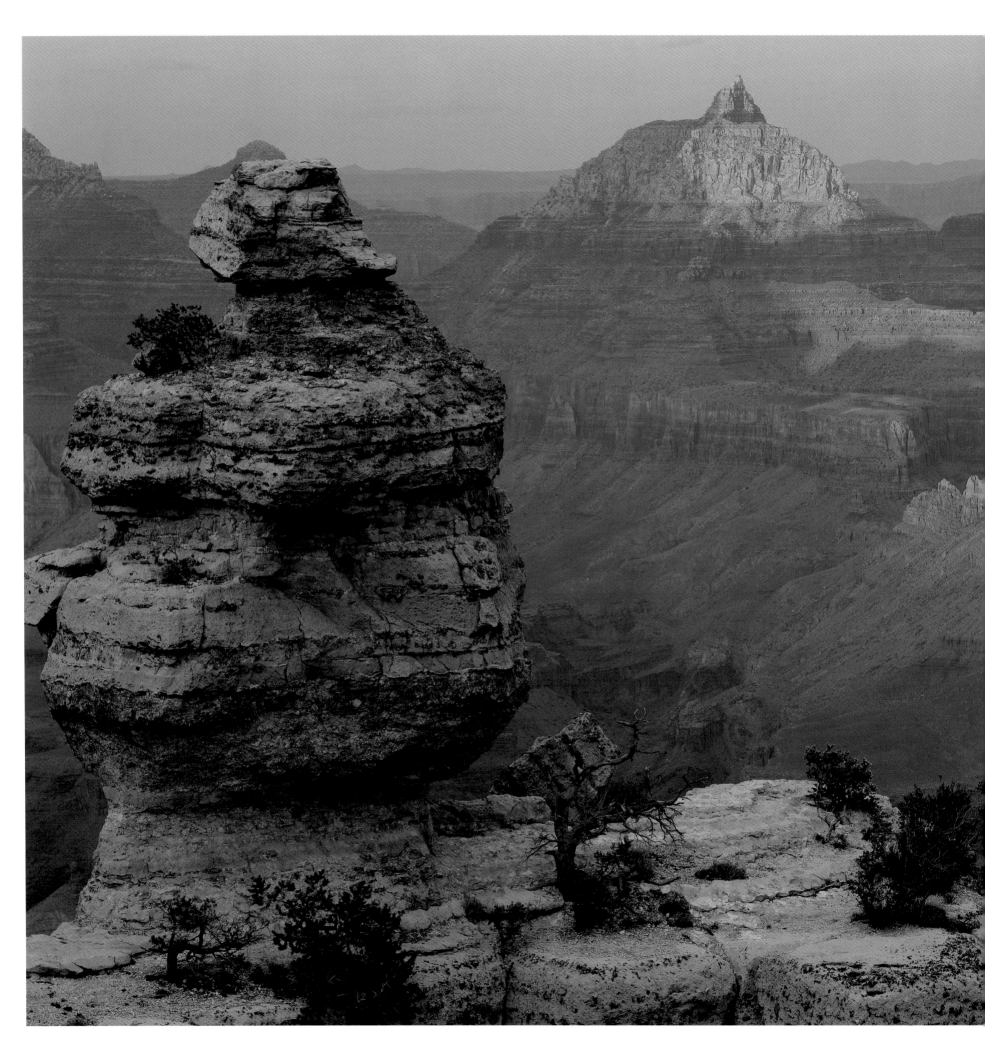

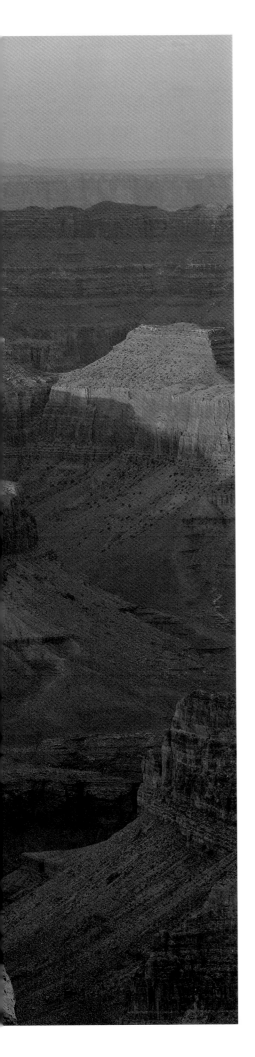

Sunset on the South Rim's Desert View (East Rim) Drive affords boundless opportunities to view the light show that the Canyon provides daily. A formation known as Duck on a Rock is perched in a wonderful spot, framing one of the dominant formations in the Canyon: Vishnu Temple. Warm sunset light sweeps through the Canyon, coloring the tips to the protruding ridges and temples, while emphasizing texture in the convoluted, sculptured walls the Colorado River has created. —JD

DUCK ON A ROCK | Shadow dims the Duck on a Rock formation, while late sunlight stains a dominant Canyon formation, the spire-topped Vishnu Temple, beyond.

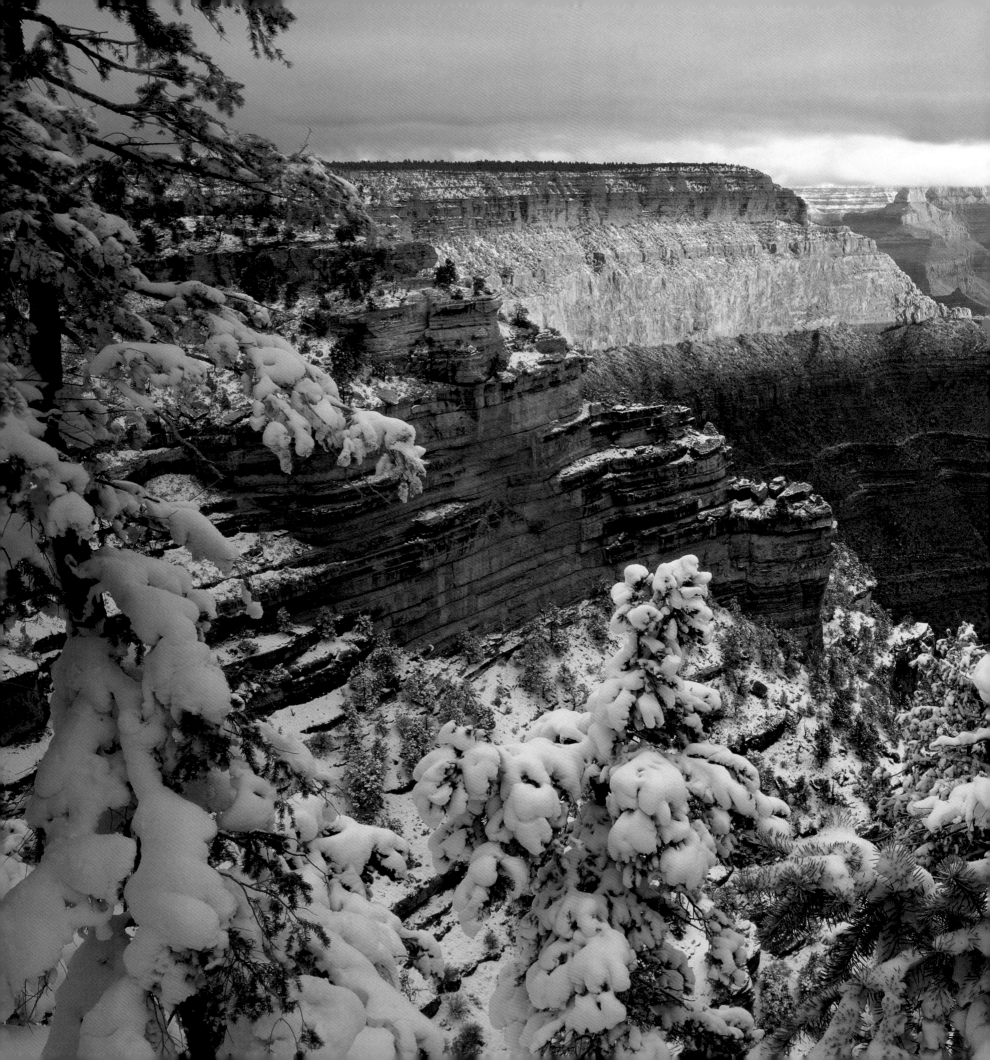

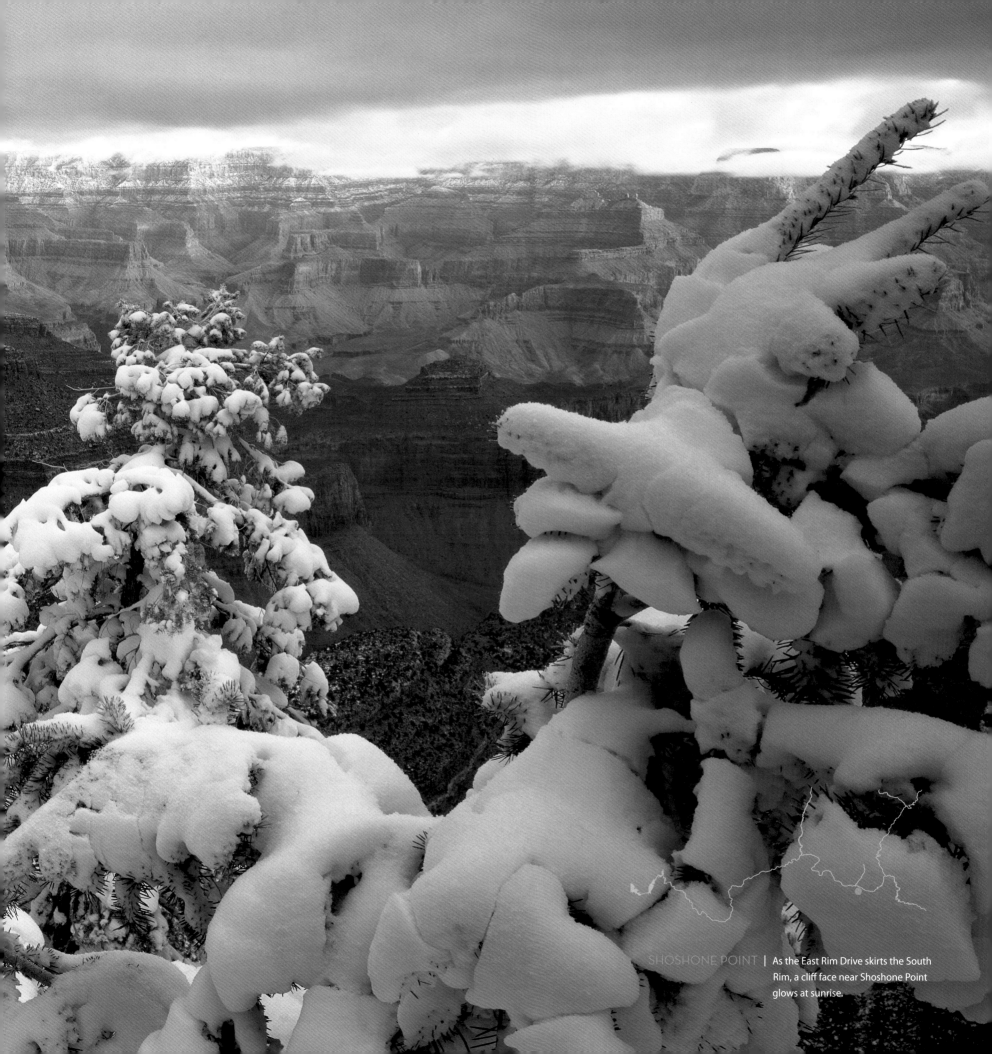

SHOSHONE POINT | As the East Rim Drive skirts the South
Rim, a cliff face near Shoshone Point
glows at sunrise.

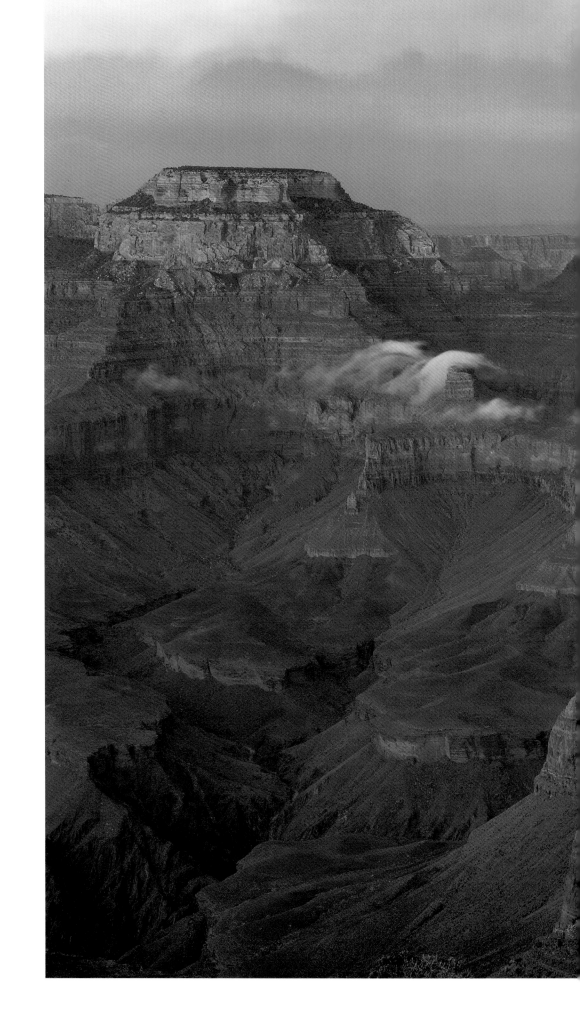

YAKI POINT | Seen from Yaki Point, the Grand Canyon glows
while the late sunset light turns the distant storm
clouds purple.

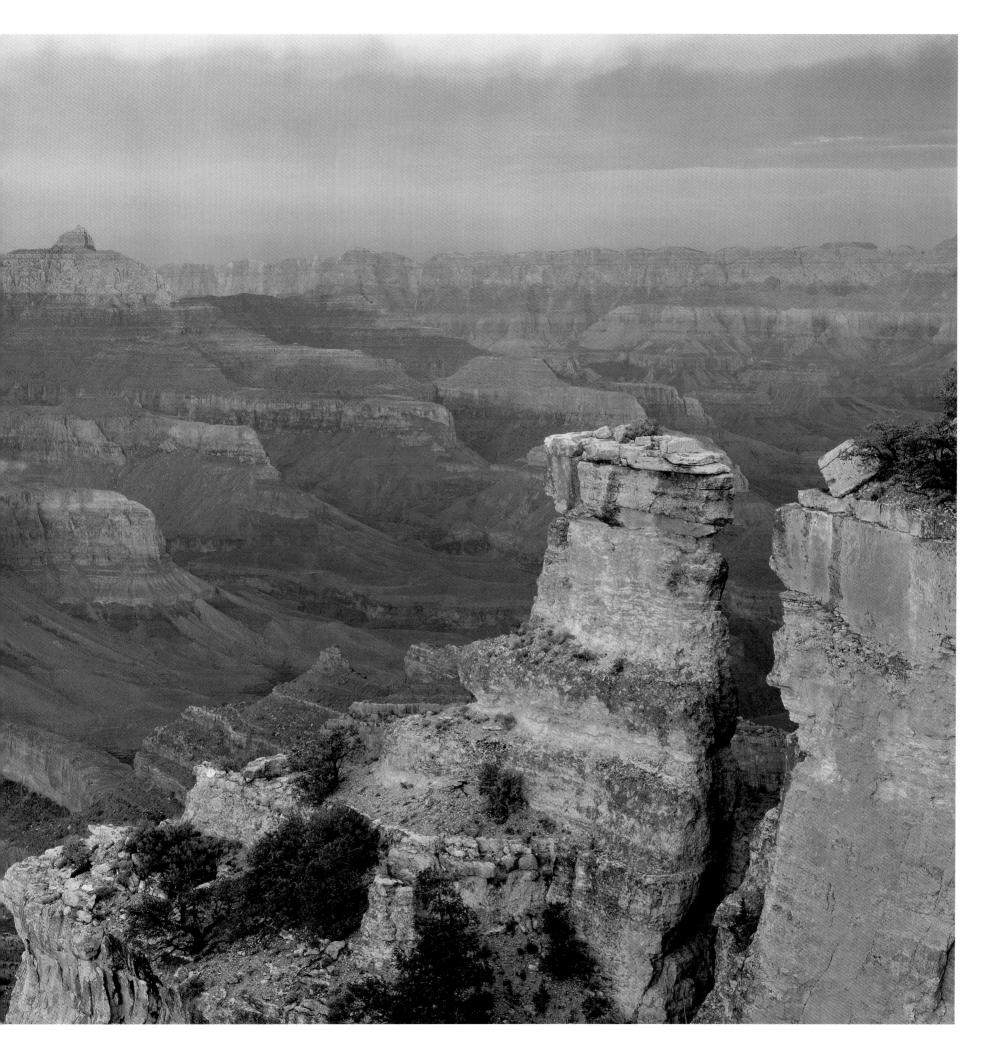

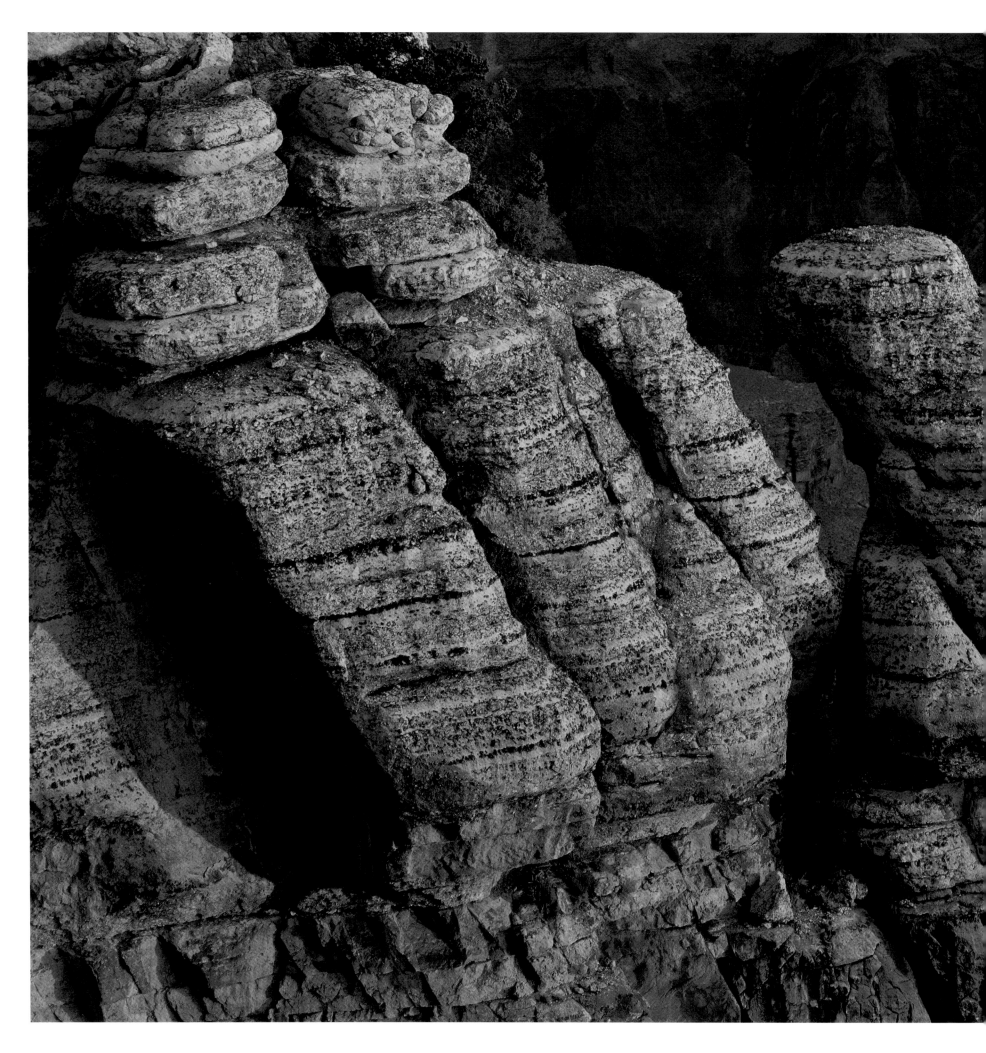

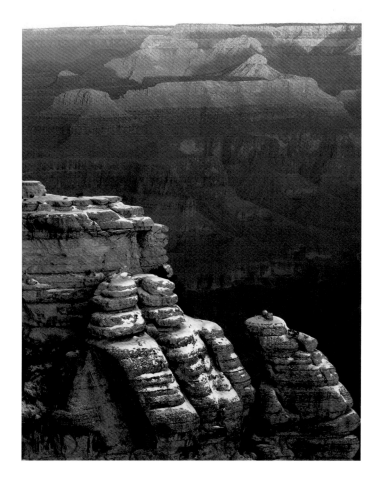

MATHER POINT | At Mather Point on the South Rim, left, eroded layers of rimrock jut above the Canyon's Inner Gorge. Above, a snow-dusted cliff face at Mather Point catches shade as the sun rises.

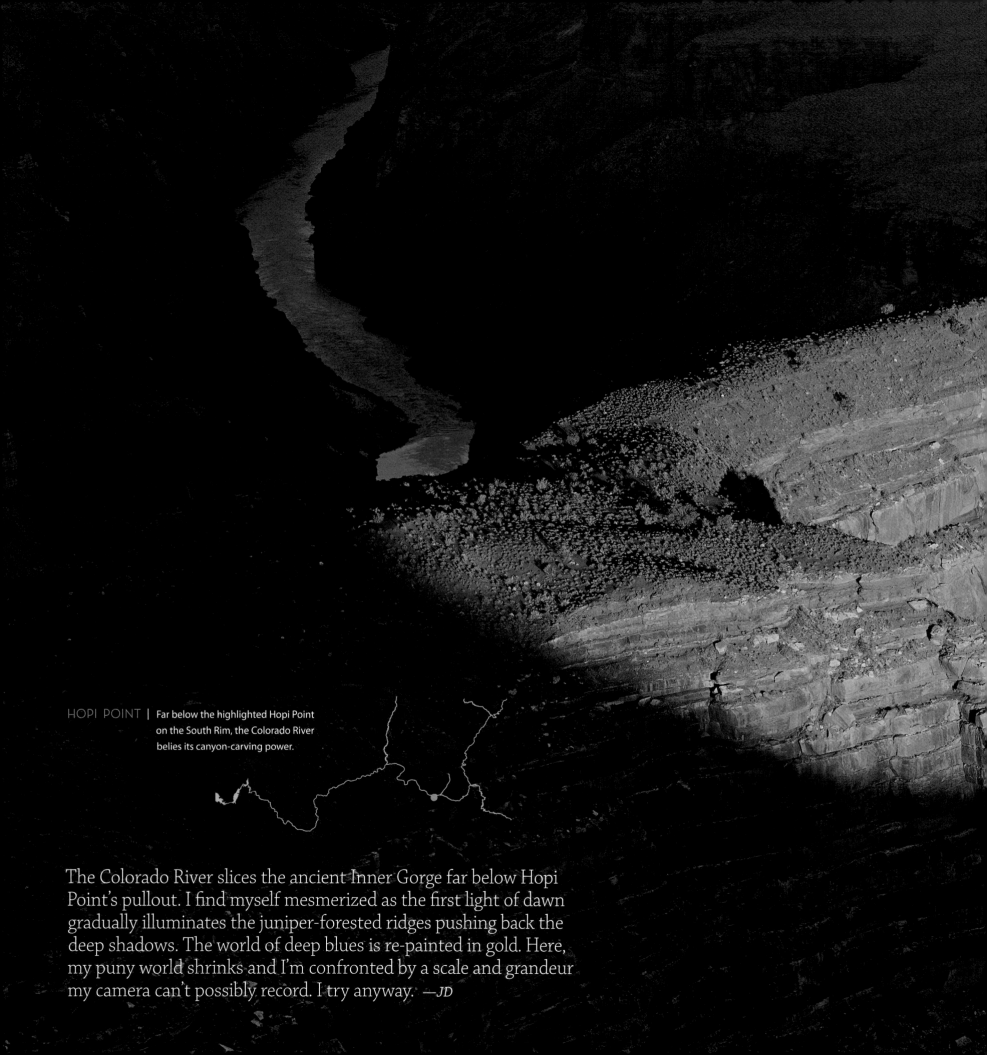

HOPI POINT | Far below the highlighted Hopi Point on the South Rim, the Colorado River belies its canyon-carving power.

The Colorado River slices the ancient Inner Gorge far below Hopi Point's pullout. I find myself mesmerized as the first light of dawn gradually illuminates the juniper-forested ridges pushing back the deep shadows. The world of deep blues is re-painted in gold. Here, my puny world shrinks and I'm confronted by a scale and grandeur my camera can't possibly record. I try anyway. —*JD*

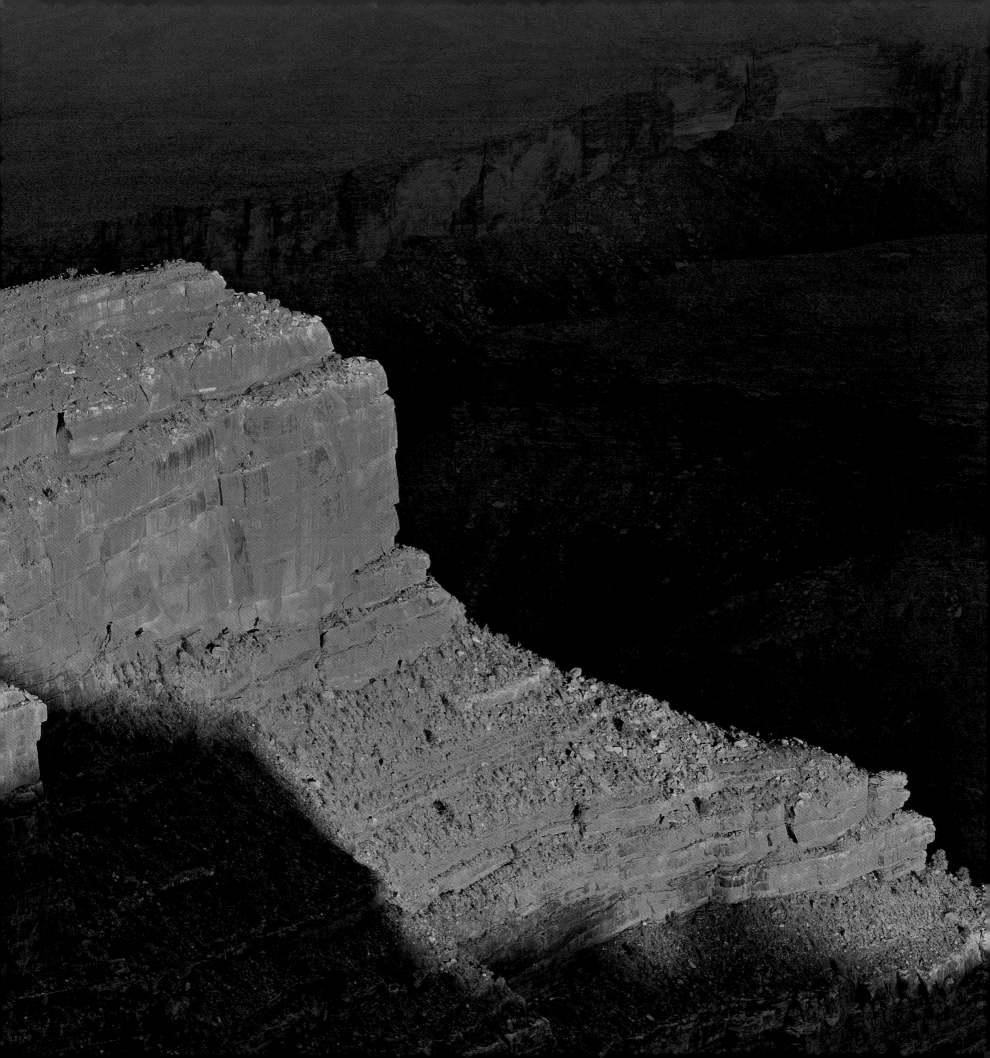

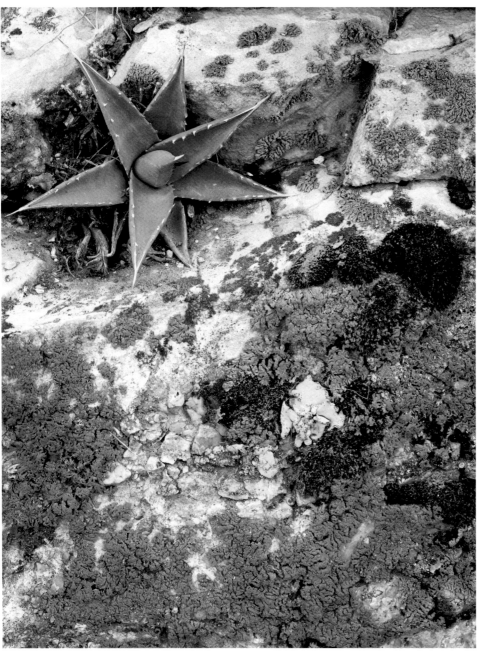

HAVASUPAI POINT | Along the South Bass Trail, above, a tiny agave and bits of lichen establish a place in the massive rock structure.

Looking eastward from Havasupai Point, right, a viewer can see a stretch of the Colorado River in Granite Gorge.

A wind-blown tree snag, once a piñon, clings to a rocky face at Havasupai Point on the following spread. The panorama of ridges and formations lies to the east, or upriver. This is an expanded view of the cover scene.

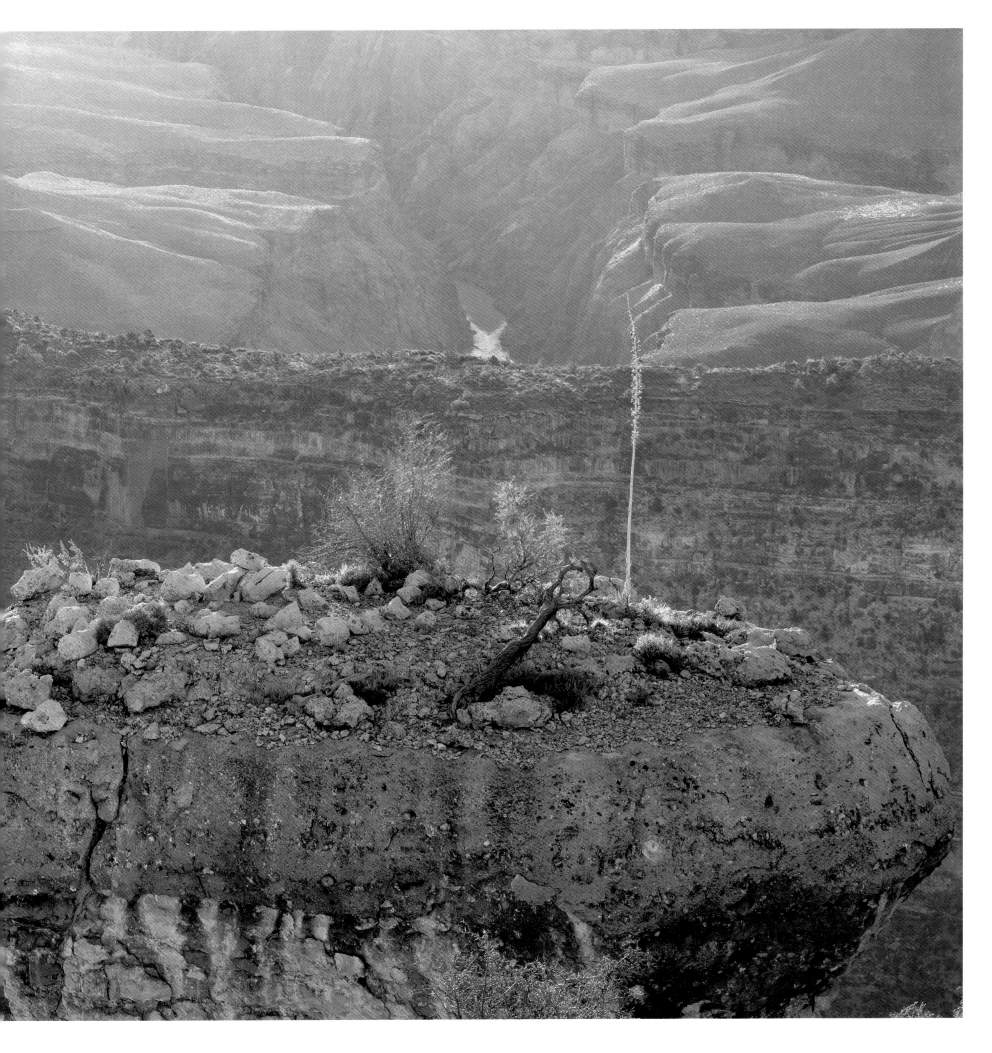

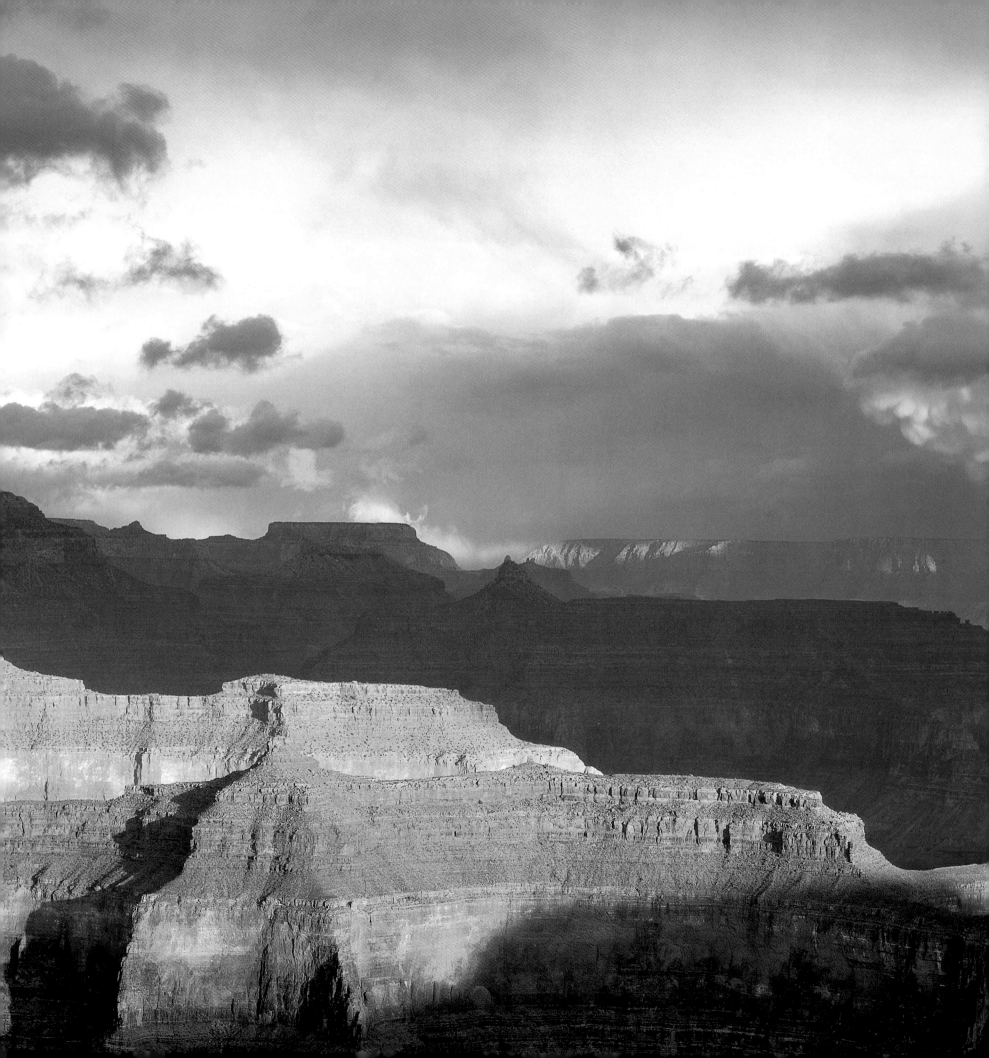

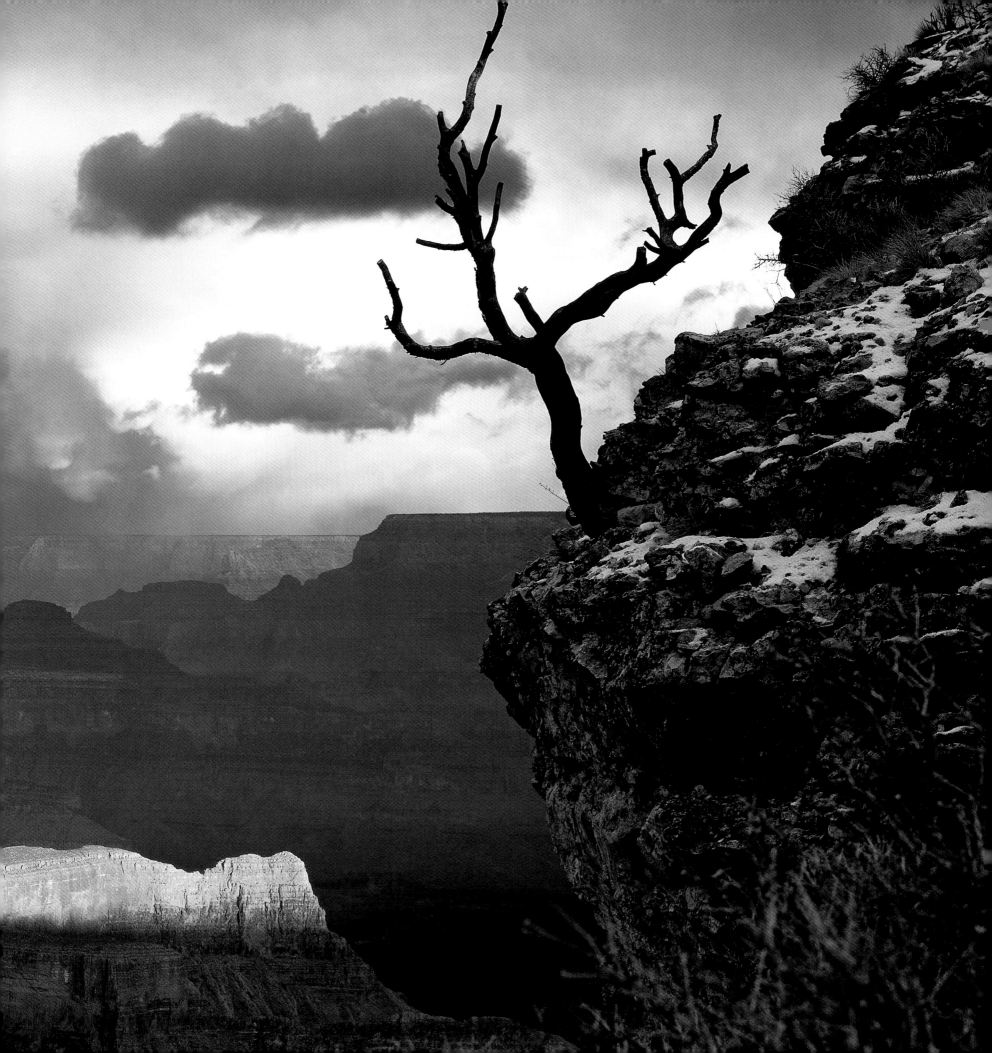

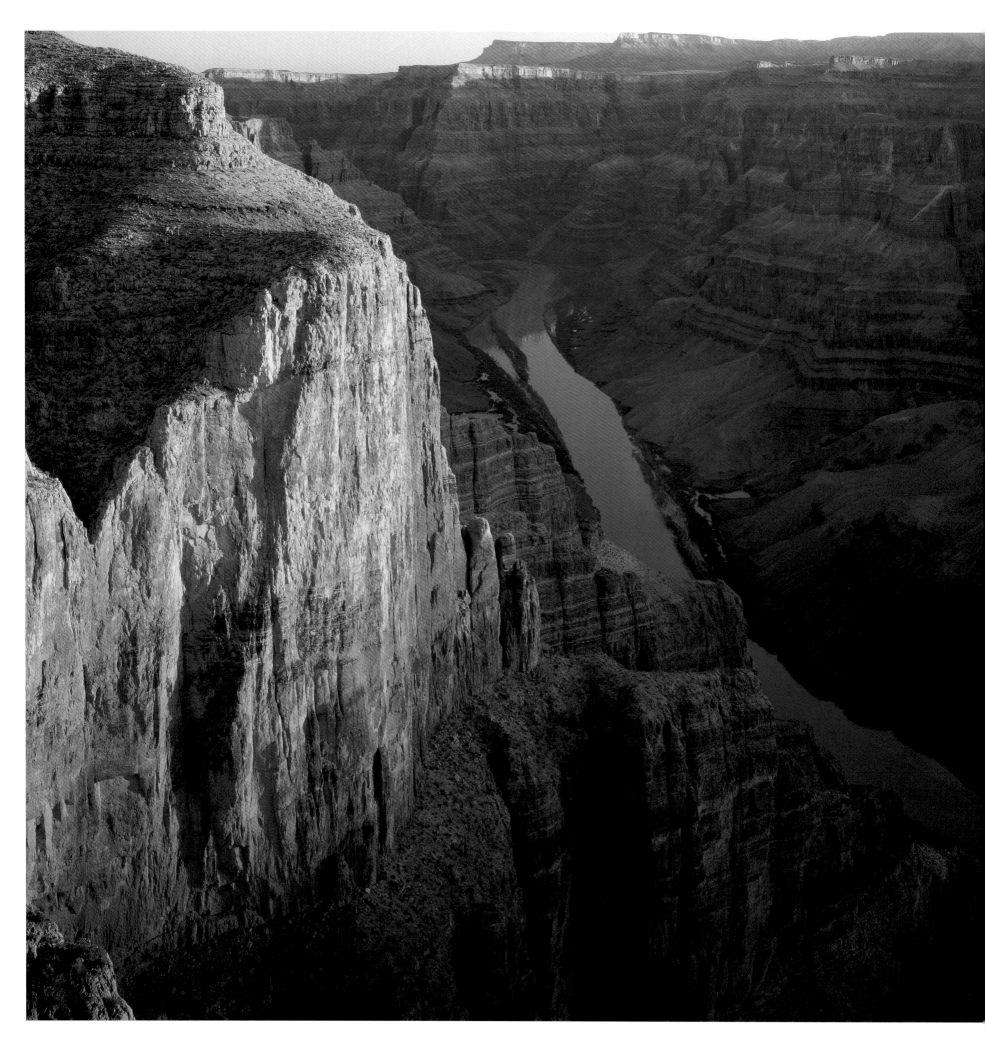

I remember completing my first raft trip down the Colorado River through the Grand Canyon. We dropped off all the paying customers at Diamond Creek and began breaking down the raft for the final miles to the take-out at Pearce Ferry. My mind was full of wonderful memories of hanging gardens, secret grottoes, and musical waterfalls echoing in narrow passages. I thought the Canyon trip was over. | I was wrong. For two more days, our raft floated with the current, gently bumping the rocky shoreline. We drifted off to sleep on deck, watching the Hualapai tribe's rim country pass slowly above. I wakened the last day to the sound of canyon wrens in the still morning air and vowed to explore the viewpoints above. | Years later, I spent sunrise after sunrise on the rim near Quartermaster Canyon, reacquainting myself with the music of canyon wrens. —JD

QUARTERMASTER CANYON | Peering west from an overlook above Quartermaster Canyon, the view at dawn touches a shadowed Colorado River below a sun struck cliff face.

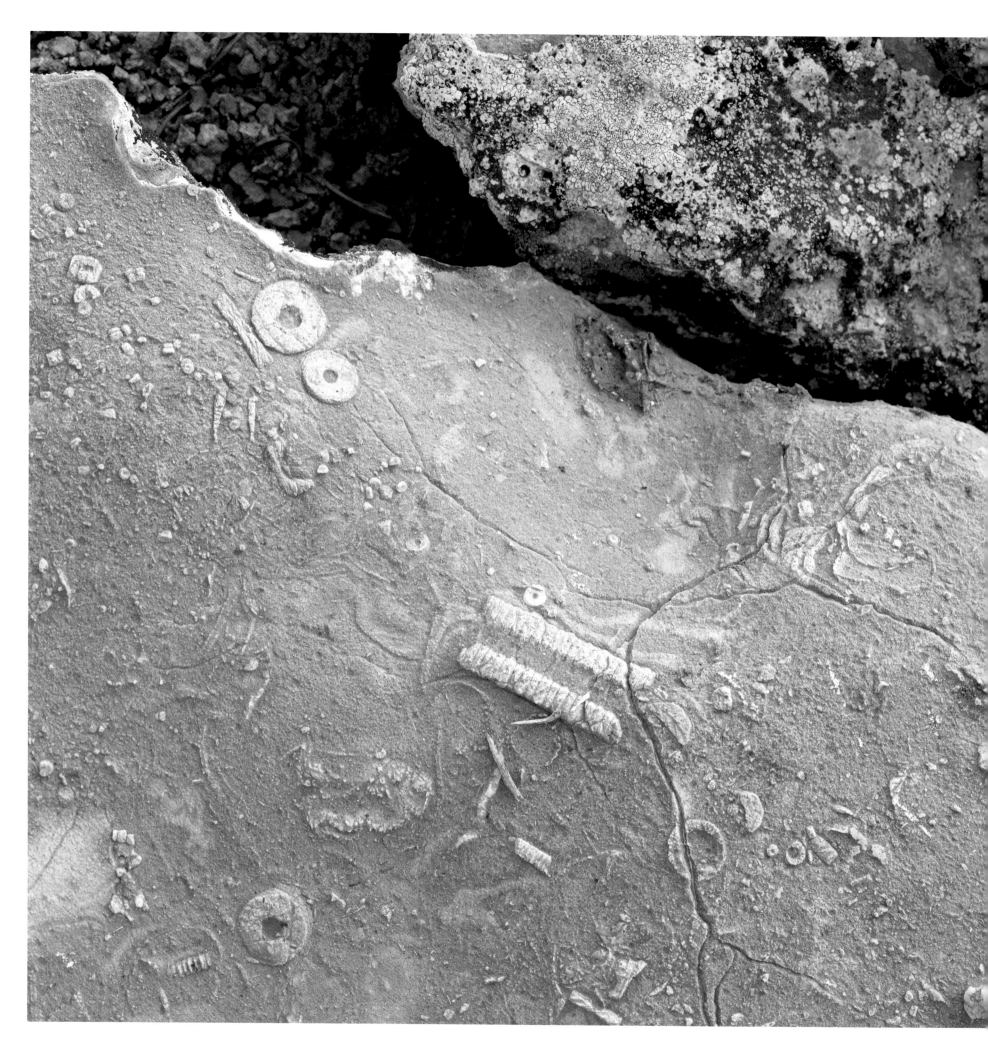

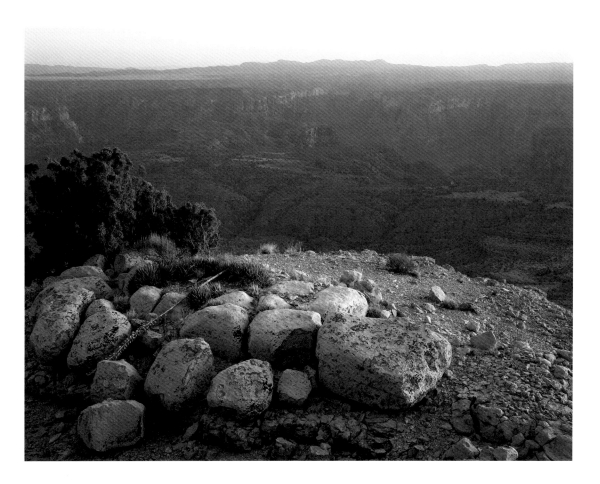

SHIVWITS PLATEAU | A jumble of boulders, above, rests along an eroded rim on the North Rim's Shivwits Plateau. At left, a slab of limestone on the plateau exposes ancient marine fossils, the remains of crinoids, sometimes called sea lilies or feather-stars.

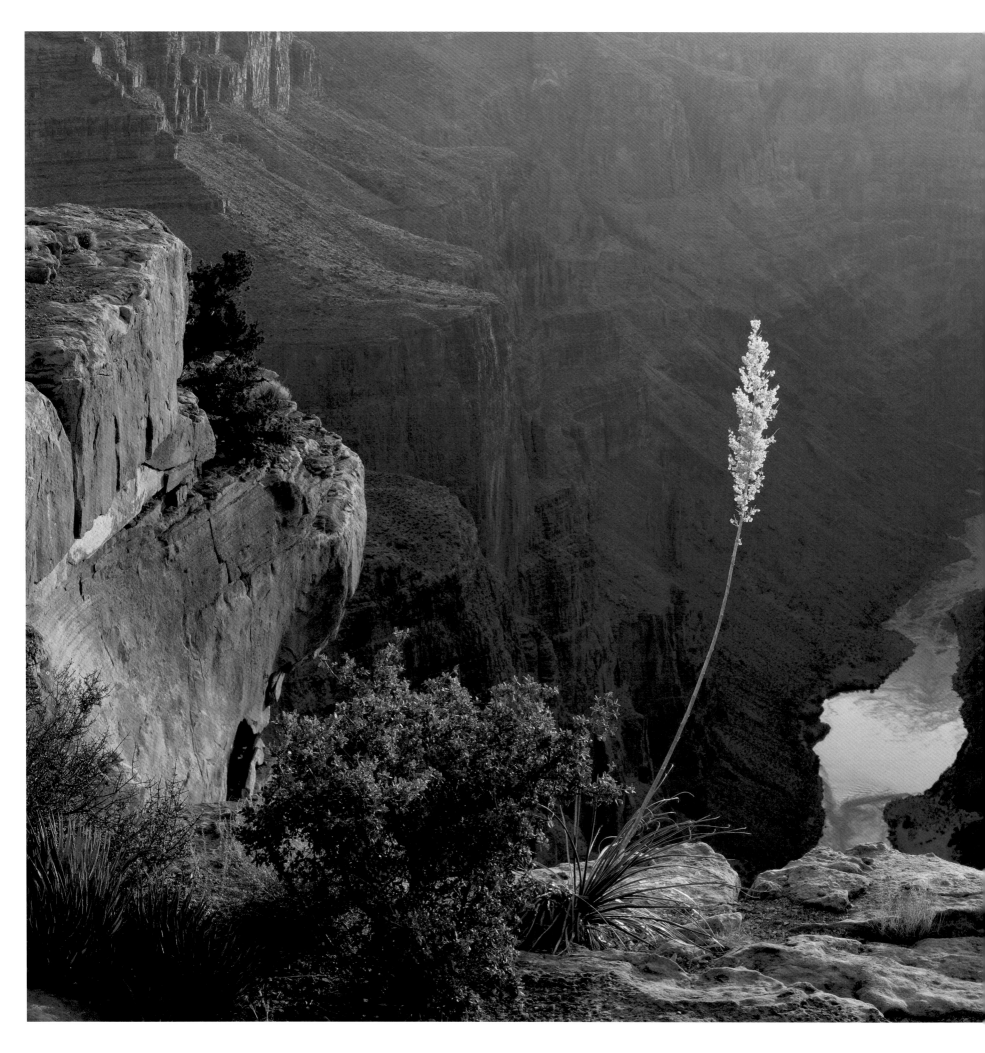

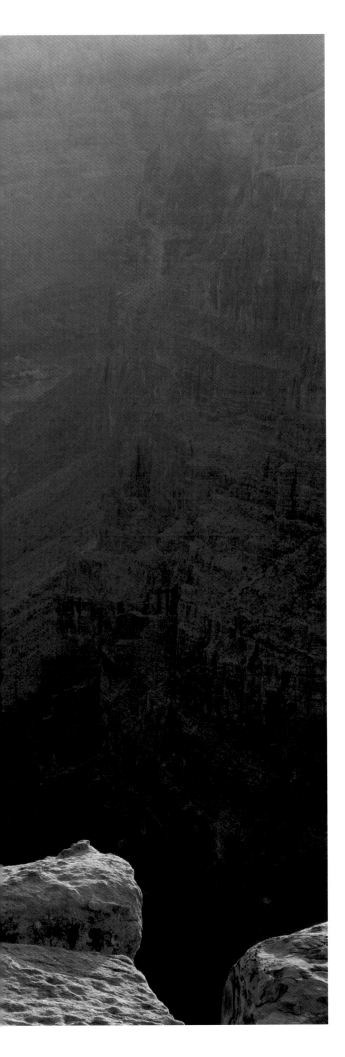

Do I really want to make the 60-mile, dirt-road trip to Toroweap? That's the question I ask myself each time I head to this remote Grand Canyon overlook. Over the years I've suffered a couple of flat tires and seemingly endless wallowing in mud, just to spend a few nights on a steep cliff face high above the raging river. | Why? The reason is simple … to see like a bird. The view in any direction is beyond belief. It is at once both exhilarating and terrifying. Like standing on the wing of an airplane. No other place provides this perspective. The soaring walls glow in morning light while the distant whisper hints of a river far below as I photograph dawn. —*JD*

TOROWEAP | Toroweap Overlook, marked by a blooming spear of beargrass, towers above the Colorado river in one of the Canyon's most remote locations.

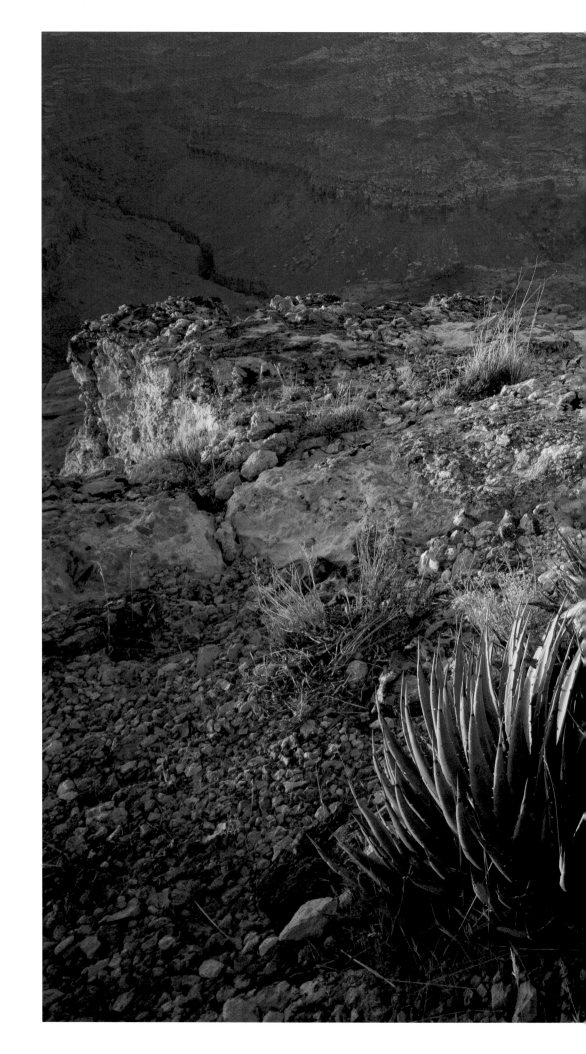

JUMP UP POINT | Overlooking the maze of Jumpup Canyon,
patches of agave and Mormon tea bristle
along the North Rim.

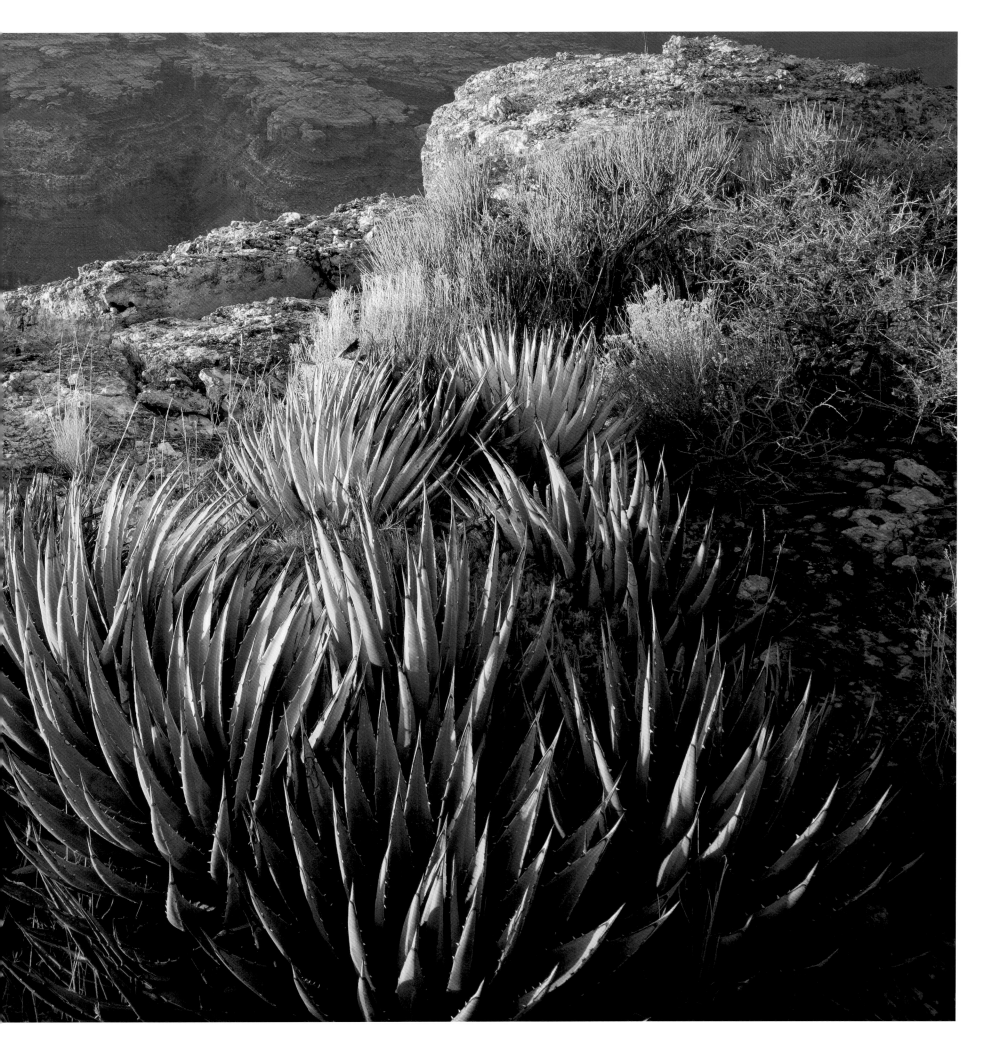

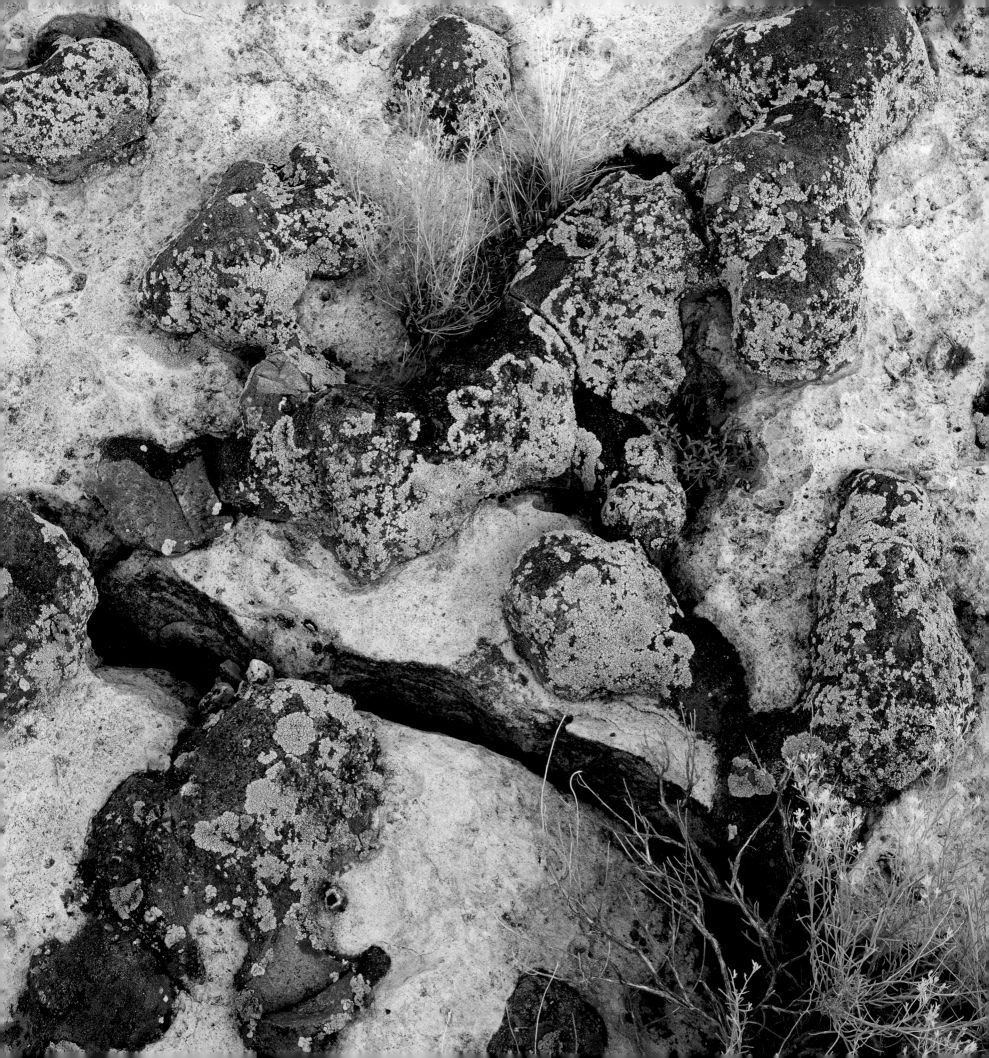

JUMP UP POINT | From Jumpup Point, below, Race Track Knoll on Fishtail Mesa below glows with the red of sunset. At left, globules of tar and lichen-encrusted stones lie in weathered pockets of a fossilized sea bed.

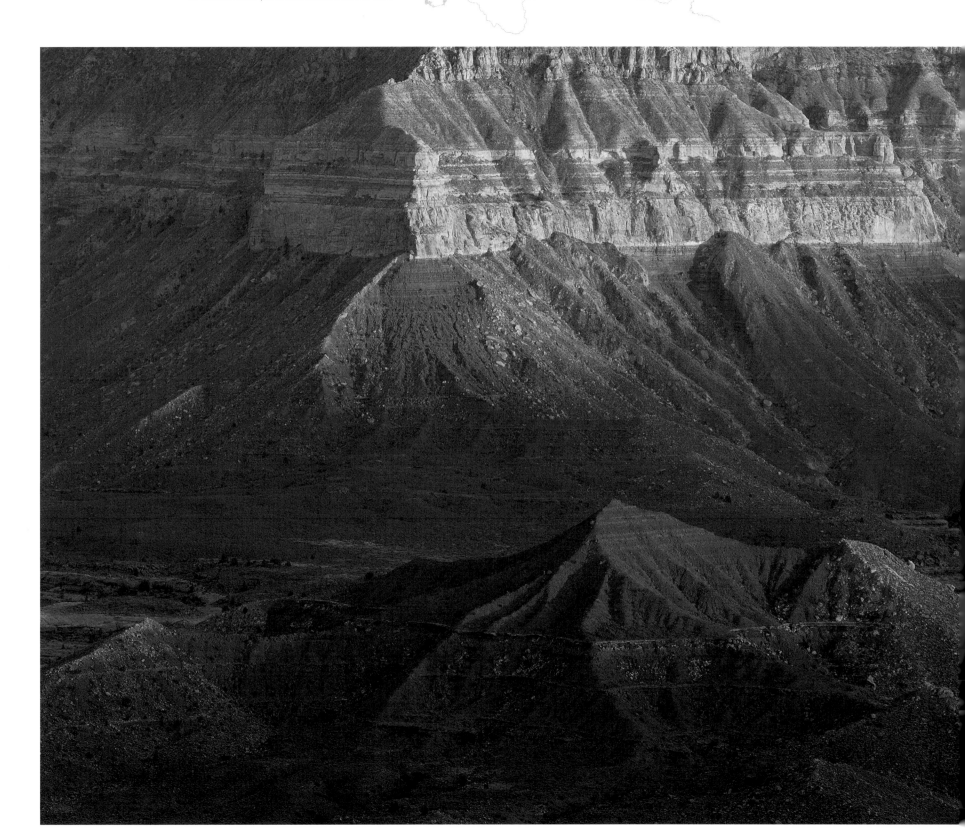

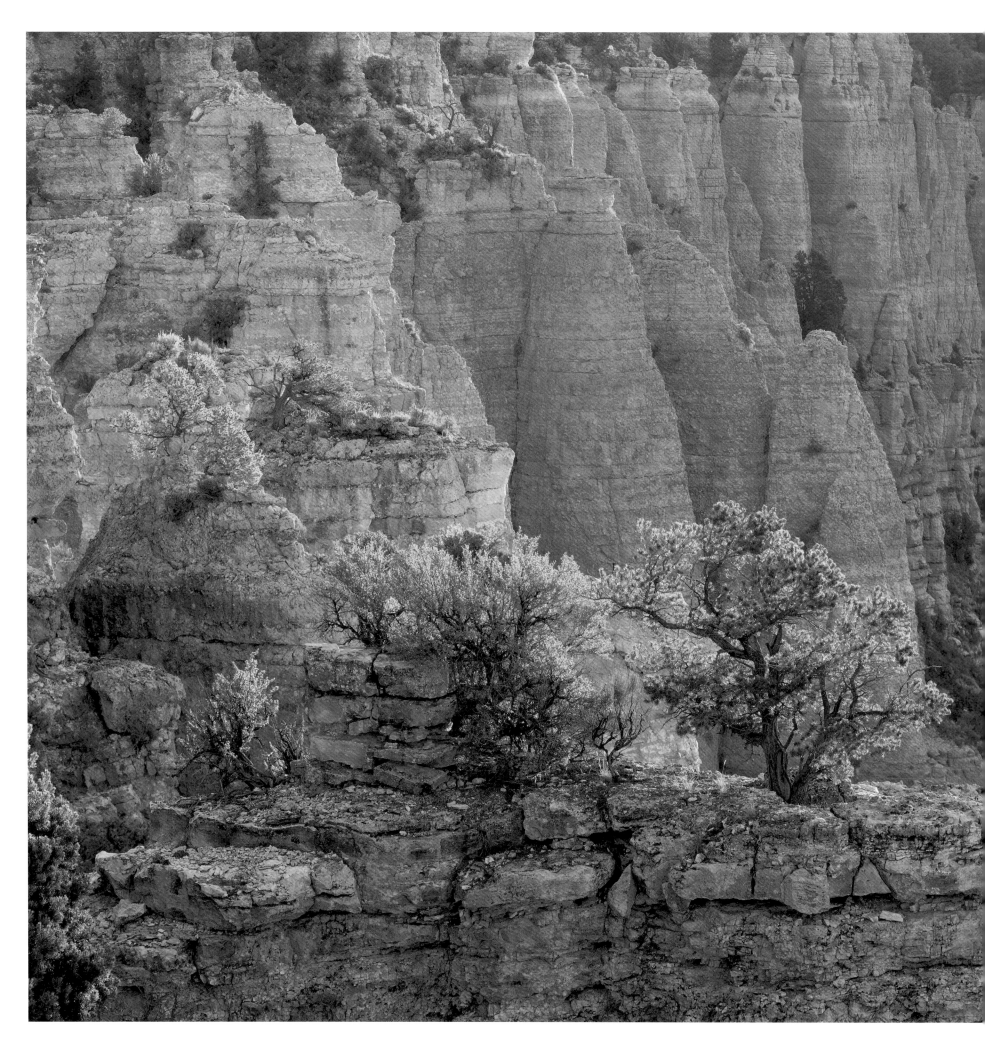

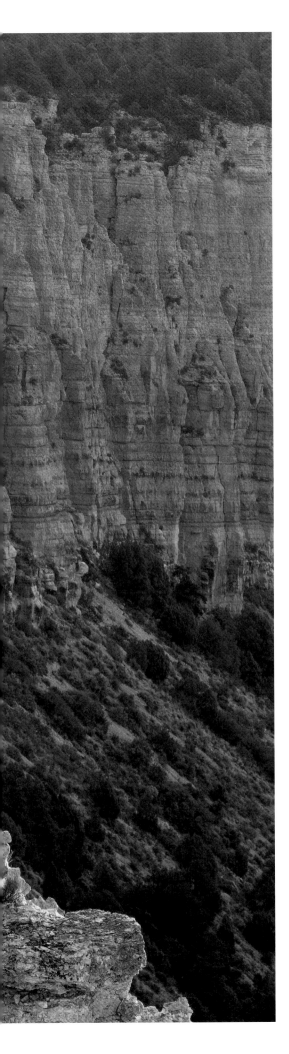

CRAZY JUG POINT | Eroded rock spires and piñon trees are the hallmark of Crazy Jug Point, left. From the overlook here, a viewer can see the Colorado River flow out from the Powell Plateau and wrap around Great Thumb Mesa.

Although the point rises to a 7,500-foot elevation, agave plants, above, inhabit the area.

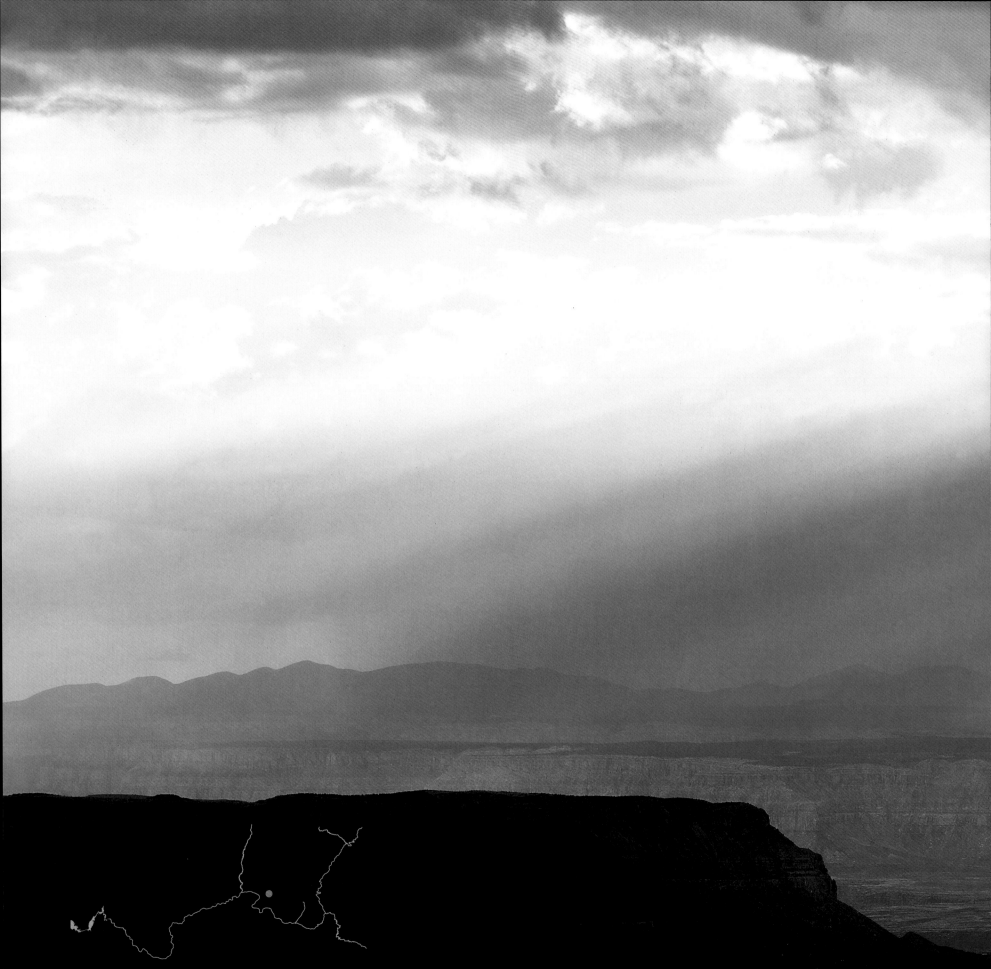

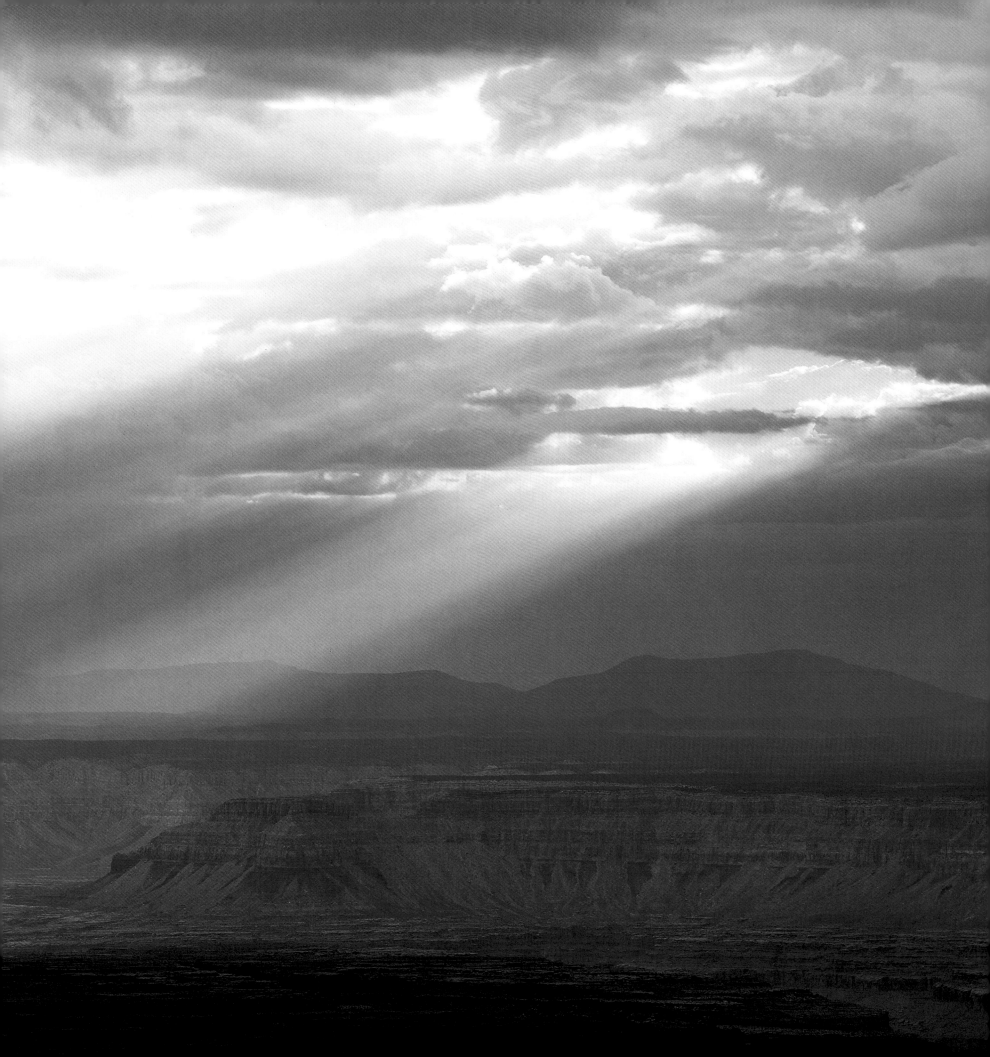

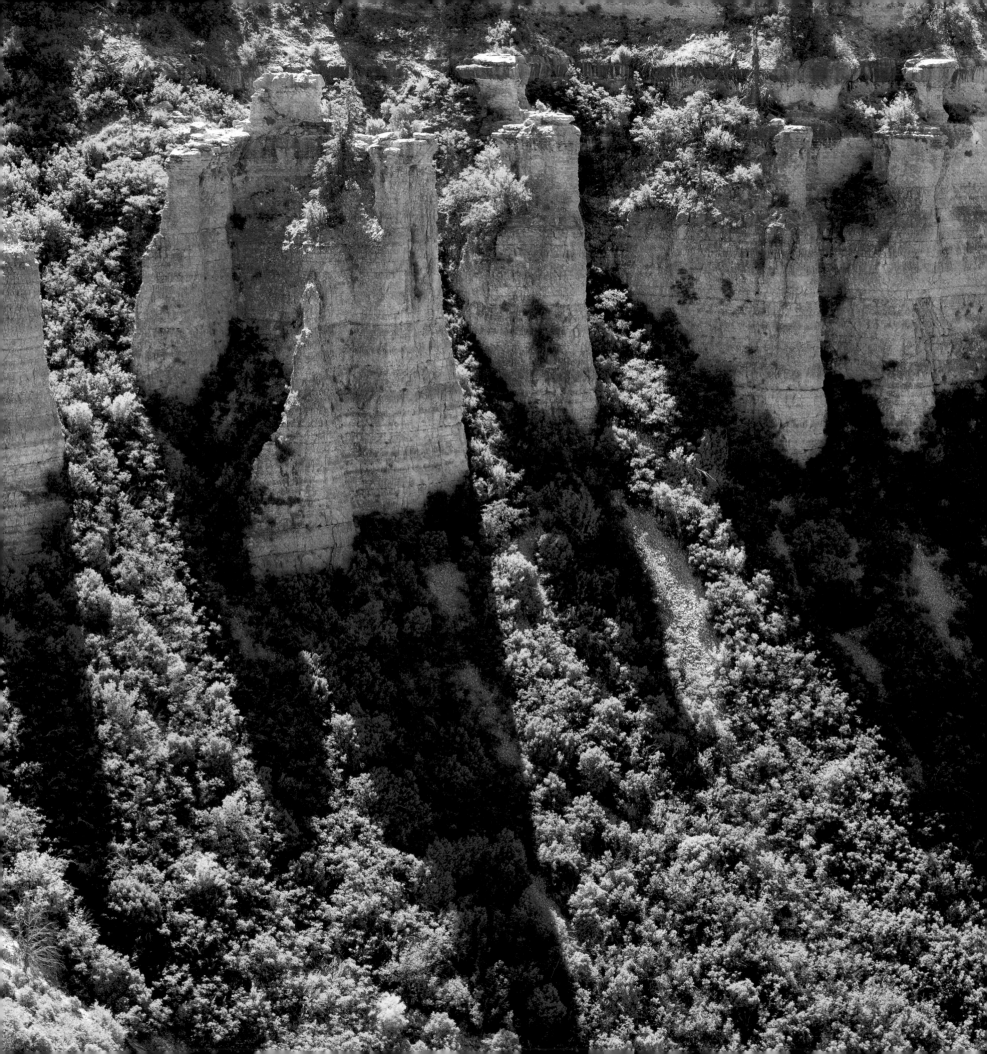

The Canyon can fool even the veteran explorer. The rainy season had been exceptionally long with deluges pouring into the Canyon regularly. Even so, I hadn't expected to see lush green gardens surrounding the rimrocks. To me, it looked like the steep mesas rising from the Venezuelan jungles. Yet, I was in Grand Canyon National Park staring into the east side of Swamp Point, from the North Rim, with Powell Plateau in the background and a deer to share my delight. —*JD*

SWAMP POINT | Near Swamp Point, left, green vegetation surrounds soaring towers of stone.

A mule deer, right, strolls the Canyon rim near the point, with Powell Plateau's cliffs in the background.

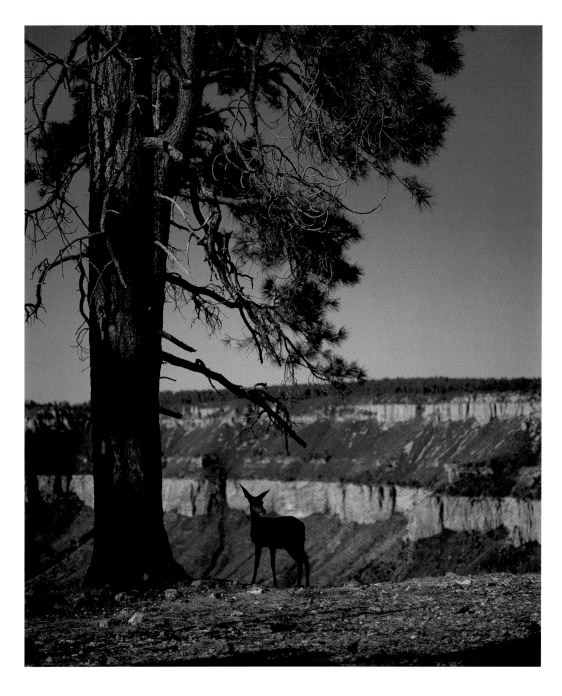

The journey is often better than the destination. I took advantage of the break in summer monsoon storms to cajole my four-wheel-drive truck through the steep, forested, narrow passages. I planned to visit an old friend: Point Sublime. In the years since my last visit, the road showed signs of being reclaimed by the forest. Deep water-filled ruts and tree roots made the trip more interesting. But the views along the way were spectacular. Giant toadstools of rock, festooned with sheets of fossils, grabbed my attention. A giant peninsula of stone veered off into the Canyon, welcoming me back to the well-named Point Sublime. —*JD*

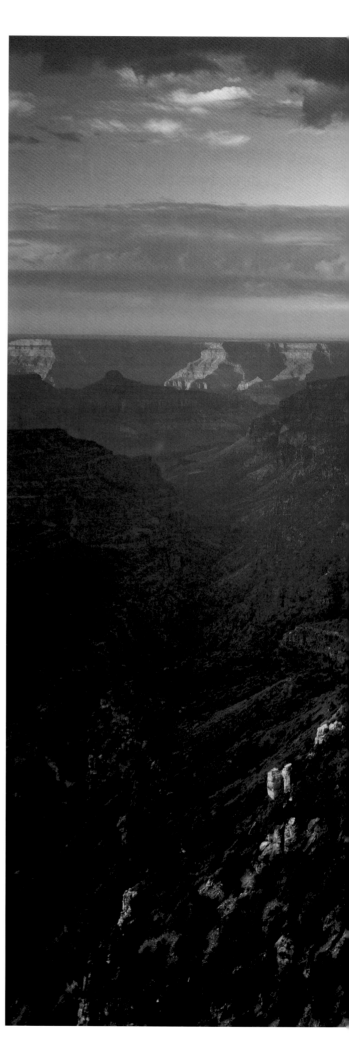

POINT SUBLIME | From the North Rim, this formation reaches far out into the Canyon, yielding views of both the North and South rims and a piece of the Colorado River. In the pre-dawn light, shades of pink and purple dominate the scene.

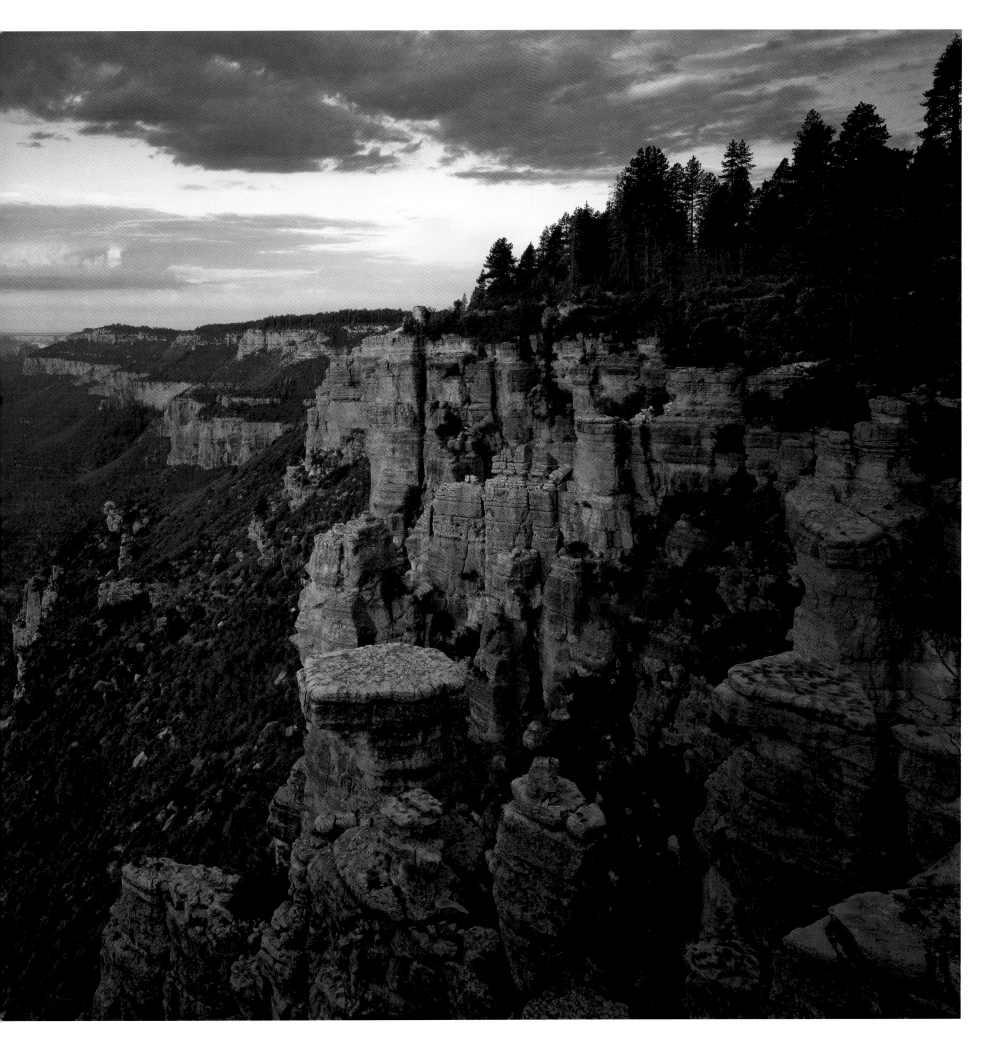

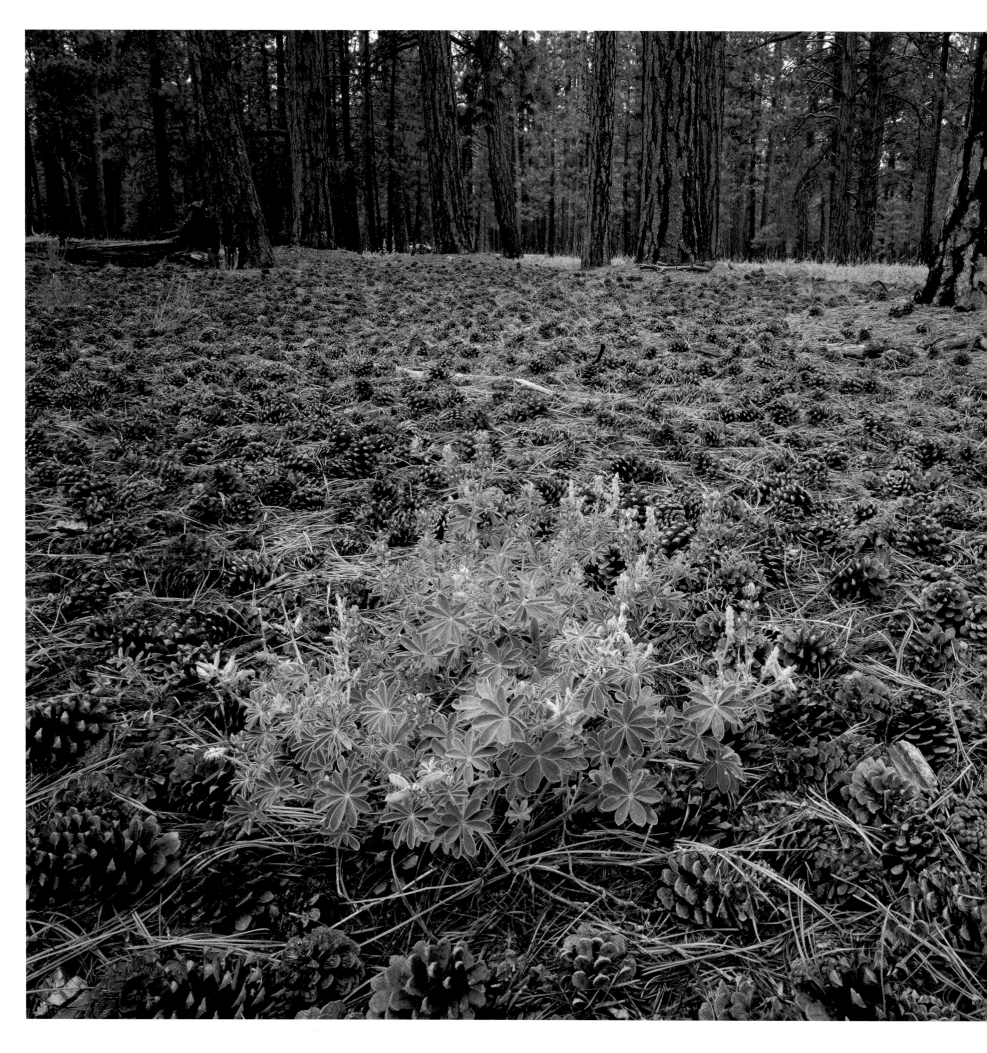

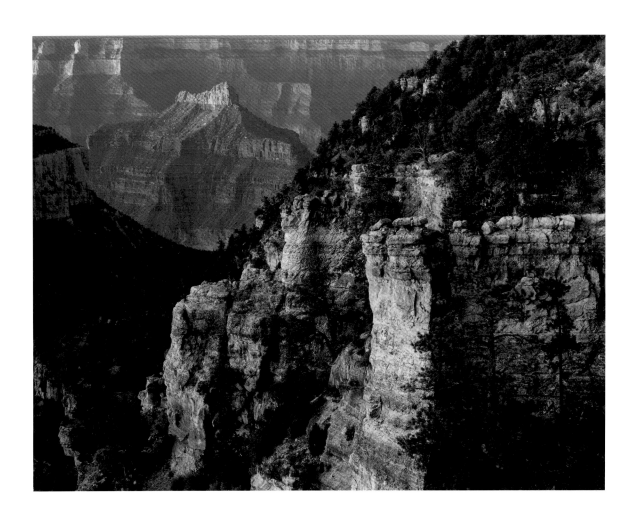

TIYO POINT | In the Hopi mythology, Tiyo is an adventurous, youthful character who wonders where the Colorado River flows. In Egyptian mythology, Isis is a goddess, revered as the model for wives and mothers.

They come together at Tiyo Point, above, as the rising sun beams on Isis. Near the point, left, a flowering lupine establishes its place among pine cones. Tiyo Point can only be reached by hiking.

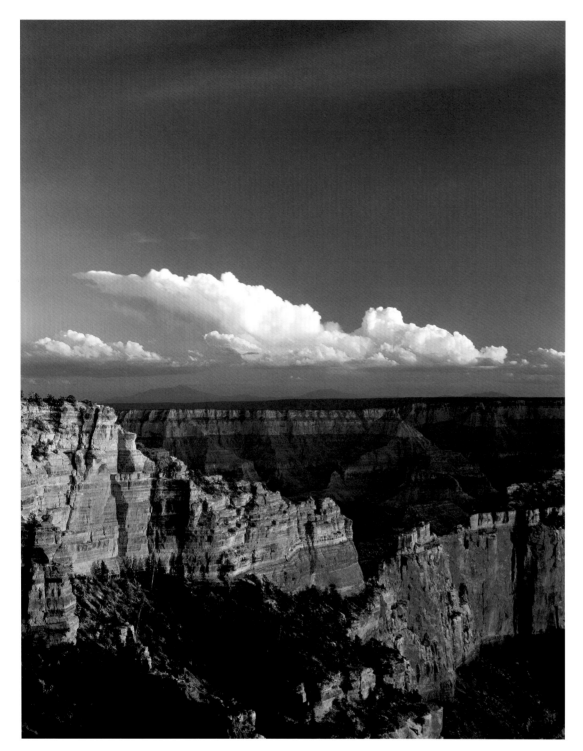

CAPE ROYAL | Cape Royal, left, becomes the North Rim vantage point for looking far beyond to hazy San Francisco Peaks on the horizon. At right, the red of blooming Indian paintbrush and the white flowers of shrubby cliffrose brighten Cape Royal.

On the following spread, Cape Royal rises above wreathes of fog.

Sunset gilds a limestone ledge at Cape Royal, pages 70-71.

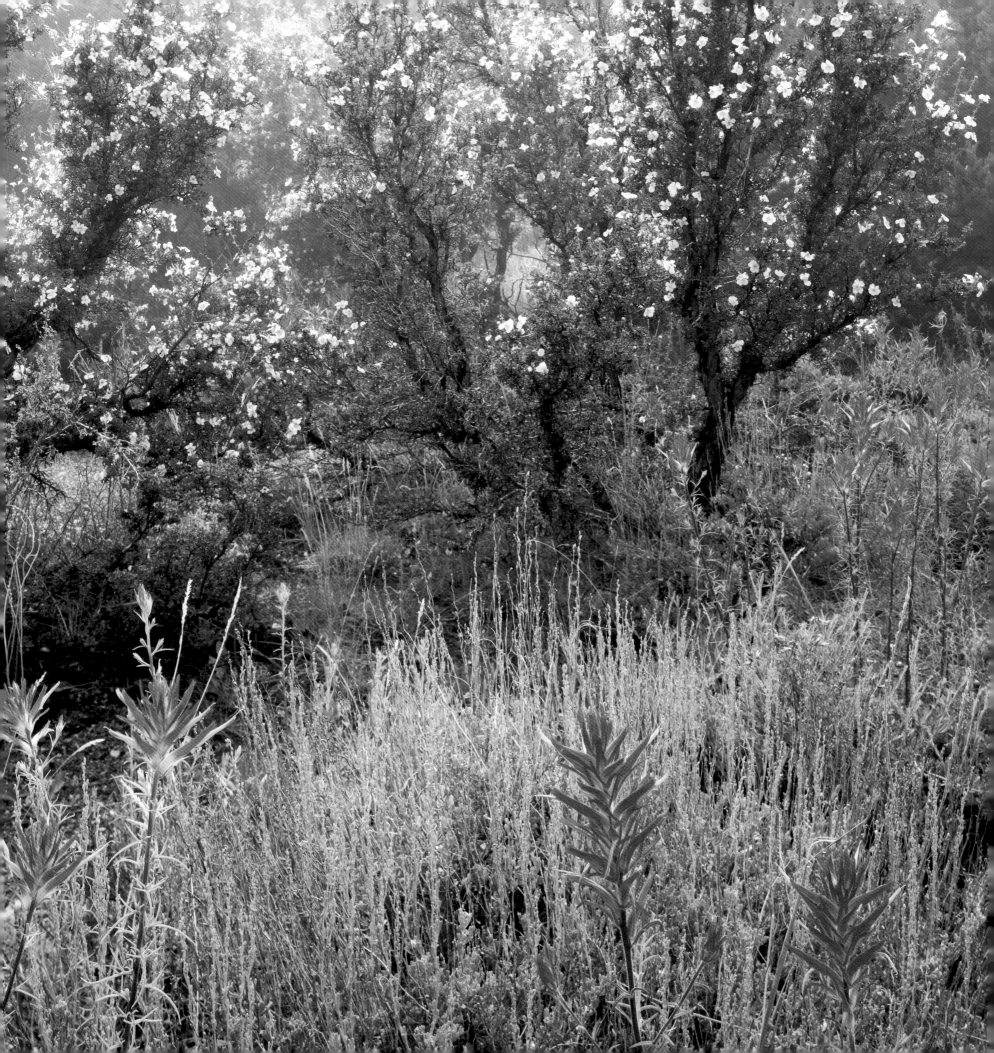

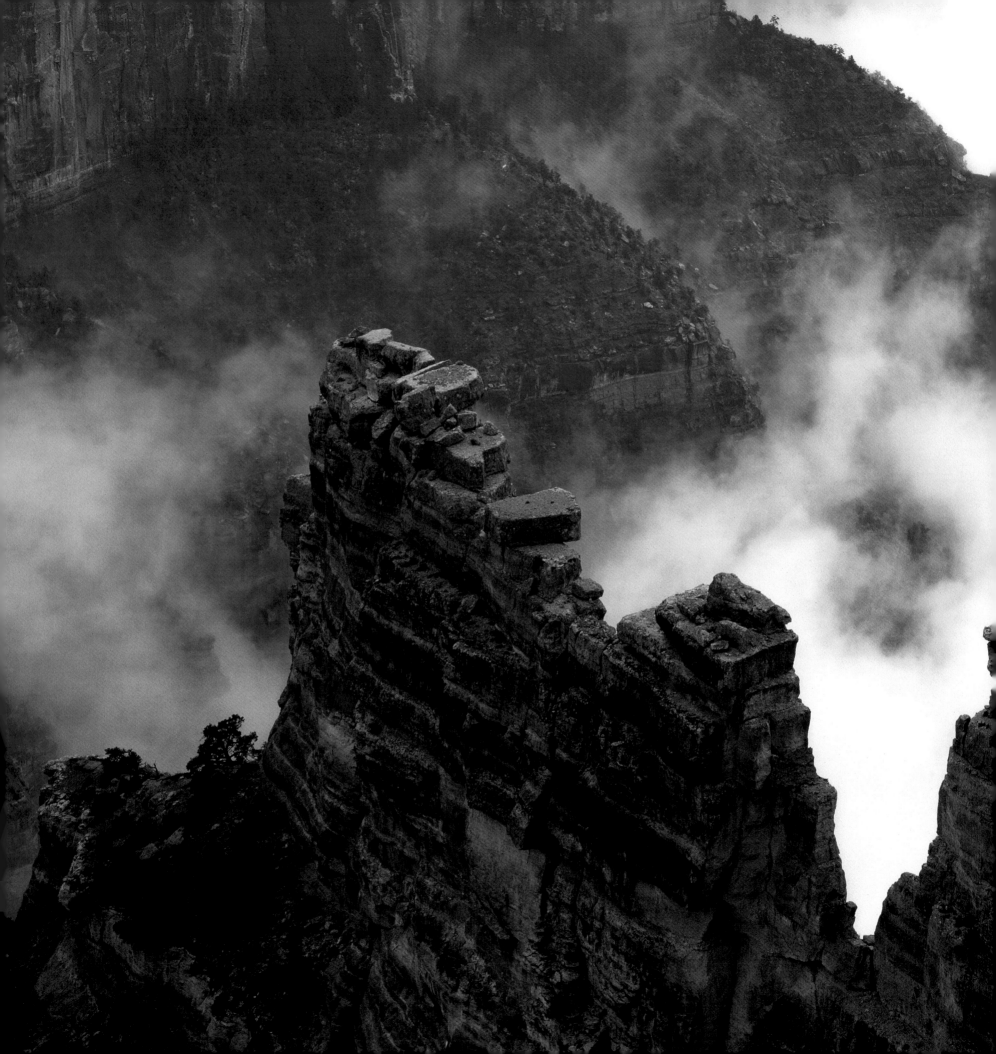

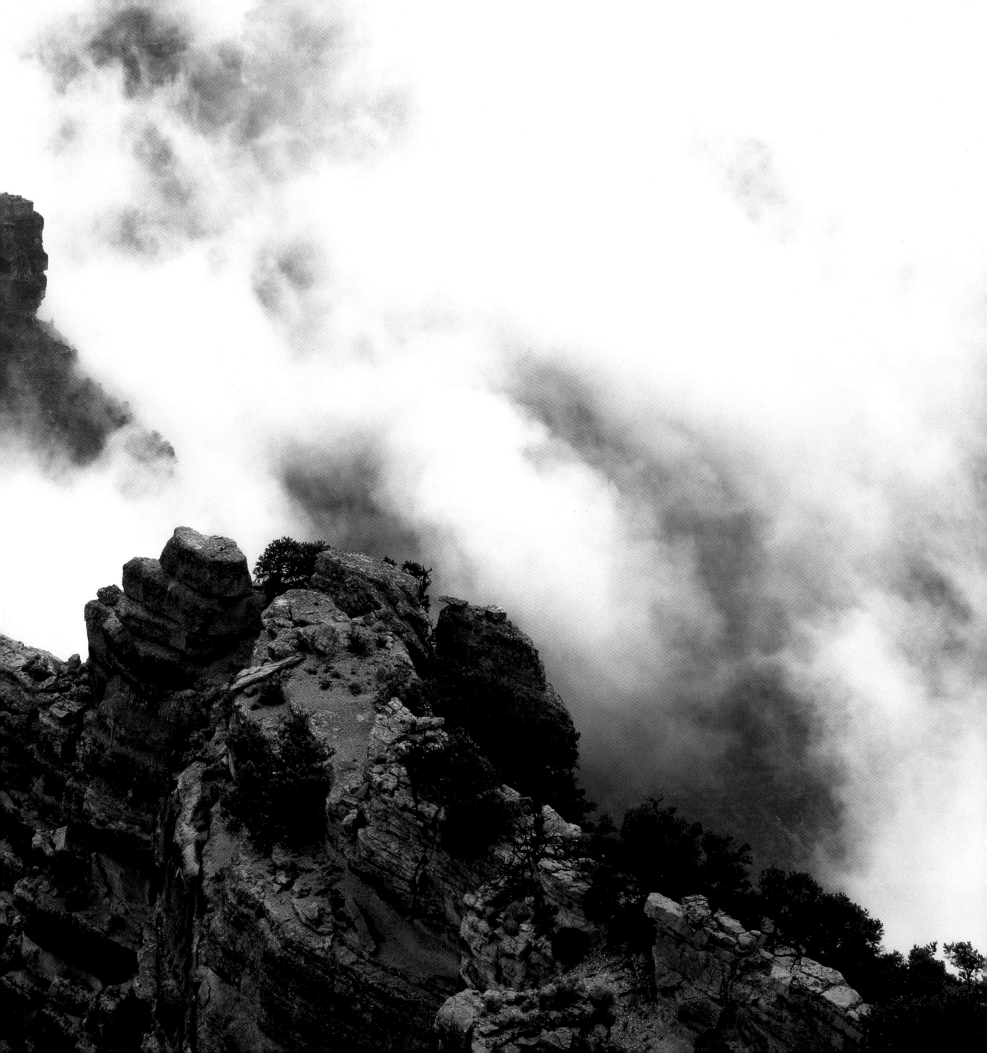

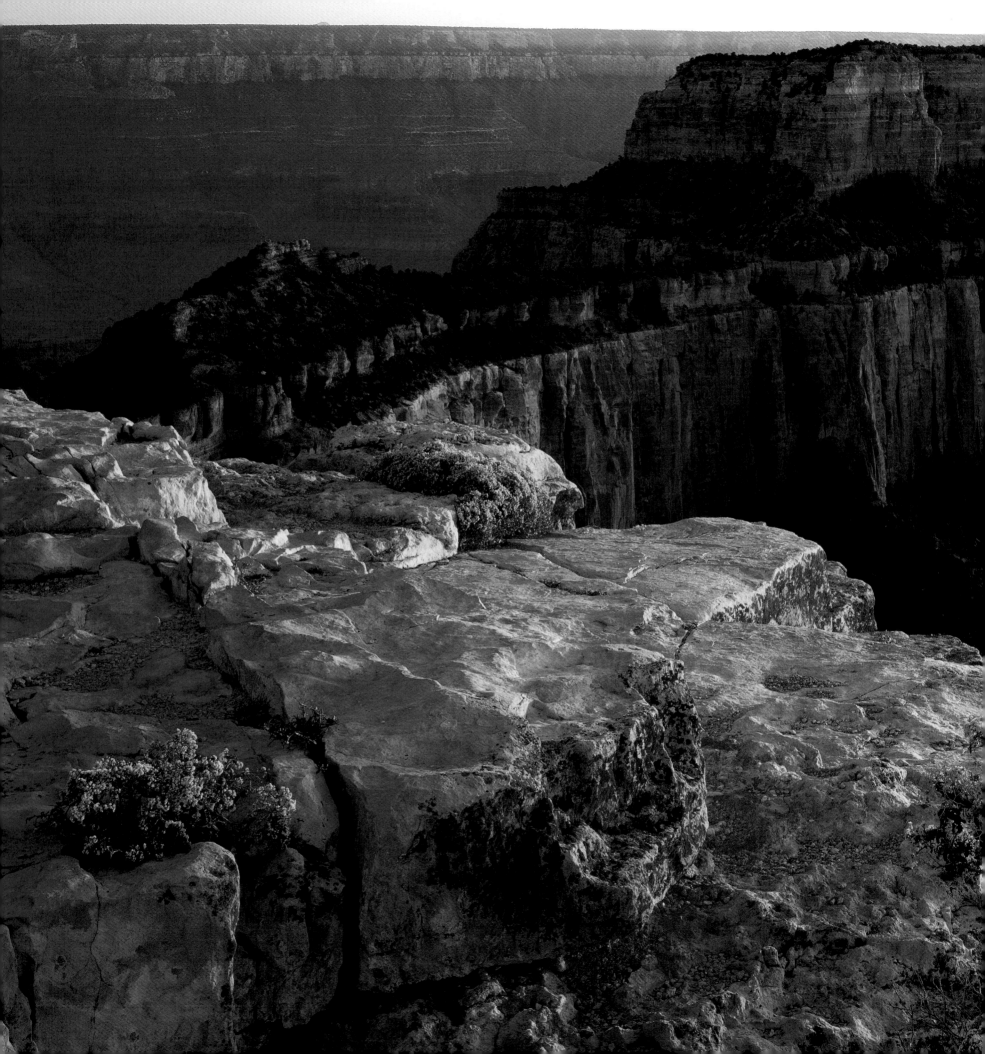

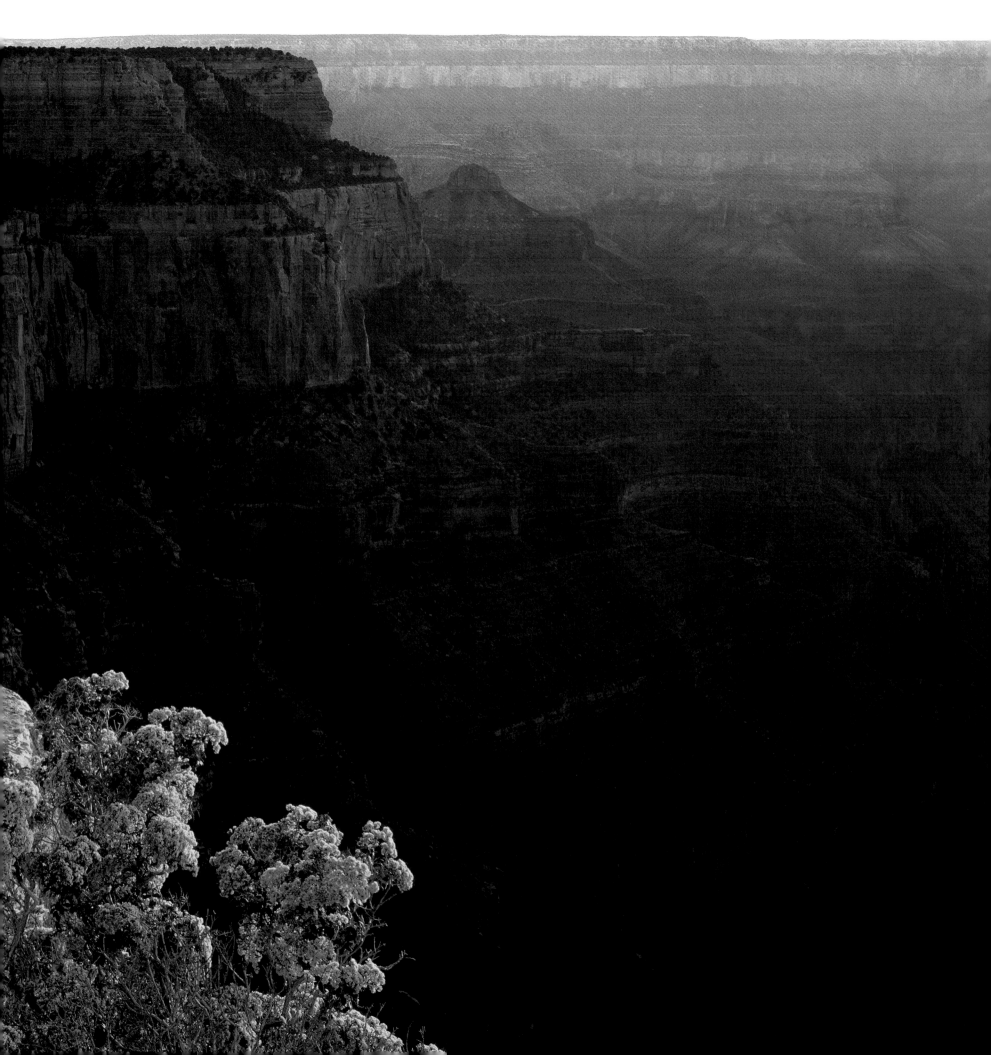

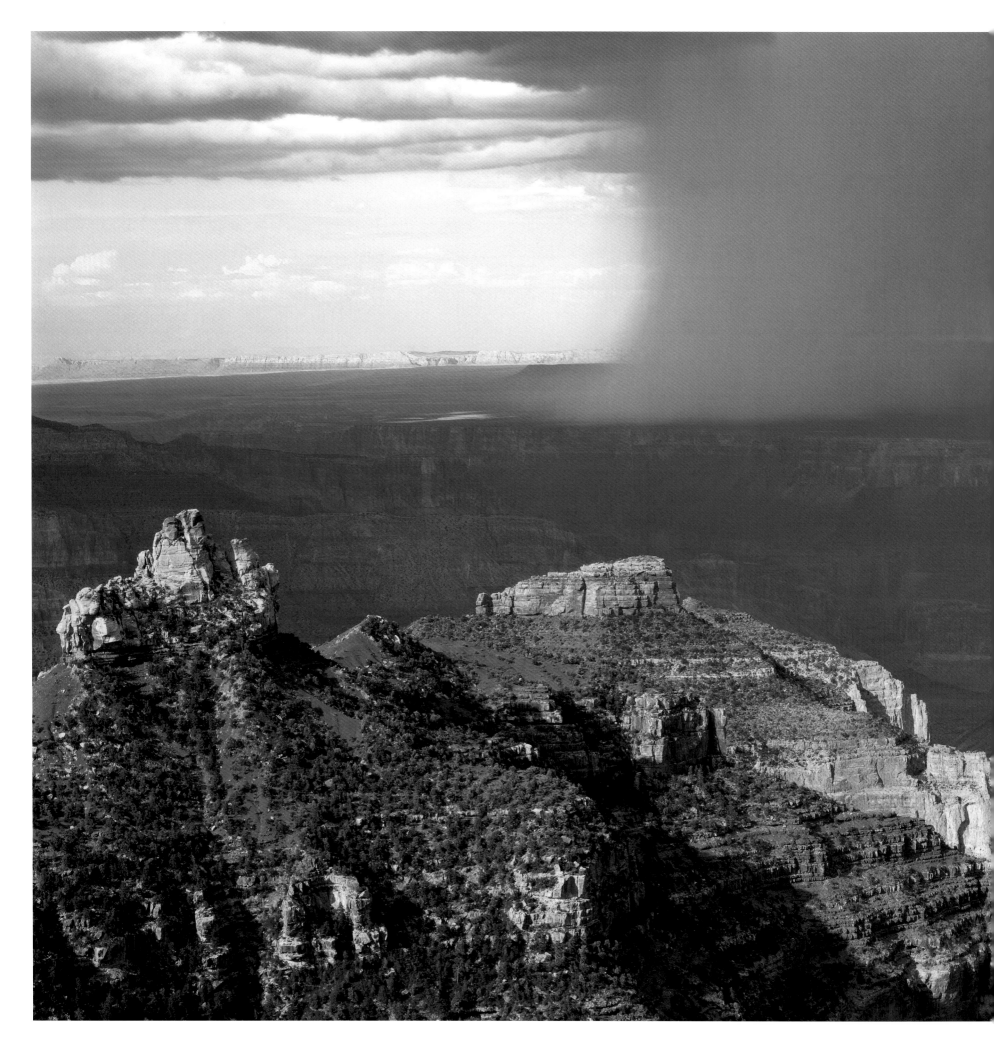

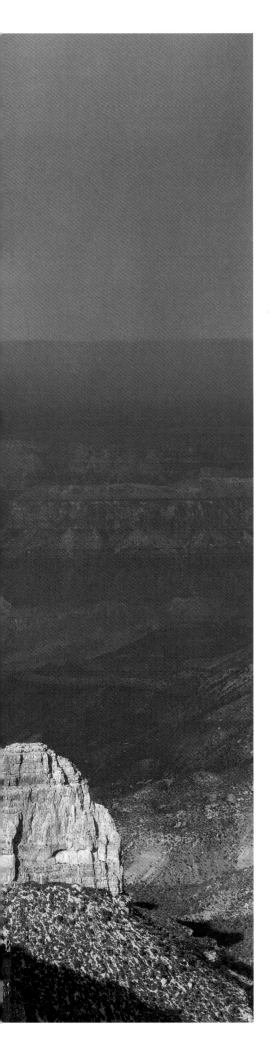

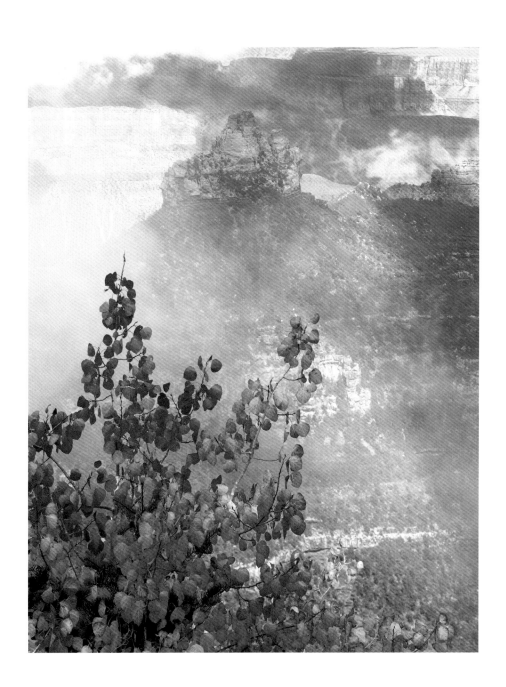

VISTA ENCANTADA | Vista Encantada, left, gives a fine view of the storm
surging beyond Brady Peak on the left
and Echo Cliffs in the background.

Above, a fall mist swirls between Brady Peak
and an aspen tree on Vista Encantada.

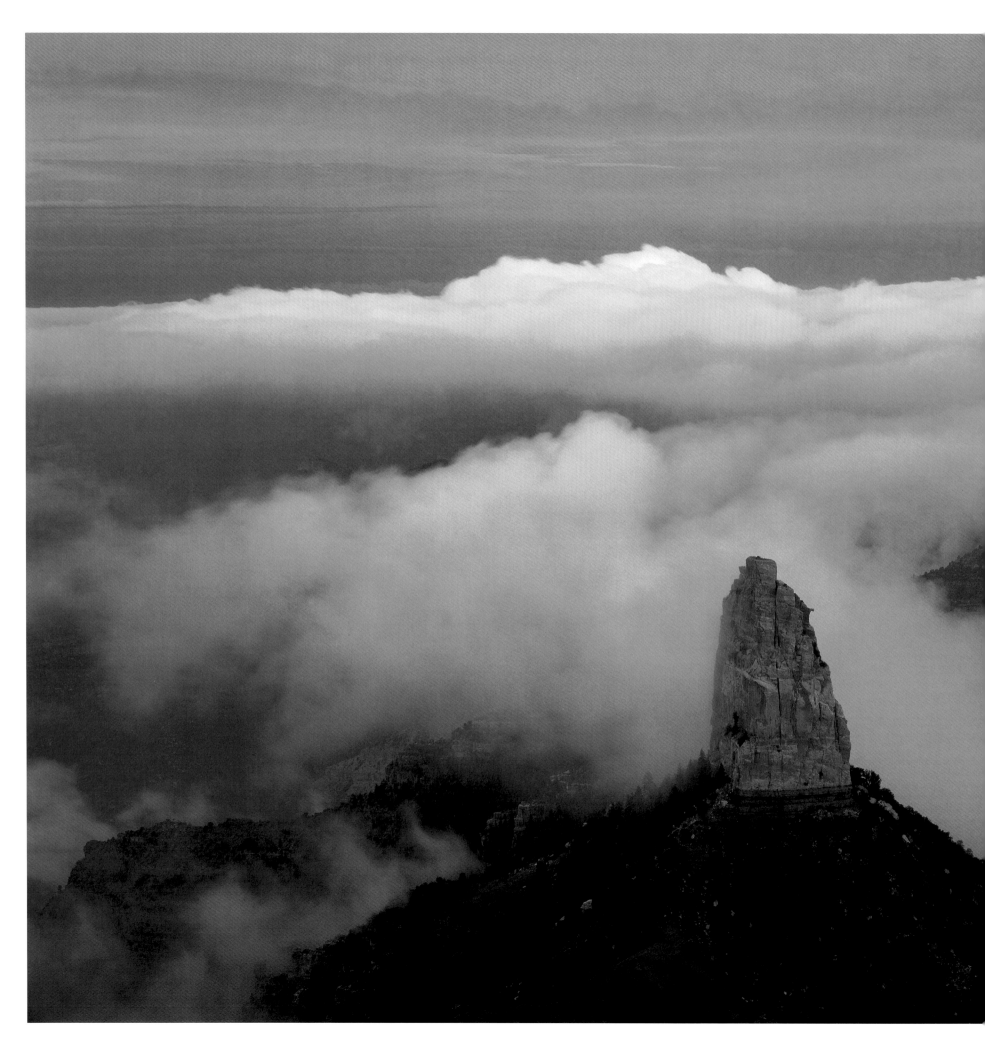

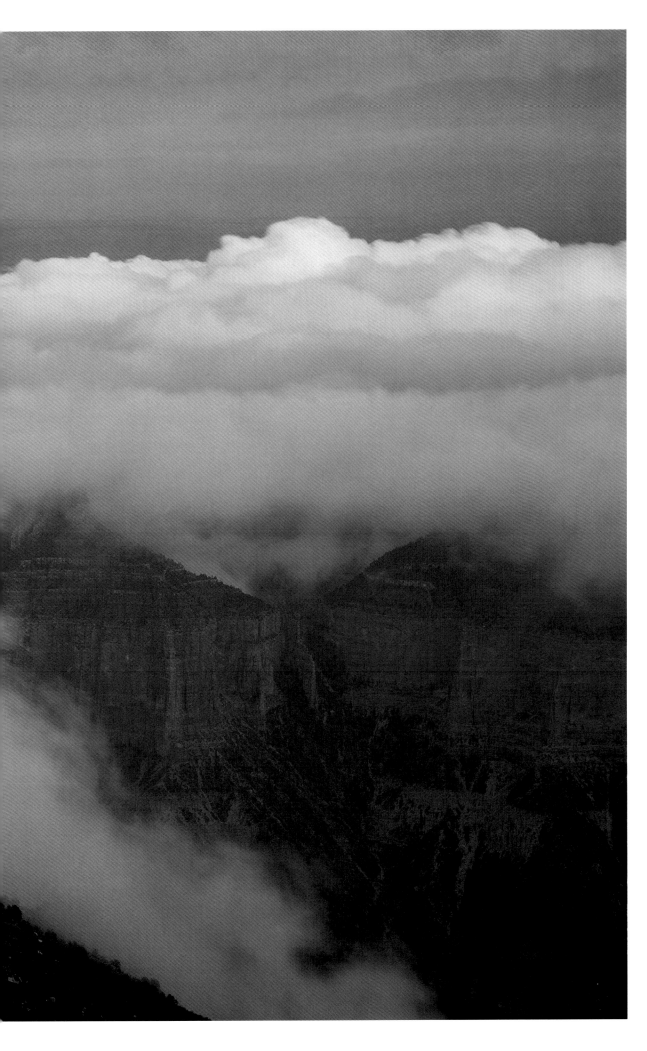

POINT IMPERIAL | As seen from Point Imperial, the bald
summit of weathered Mount Hayden, left,
stands clear of the swirling fog.

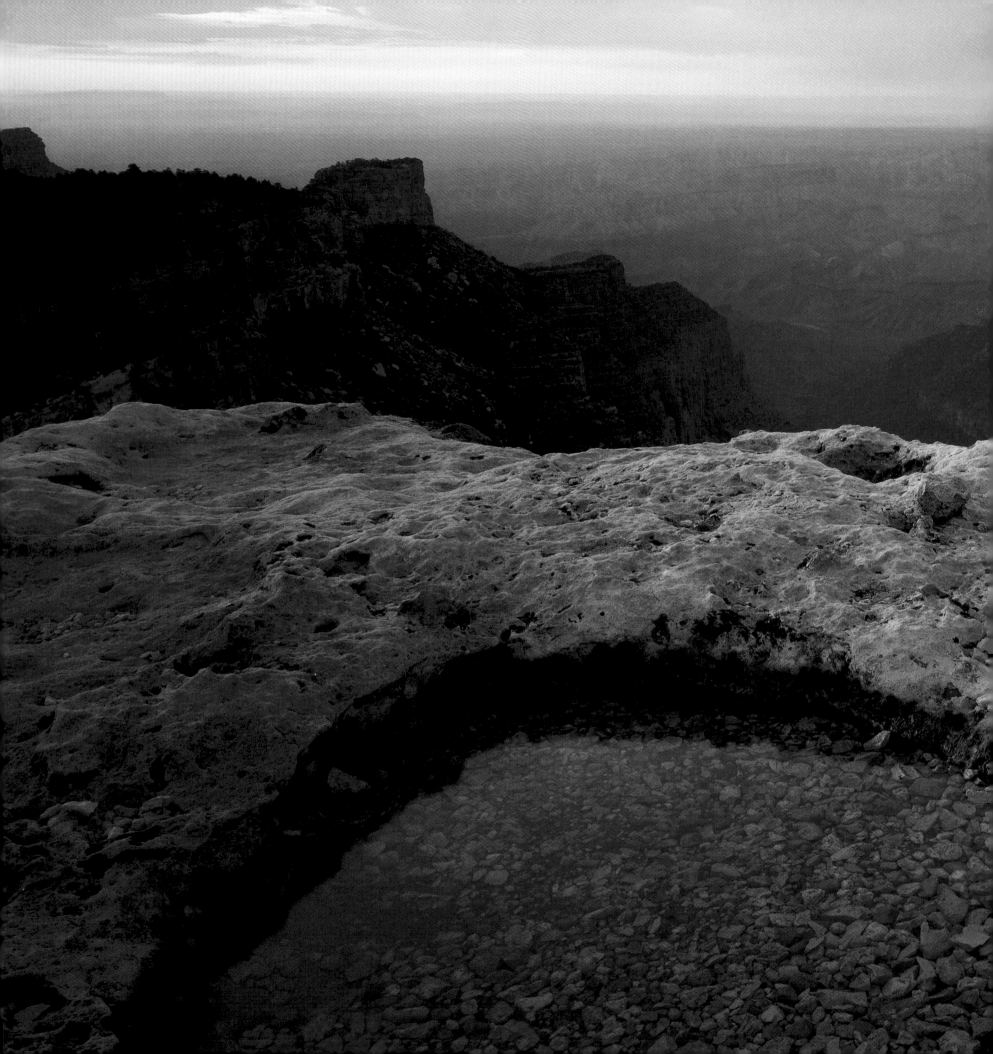

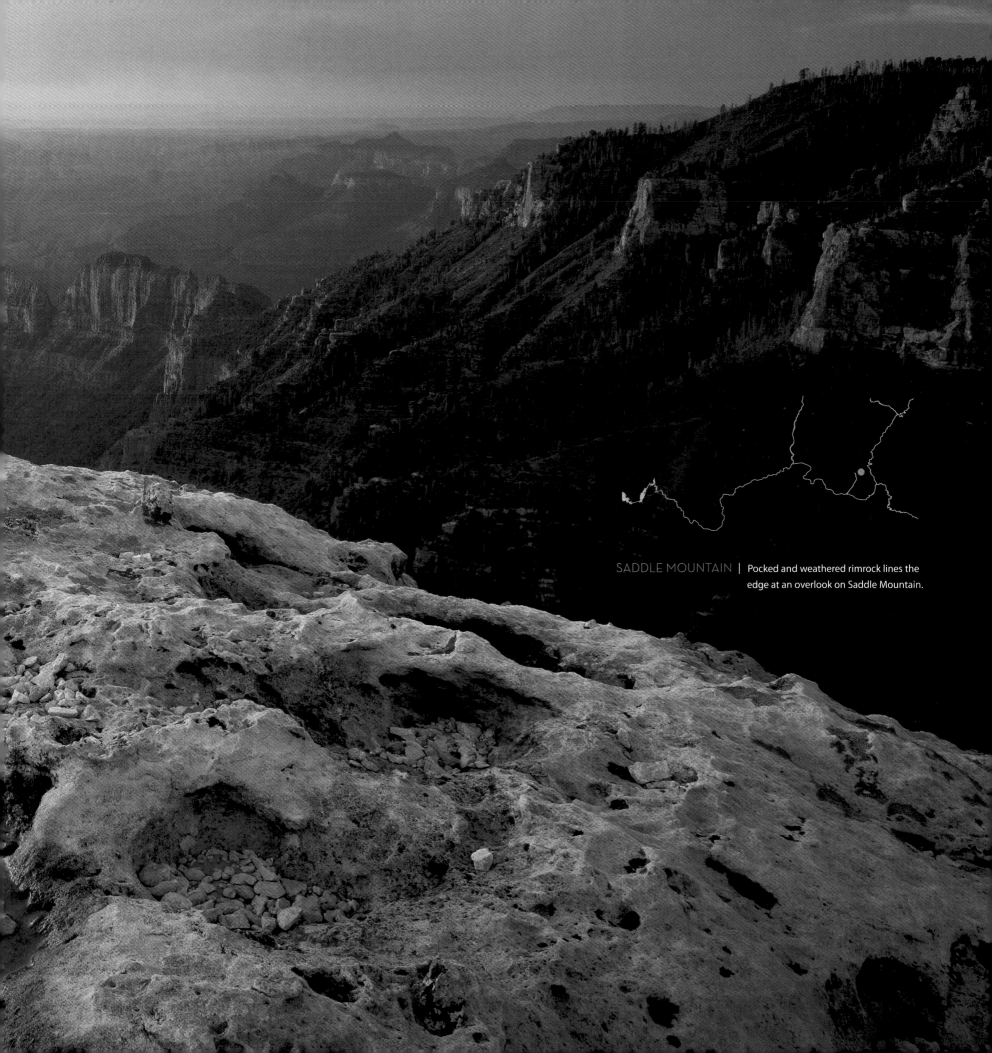

SADDLE MOUNTAIN | Pocked and weathered rimrock lines the
edge at an overlook on Saddle Mountain.

DOG POINT | Cloaked by the conifers of Kaibab National Forest, below, rocky Dog Point juts into the Canyon. At left, a field of oxeye daisies edged by aspens catches the sun near Dog Point. Higher and cooler than the South, the North Rim is also wetter and greener.

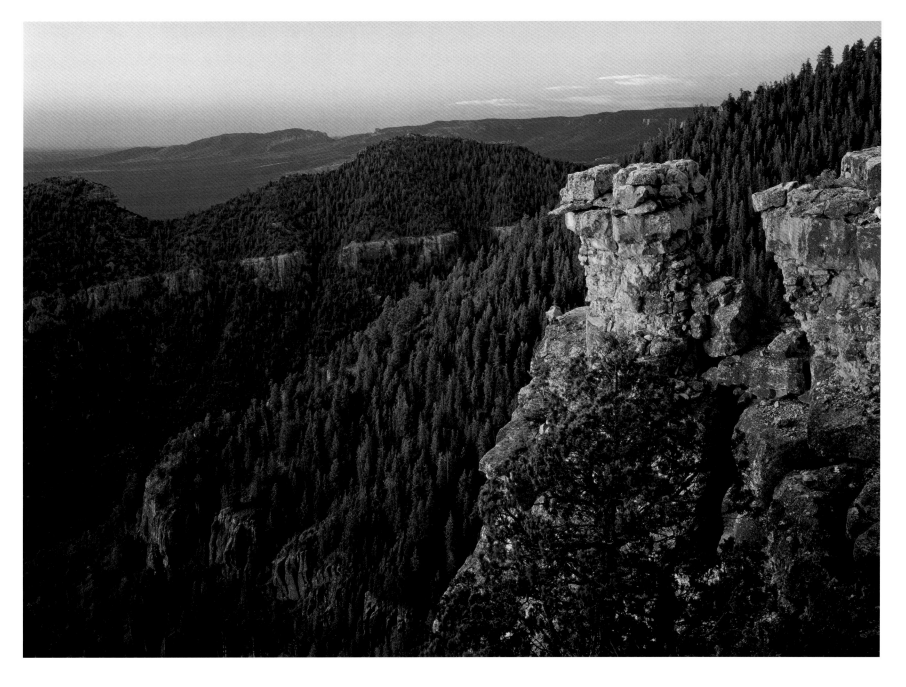

Now a favorite photographer's viewpoint, Horseshoe Bend offers an intimate insight into the river's power to slice rock. Eons of time and countless tons of silt have turned a simple bend in the river into a steep, rounded work of art. Here, the river below winds toward Lee's Ferry, where John Lee homesteaded and today's river-runners begin their descent through Marble Canyon and the Grand Canyon. You can literally trace the watery pathway that John Wesley Powell followed and try to imagine the sense of wonder and fear. —*JD*

HORSESHOE BEND | At Horseshoe Bend, which lies between Glen Canyon Dam and the downriver start of the Grand Canyon at Lee's Ferry, the Colorado River carved a 180-degree turn in Glen Canyon.

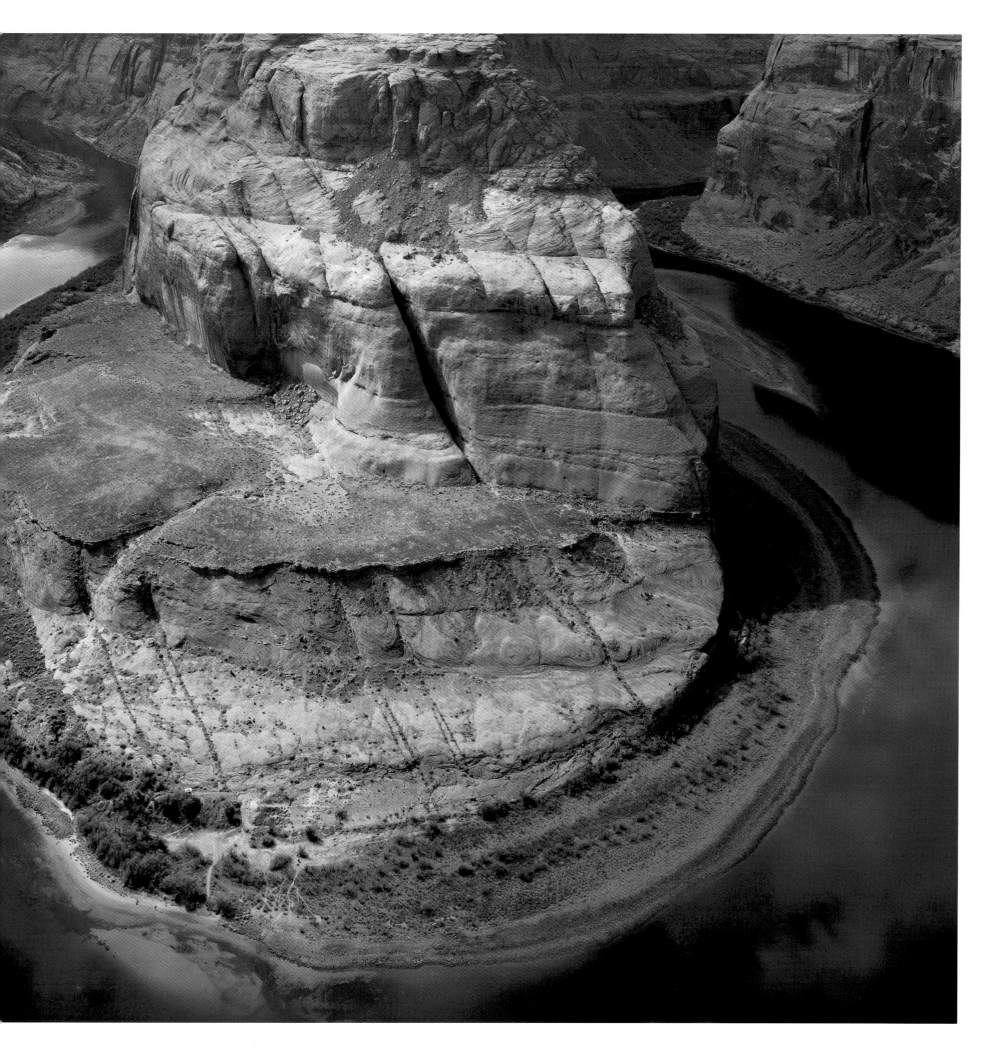

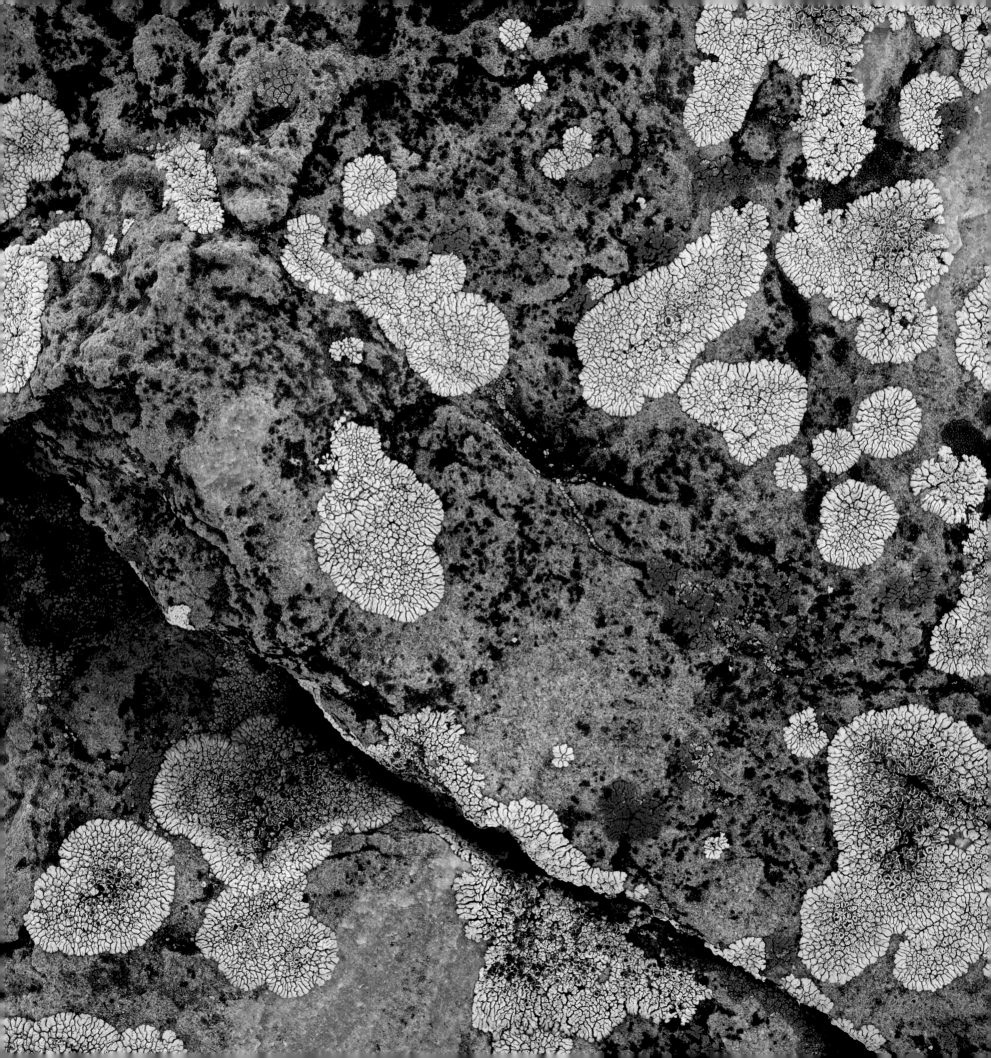

How do you separate Glen Canyon, Marble Canyon, and the Grand Canyon, when they're strung tightly together by the Colorado River like beads on a necklace? To get the long view and to appreciate this canyon country, I like to peer over the edge into this last remnant of Glen Canyon, far upriver from the point where mere mortals have proclaimed the canyon "Grand". —*JD*

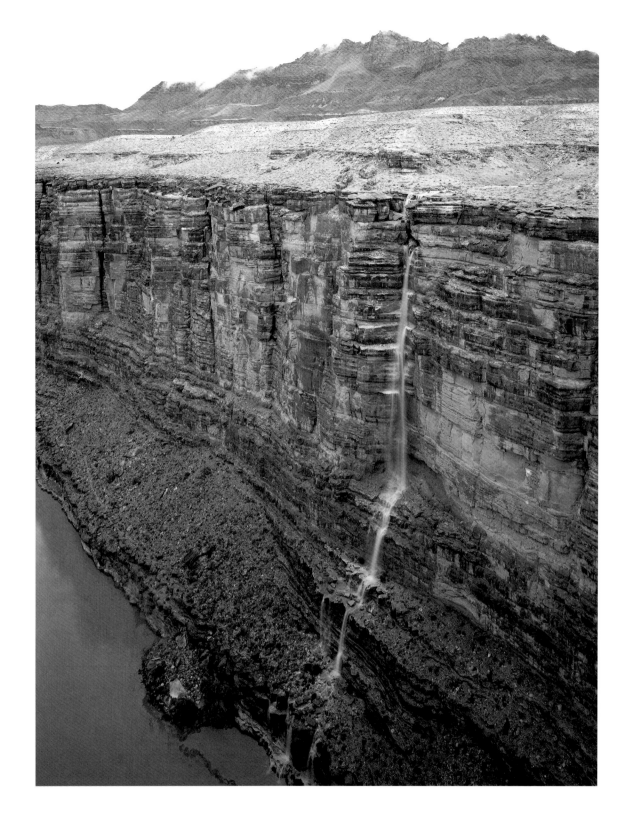

MARBLE CANYON | An ephemeral waterfall, right, plunges over the edge of Marble Canyon. At left, rimrocks splotched with lichen lie high above Marble Canyon.

North Canyon Rapid, following spread, developed at the confluence of North and Marble canyons.

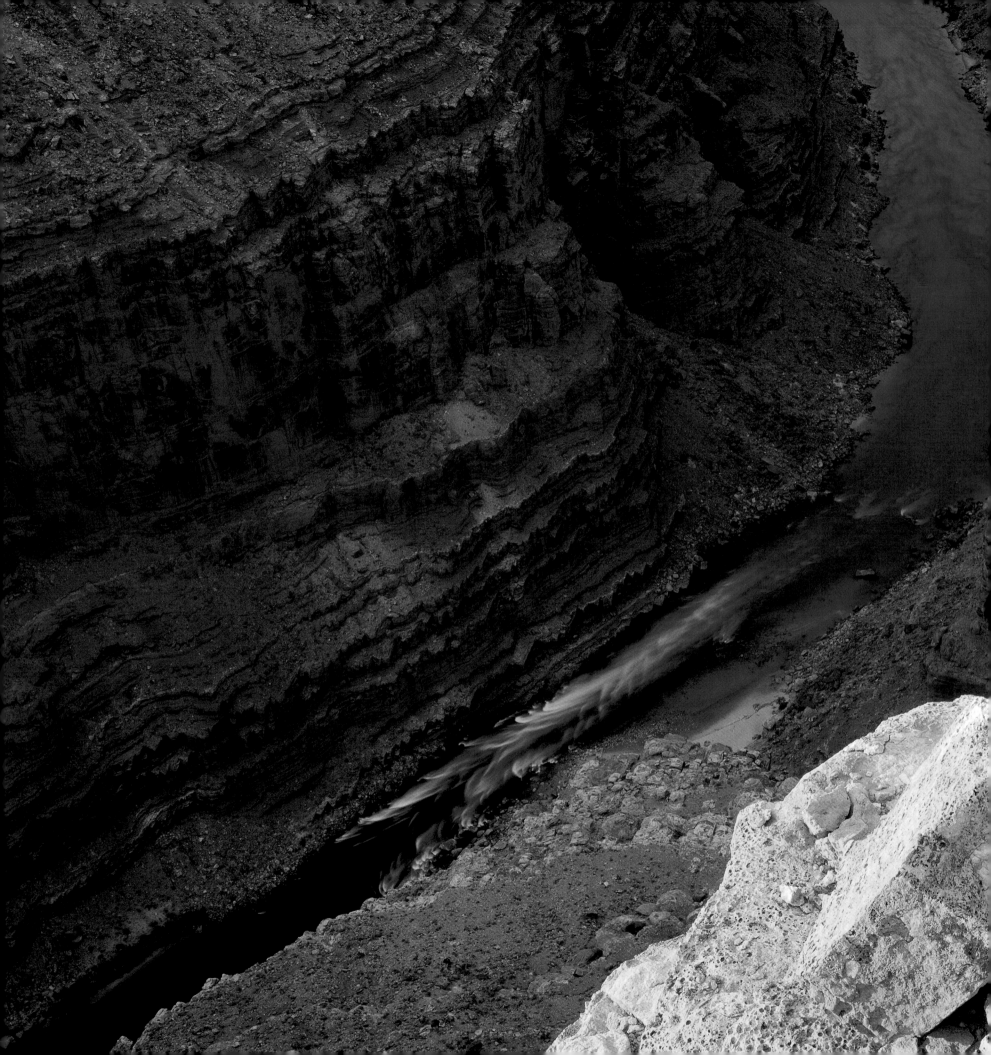

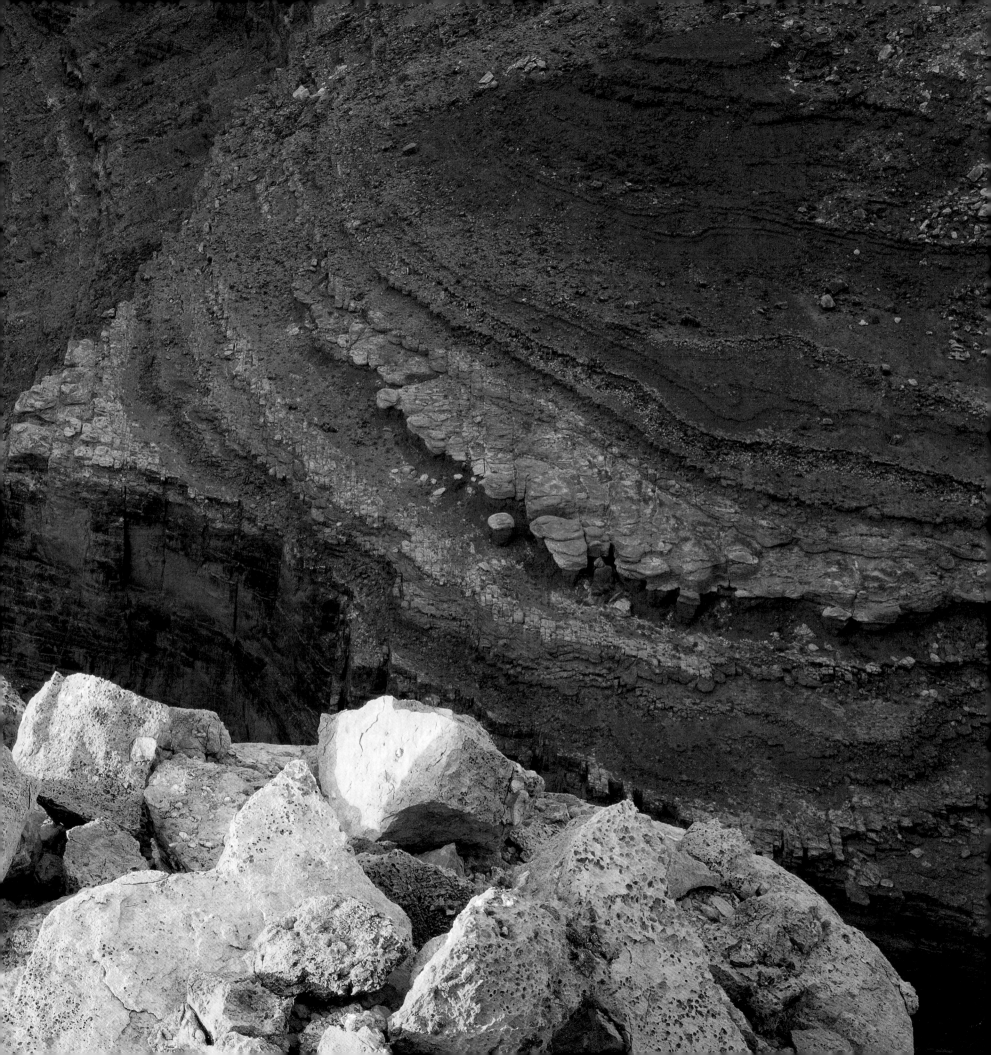

NATURAL HISTORY | BY WAYNE RANNEY

BEGINNING GRAND CANYON | Obviously, the Grand Canyon is a very big place. However, imagine— it is so large that some of its far-flung parts may have formed at different times. As difficult a thought as that may be to grasp, a few geologists believe that parts, or even all of the Canyon, may be 60 or 70 million years old.

Most however, ascribe an age of about 6 million years for the Canyon—this roughly being the age of evidence found for a Colorado River that flows precisely along the same course and in the same direction as the one we see today. A few skeptics of such a "young" Canyon point out that some early incarnation of it must have certainly existed before this time. But this wide range of ages for the Canyon, between 6 million and 60 million years, attests to its immense and perhaps unknowable size.

In trying to grasp the enormity of the Grand Canyon, I consider it useful to separate it into three distinct sections, each marked by striking differences in appearance—locally imperceptible but quite dramatic throughout its length. I call these parts Beginning, Classic, and Wilderness.

The Beginning stretches from Lee's Ferry, near the Utah border, to a line drawn between Cape Final on the North Rim and Desert View on the South Rim. As measured along the river, this distance is about 70 miles.

The next—Classic—runs west from the Cape Final-Desert View line to an area just beyond Crazy Jug Point on the North Rim. The length of this section is about 70 miles as well.

And the final section, measuring about 140 miles in length, I call Wilderness Grand Canyon. Very few people actually see the Canyon from this remote expanse, which begins west of the Kaibab Plateau and goes to the Grand Wash Cliffs near the Nevada border.

The first two sections combine to make up about one-half of the Canyon, and the last one accounts for the lower half of the Canyon.

Dividing the Canyon into sections in no way detracts from the its extraordinary superlatives. Most everyone knows that it's a steep, one-

mile vertical drop from the rim to the Colorado River. And most people have heard that the Canyon is 10 miles wide measured between the El Tovar Hotel on the South Rim and the Grand Canyon Lodge on the North Rim.

What makes the Grand Canyon especially big is its extreme length. Measured end to end, the Grand Canyon is 277 river miles long, much longer than the Barranca del Cobre in Mexico, which is often compared to the Grand Canyon of the Colorado River. Although this fact of its immense length is relatively unknown to most people, it is one of the Canyon's most remarkable dimensions. If an imaginary highway were built along the river through the Canyon, a car traveling at the eye-blurring speed of 70 miles an hour would take four hours to travel through the Canyon. It takes a motor-assisted raft seven

Near the end of the "beginning" Grand Canyon, Desert View's watchtower has a commanding view of the Colorado River and the Canyon it formed.

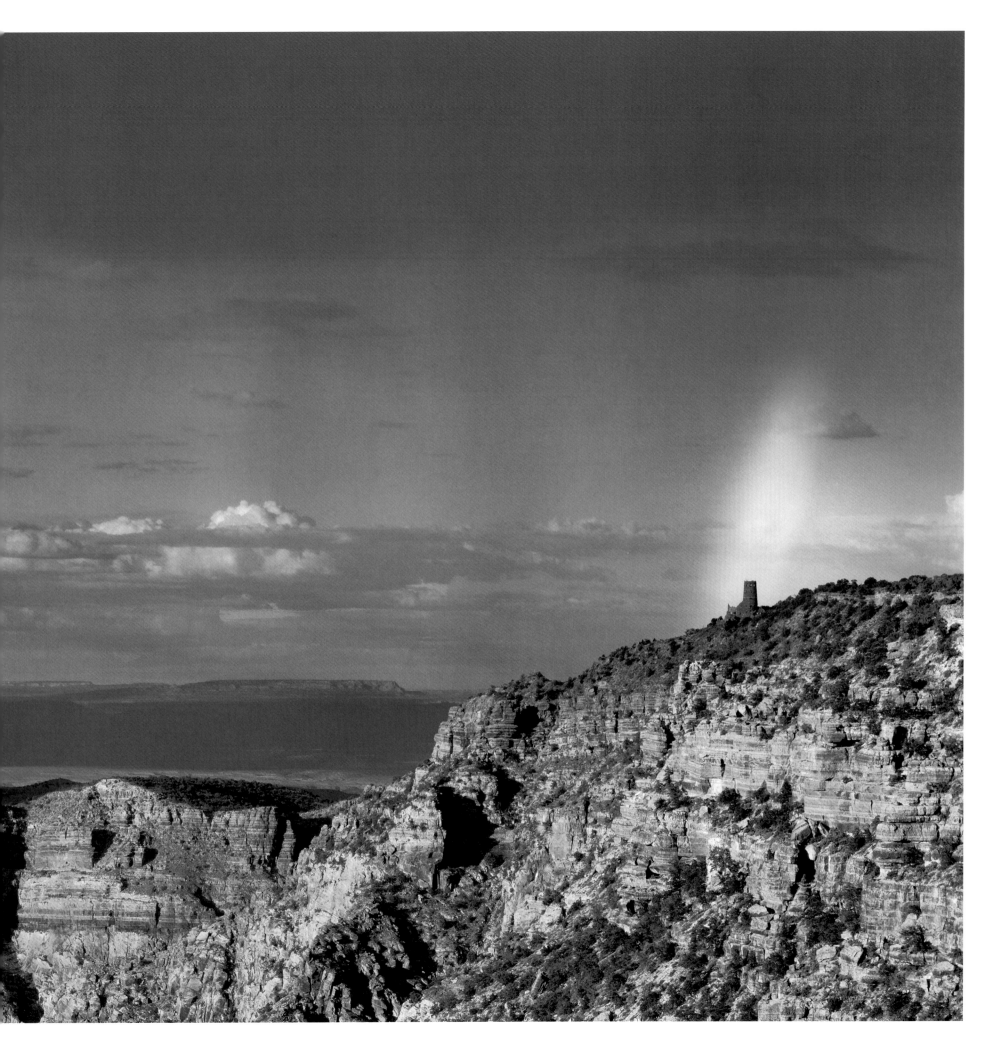

When this stratum makes its discreet appearance above the river level at Lee's Ferry, the Grand Canyon officially begins.

days to traverse the whole length of the Canyon and an oar-powered boat almost two weeks. When visitors look out from El Tovar or Grand Canyon Lodge, their view can take in only a little more than one-tenth of the Canyon's entire length. The Grand Canyon is indeed a very big place.

But all places, big or small, have a beginning, and Grand Canyon has its rather humble origin at a small spot on the map called Lee's Ferry.

Here the Colorado River undergoes a quick transition from the sandstone enclosure that was Glen Canyon (before the creation of Lake Powell) to a multitude of other rock formations that will, in short time, compose the steep walls of the Grand Canyon. The top layer throughout the Canyon is Kaibab limestone. When this stratum makes its discreet appearance above the river level at Lee's Ferry, the Grand Canyon officially begins. Here the great gorge can be measured in only a few feet or even just inches, but because of what the Canyon will soon become, it's a wry thought to imagine such modest beginnings.

The notion that the Grand Canyon possesses a physical beginning also conjures up thoughts regarding the Canyon's origin through an immense span of geologic time. Some may wonder: "How was the Canyon formed? When did the river accomplish its task?"

The Canyon does seem to draw out a natural curiosity in all of us. Who hasn't engaged in such reflections while looking deep into the abyss? I had such a meditation while resting on a solo hike into the Canyon a few years back. Usually, I think of the Canyon's origins while explaining its many nuances to visitors on the backpacking and rim tours I lead. Finding myself in such a solitary moment within the Canyon caused me on this occasion to deeply consider the immense amount of time and the many elements that have combined to create this spectacle upon our planet. Tears literally welled up in my eyes at the thoughts that came over me. I realized just how deep an influence this seemingly inanimate feature has on my whole being.

The truth is that no one knows for sure how or when the Grand Canyon began. Even though scientists have been trying to unravel the mysteries of the Canyon's origin for almost 150 years, it's still beyond the grasp of modern scientific understanding. Various ideas have been proposed, but none has been accepted as a valid, comprehensive truth. It seems that despite its humble beginnings at Lee's Ferry, the Grand Canyon is just too big physically and its geologic history is too complex to be easily known by human beings.

However, a few statements about the Canyon's origin can be accepted— the Colorado River carved it; it has the potential to become even deeper; and it's not likely anyone will ever figure out exactly when or how it began.

Regarding the first two, the words Colorado River and Grand Canyon can be used almost interchangeably, since without the river there could be no Canyon. And it's likely that the deepening process is not yet over.

The third statement comes from the fact that we humans may have come to the Canyon too late to find the specific evidence for the river's early history: As the Canyon progressively became deeper and wider, it removed the evidence of its earliest existence, leaving only scattered bits of obscure river gravels, little of which dates to the time of the Canyon's origin.

While modern scientists have been working to unravel the hidden secrets of the Canyon's inception, the very first humans laid eyes on it ages ago. It may have been 12,000 or even 15,000 years ago—archaeologists still debate when the first people arrived on this continent. But someone had to have been the first human being to peer into this chromatic shrine. We can only guess at what his or her thoughts and feelings were upon seeing this "world within a world". (And yes, even 15,000 years ago the Canyon's profile would have looked entirely the same as it does today, except for relatively minor rockfalls and debris flows.)

Contemplating this noteworthy occasion presents us with another thought: Where did the first human being lay eyes on the Grand

Saddle Mountain, where these contorted aspen trees, lupine (purple), and Indian paintbrush flowers are growing, overlooks the Colorado River (not shown) a little more than halfway between Lee's Ferry and Desert View. The mountain is a part of the eastern side of the Kaibab Plateau.

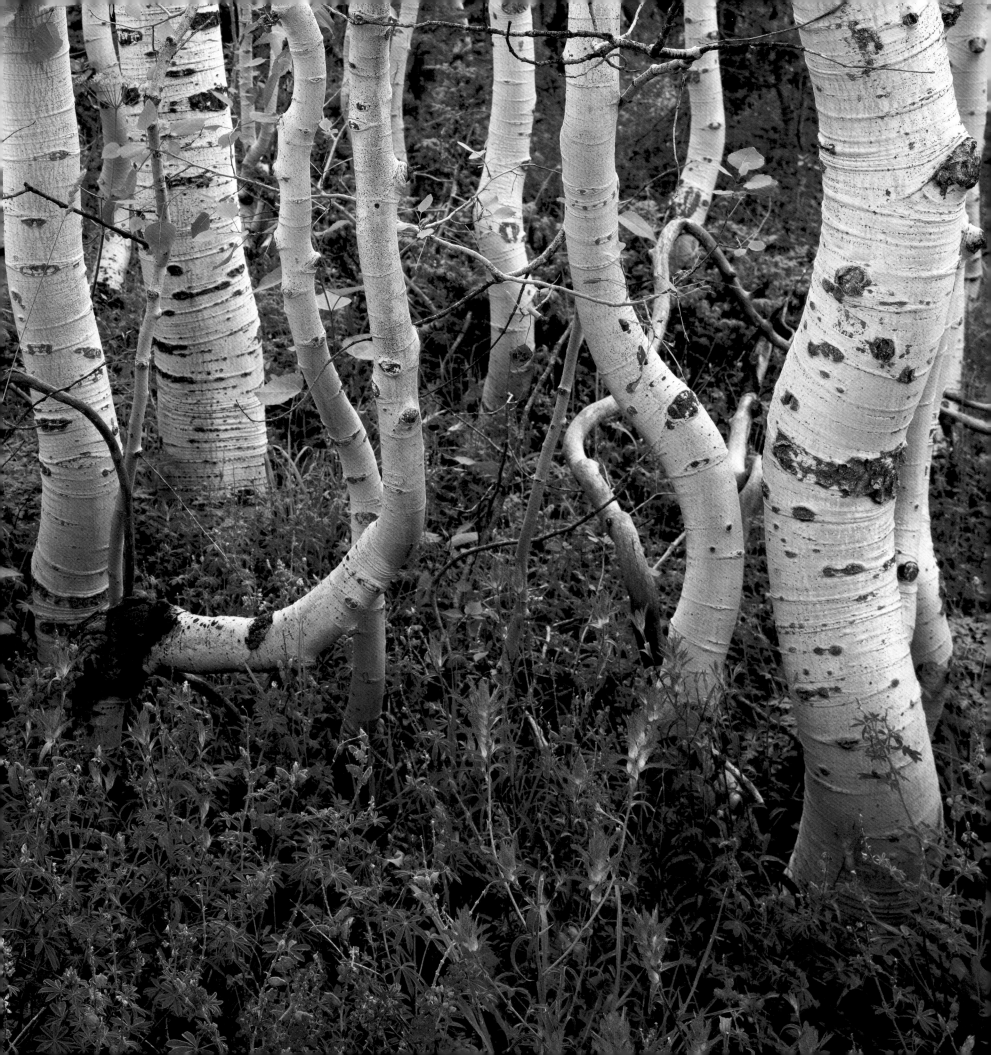

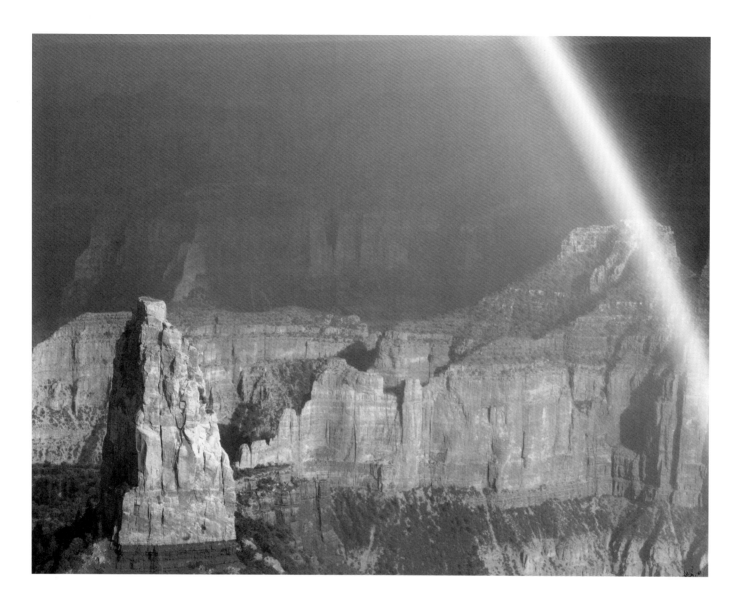

Although it appears that forces thrust Mount Hayden upward, erosion is the architect creating the spire.

Canyon? Where did someone first drink from the Colorado River?

One long-held theory holds that humans first arrived in the American Southwest after a southward journey along the eastern face of the Rocky Mountains. When those people rounded the southern end of the Rockies, their westward wanderings would have naturally led them to the area where the Grand Canyon begins— a stretch of spectacular canyon country known today as Marble Canyon, about 62 miles in length and located between modern-day Lee's Ferry and the Little Colorado River. In this region, the lay of the land naturally funnels westbound travelers to the brink of the Canyon and eventually northward and the banks of the Colorado River at Lee's Ferry. It's an intriguing thought that the Grand Canyon may not only emerge physically here, but perhaps could be the place where we humans began our spellbound and wondrous relationship with it.

Continuing downstream from Lee's Ferry, the Colorado River slices with utmost persistence through the Kaibab limestone-capped Marble Platform and into a marvelous stack of sedimentary rocks. Great thicknesses of variably colored layers appear, and eventually erosion shapes them into the widely recognized profile of this iconic landscape. The average drop or gradient of the river in Grand Canyon is about 8 feet per mile, more than double the gradient immediately above or below the pre-dam Canyon. Yet even at this rate of cutting, the Canyon should only be about 700 feet deep when it reaches the vicinity of Grand Canyon Village, on the South Rim about 87 miles downstream from Lee's Ferry.

What gives? How come the Canyon is more than a mile deep in the village area? The answer lies in one of the most important processes responsible for the formation of the Canyon— uplift. Without uplift of the surrounding land after the rocks were deposited, the Colorado River would have had no "canvas" upon which to "paint" the Grand Canyon.

Uplift combined with the river's gradient makes the Canyon about 70 feet deeper on average for each of the 70 miles the river flows from Lee's Ferry towards Cape Final and Desert View.

Significant faults cross the river near the terminus of Beginning Grand

This widening process has formed all of the many temples in the Grand Canyon, and in time they will all erode away.

Canyon and raise the strata even more in a spatial instant. Where the river passes the magnificent viewpoint of Point Imperial, the elevation of the Kaibab limestone that was only 3,150 feet in elevation at Lee's Ferry is a whopping 8,803 feet above sea level. The river's elevation below the point is about 2,760 feet, making the Canyon more than 6,000 feet deep as measured from the North Rim. By this point, the river has truly created a very grand canyon.

Travelers can reach many fine viewpoints atop this uplifted mass to see Grand Canyon's beginnings. Marble Viewpoint and Dog Point are two little-known points off State Route 67 south of Jacob Lake. From these lonely vantages, one can look out upon the vast expanse of the Marble Platform and see the shadowed gash of Marble Canyon set within a seemingly unvegetated plain. Blackbrush, however, grows in profusion on this surface and defines the area's biotic inclusion in the Great Basin Desert. This plant is a signature indicator for this specific North American desert, even if it's in odd contrast with the many fir and spruce trees that frame

the view below. Such is the consequence of the fortuitous interplay of the area's capricious geologic foundation and its consequent biologic repercussions.

From these viewpoints visitors may also discern many "small" tributaries of the Colorado River, which can be seen as the sheltered recesses set upon the Marble Platform. Curiously, these tributaries have carved their canyons just as deep as the Colorado's Grand Canyon, despite the fact that most of them are dry most of the year. An odd question presents itself—how can a usually waterless tributary cut a canyon as deep as the Colorado River? It doesn't seem to make sense, yet the evidence is laid bare before our eyes. Perhaps water once flowed in these tributaries when the climate was much wetter. That's certainly a possibility and may provide part of the answer. But something even more surprising may be at work, since the amount of water in the tributaries could never surpass that of the Colorado.

Geologists originally assumed that it was the muddy water of the pre-dam Colorado River that carved the Grand Canyon. Imagine this process like a sheet of sandpaper gradually

wearing down a piece of wood. Viewed in this way, the muddy Colorado could gently wear away at the bedrock to form the Canyon over millions of years. However, when geologists began to study the riverbed beneath the muddy water, they found that its channel contained huge amounts of loose sand and gravel, precluding a gradual wearing away of the bedrock by muddy water. It became obvious that something else had to cut the Canyon and, as it turns out, its tributaries.

This something else is the never-ending supply of cobbles and boulders that crash down the river and its tributary channels in huge floods. The process of large boulders moving in huge floods neatly explains how a dry tributary can be as deeply cut as the Grand Canyon of the Colorado River.

Other kinds of erosion are at work as well. Consider, for example, Mount Hayden, a tower-like needle of rock rising from within the Canyon at Point Imperial. An untrained observer once asked me if this spire was thrust upward much like a rocket shooting up through the sky. I can understand how features like Mount Hayden could be viewed in this way, but a quick

glance at the stratified nature within its structure shows that it conforms with the strata found in adjacent rocks. So, Mount Hayden was formed by the progressive widening of the Canyon that broke rocks away from a once-larger mass. The spire only appears to be rising from the depths below.

This widening process has formed all of the many temples in the Grand Canyon, and in time they will all erode away. Some people may feel a sense of loss at the prospect of this natural change, but continued widening of the Canyon will chisel away at the edge of both rims and new temples may appear. Grand Canyon, it seems, is an incubator of stone temples. I like that thought.

Next: At the south end of Beginning Grand Canyon, Desert View and Cape Final stand as graceful portals to the middle section of the Grand Canyon. Between these two points the Canyon is a little more than 8 miles across. The high-standing eastern edge of the Kaibab Plateau looms almost 3,000 feet above the adjacent Marble Platform. For 70 miles the Colorado River has been at work creating Classic Grand Canyon.

CLASSIC GRAND CANYON | Like most people, I first saw the Grand Canyon after traveling on a paved road toward one of her many hotels.

However, unlike most, my first view was framed through the fir forest and picture windows of the Grand Canyon Lodge on the North Rim (only one in 10 people who visit the Canyon see it from the north side). It was 1973, and I was hitchhiking around the West, keen on seeing as many of the natural

wonders in the region as I could in six weeks. As expected, I was enthralled by the vista presented to me on the North Rim. But the Canyon had grander schemes in store. Shortly after my arrival, a giant thunderstorm moving in from the west obliterated my view of the Canyon. I actually looked down onto a spectacular sight of swirling clouds, jagged lightning, and pounding rain, all moving among the many temples that have since become old friends to me. Thunder and lightning snapped the air and charged it with dynamic energy. I held onto my hat and gazed in pure amazement as the spectacle moved on, leaving behind a sun-drenched landscape bejeweled in sparkling wetness. I was hooked! Within two years I was living at the Grand Canyon.

Easily reached vistas like these, although developed and oft visited, have become precious to me because they contain as much magic as any other part of Grand Canyon.

Classic Grand Canyon encompasses

the broad area where the high-standing Kaibab and Coconino plateaus are found. Thus, it has the most thickly forested views in all of the Canyon's entire length. This section can fittingly be called Classic since it's the area where people most often experience the Canyon and readily recognize it.

The Classic part begins at the eastern edge of the Kaibab Plateau between Desert View and Cape Final. These two high-standing vantage points function like a giant entryway to the Classic section, where the Canyon attains its most noble grandeur, its most elegant profile— burnt tones of rocks are cloaked in a green canopy that oftentimes receives generous amounts of rain in the summer and snow in winter.

Somewhat surprising, perhaps, is that the Canyon's long-ago geologic story determined the precise placement of its development as a major destination today. Rich asbestos and copper deposits beneath the South Rim were a magnet for early miners who

settled here and later became the first tourist guides. Luxuriant spring water found at the head of The Transept drew those who pioneered the North Rim's development on Bright Angel Point. Everywhere we turn, it seems, we find that everything at Grand Canyon is intimately connected to its intriguing and colorful geology.

For example, near the beginning of the Classic section, the Colorado River makes a slow but determined bend from a south flowing to west flowing. For most of its previous length (about 900 miles), the river has run in a fairly arrow-like course towards the southwest, pointing the way to its salty rendezvous with the Sea of Cortés in Mexico. Therefore, this westward bend, visible from Lipan Point, represents a significant deviation in the river's overall path. The bend becomes all that more remarkable when one considers that the river here is being

redirected into and through an uplifted mass of strata that elevates rocks on the Kaibab Plateau almost 3,000 feet higher than those on the Marble Platform. Ordinarily, rivers turn away from uplifted terrain and take the path of least resistance. Obviously, the Colorado is no ordinary river.

Most people probably are unaware of the importance of the "big bend" in deciphering the history of the river. To some, Lipan Point may only represent a palette where nature's colors are indiscriminately mixed and brushed onto a rocky canvas. The sheer size of the masterpiece that is Grand Canyon may unintentionally direct one's focus to a bland acceptance of what is, and away from a larger curiosity concerning the artists' intent.

Fortunately, others come here seeking answers about why this river mysteriously curves into a massive wall of rock. A single, accepted

A balanced rock and Wotan's Throne (background, at right) are among the formations signaling that Classic Grand Canyon has begun. This scene is visible from Cape Royal.

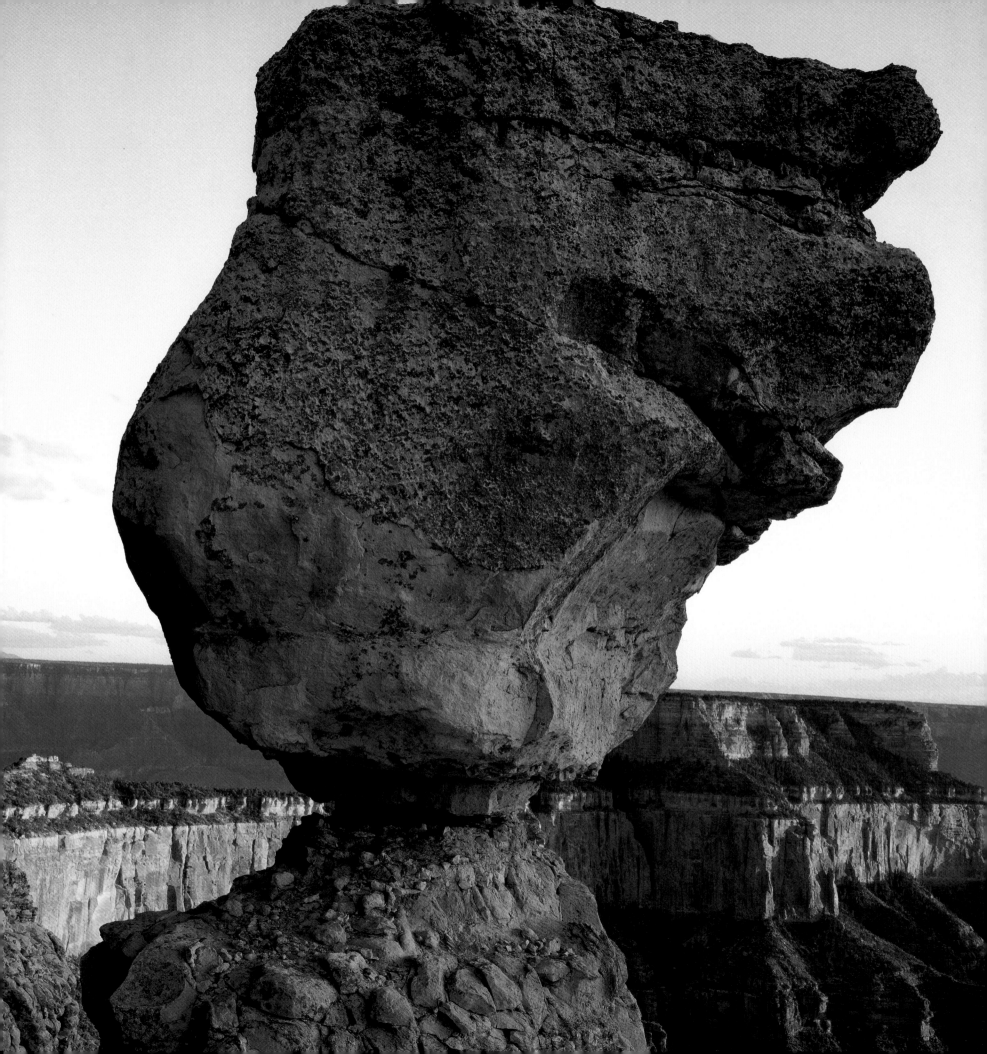

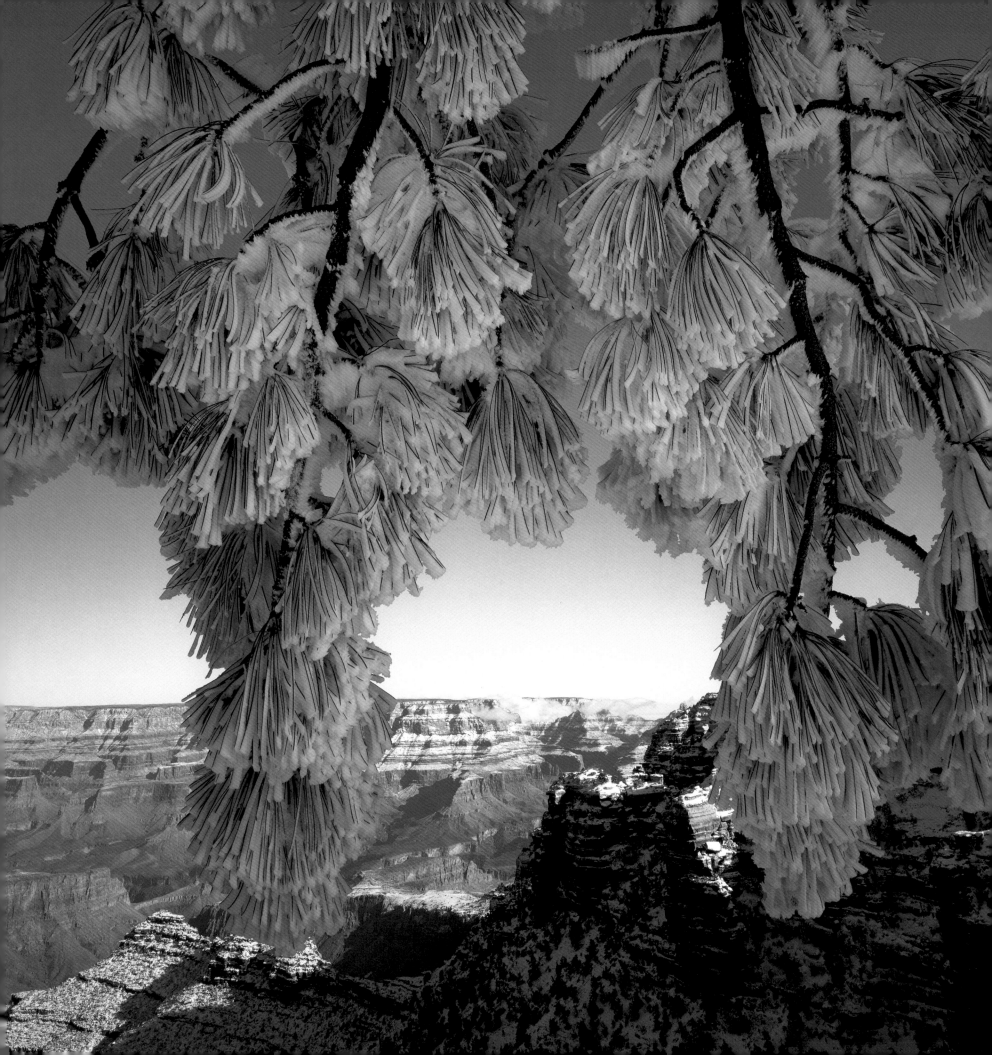

answer from geologists has not yet been forthcoming, but efforts to unravel the enigma have yielded a multitude of interesting possibilities.

One of these is that the river we see today has been cobbled together from two separate and distinct ancestors, which eventually connected as one.

As crazy as this may sound, it's one of the leading theories regarding the rivers' origin and could also explain how the bend came into existence. In this scenario, the river downstream from Lipan Point may have once been an energized, steep-gradient predecessor to the lower Colorado River. Steep-gradient rivers have the ability to lengthen their channels in the uphill direction. The headward (upriver) lengthening of the lower Colorado River towards the east could have intercepted and captured a more sluggish ancestral upper Colorado River, running perpendicular to it east of Lipan Point. In this way, the two rivers may have become integrated into the single Colorado River we

see today. Through the years many geologists have favored this idea, although the best of them certainly remain open to other possibilities.

A variation of the "two-rivers" theme has been around for almost 80 years but has been reinvigorated recently with a fresh look.

East of Grand Canyon is the valley of the Little Colorado River. Within it are scattered patches of sediment that look to some as though they might have been laid down in an ancient lake. It's been proposed that the lake, which could have existed on and off between 6 million and 16 million years ago, may have been catastrophically destroyed somewhere in the vicinity of Lipan Point. This occurred either when lake water spilled over the western edge of a presumed overfilled lake basin, or when the headward erosion breached the lake. Either scenario could account for the "big bend" since the lake would have been filled from the ancestral upper Colorado River to the north.

Still others believe that the

enigmatic westward bend is simply the result of the exact course of the river we see today having originated at some earlier time on a surface that concealed the various faults and folds that make the Kaibab Plateau so much higher today than adjacent areas. The river could have established its course as it meandered across the plateau's surface, then begun to chisel down into the bedrock that now makes up the inner walls of the Canyon. In this way, the river would have gradually dissected deeper into the variably inclined, folded, and faulted strata. This process would only make it appear as if the river had actually turned and flowed into an uplifted wall of rock.

This geologic blueprint for Classic Grand Canyon leaves ample room for myriad biological wonders.

Because of the great height attained during the uplift of the Kaibab Plateau, trees that commonly are thought of as belonging to the Rocky Mountain region can also be seen here. Engelmann spruce, Douglas fir, aspen, and even blue spruce are just some of the species found upon the 9,000-foot crest of the giant blister on the Earth's crust.

The trees shelter one of our country's healthiest deer herds, which in turn support mountain lions. These large cats are no doubt occupying every available niche on both rims of the Canyon, making relocation attempts fruitless since they depend on exclusive hunting ranges. The North Kaibab forest provided man with a lesson in the intricacies of ecology in the 1920s when mountain lions were removed to enhance deer survival only to have the deer populations surge beyond the land's capacity to sustain them. Strike one up for Mother Nature.

In 1540, the first non-Indians saw the Grand Canyon from a place most likely between Lipan and Moran points on the South Rim. The Spaniard Lopez de Cárdenas led a small expeditionary force west from the Hopi mesas as part of the larger Coronado expedition. His purpose was to meet up with a planned resupply party that would have first come by way of the Sea of Cortés and then up a little-known river near the land of the Hopi. Cárdenas came to Grand Canyon looking for tall-masted ships but instead found an impossible landscape too rough for overland travel. He sent a few men down for

It's clear that geology is the major attraction in Classic Grand Canyon, but vegetation such as ponderosa pine trees add their touch to the overall scene. The scene here looks toward the North Rim on the horizon.

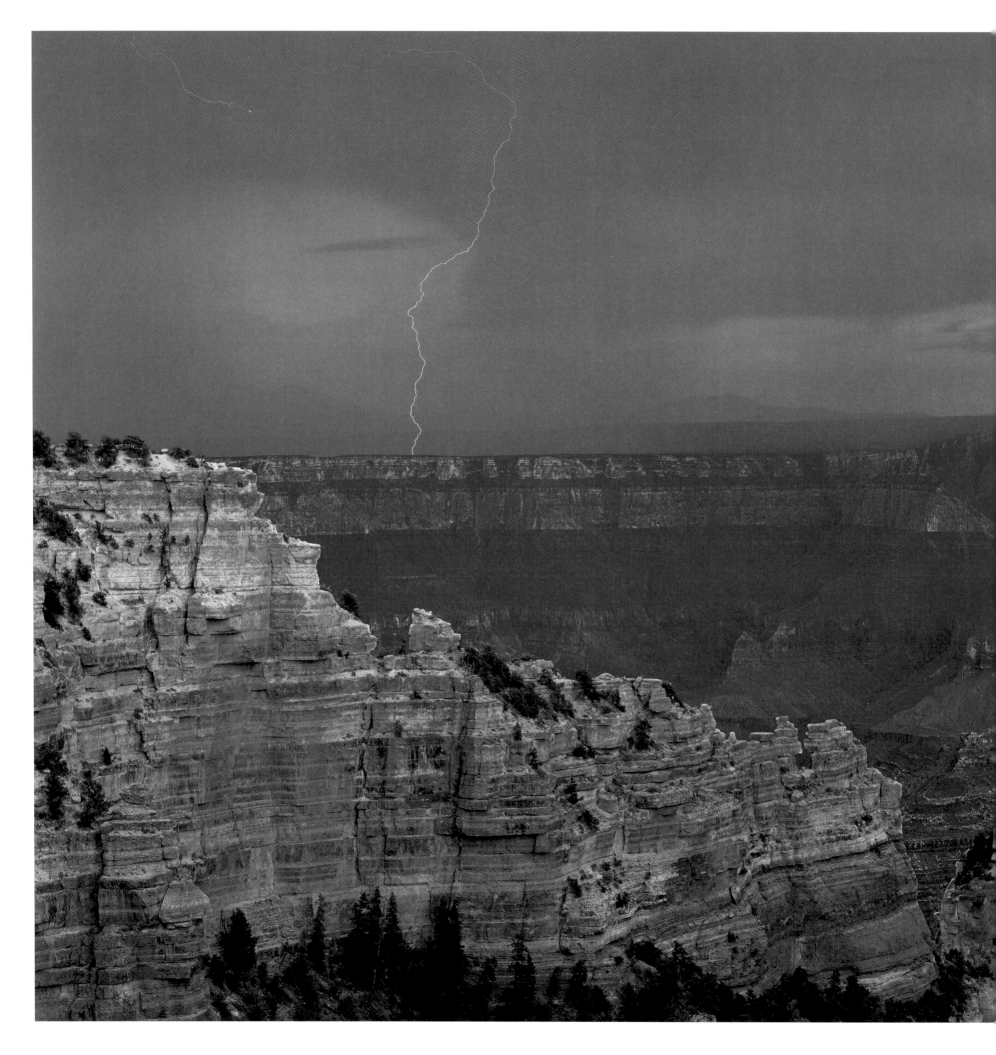

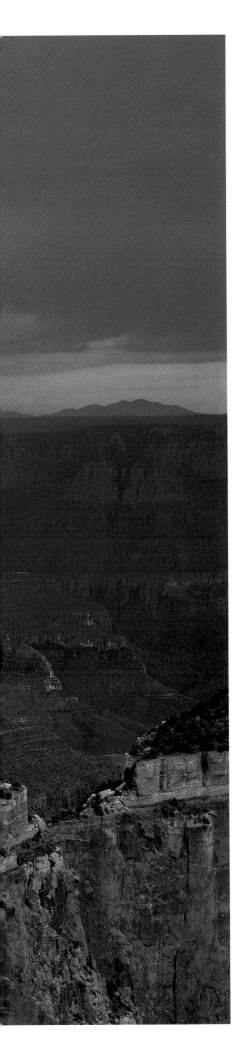

drinking water thinking that the river he saw below was only 6 feet wide.

However, the Canyon's expanse was much greater than he had realized, and his men never reached the river. When he wrote an account of the event the only known object to which he could compare the rocks in the Canyon was the Tower of Seville in Spain at 320 feet.

Shoshone Point, located between Lipan and Mather points, beckons visitors who hope to experience the thrill of coming upon the Canyon much the same way that Cárdenas or other pioneers did—on foot. A 1-mile fire road (normally locked to casual auto use but open to hiking and available for a fee for weddings, reunions, and picnics) is one of the best backcountry routes available to enjoy the Canyon in all its quiet splendor. Since cars normally are not allowed there, Shoshone Point

From a geographic perspective, Cape Royal juts into the Grand Canyon at the end of the Walhalla Plateau; from a touring perspective, it lies at the end of a North Rim paved road. Flagstaff's San Francisco Peaks are on the horizon.

offers solitude, spectacular views, and great stargazing. Like many of the other South Rim viewpoints, it was named for one of the many groups of Indians that inhabit the West.

Hopi Point has long been considered one of Grand Canyon's best places to watch a sunset. From this spectacular view one can see colorful strata that record the ancient environments responsible for the Canyon's sedimentary rock: desert dunes in the Coconino sandstone; tropical seas in the Kaibab and Redwall limestones; and an ancient beach in the Tapeats sandstone.

It has been only a few hundred years since humans discovered that a record of the Earth's history is preserved in rocks such as these. Ancient environments that had no firsthand witness are now routinely resurrected in astonishing fashion. The geologic wonders of Grand Canyon inspire and enchant if only we heed their silent whisperings.

One of Classic Grand Canyon's most surprising features is that the North Rim sits more than 1,000 feet higher than the South Rim. Visitors to the

South Rim's Mather Point are amazed to learn that fact, since the seemingly flat-lying strata make it appear like each side is level with the other. The reason for this difference in elevation is that the Colorado River has carved its course on the south flank of a broad, uplifted dome. The crest of this dome is in the vicinity of DeMotte Park, north of the Canyon on the Kaibab Plateau. From here all strata dip downslope at about two degrees. If the river had carved it's course on the crest of the uplift, both rims would dip away from the river and be of comparable height. The river's position on the south flank of the dome means that rocks dip to the south about 100 feet per mile.

Take a drive on any one of Classic Grand Canyon's paved roads to her many viewpoints—Grandview, Yaki, or Mather. Take the hiking trail to the North Rim's Tiyo Point. At any of these, one can witnesses the pageantry of Earth history exposed on a grand scale.

Next: Gazing westward from Classic Grand Canyon, it's difficult to imagine the size and remoteness of the Canyon's third section.

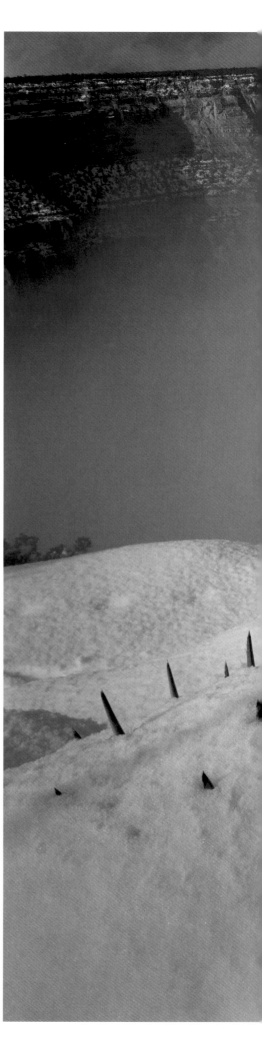

WILDERNESS GRAND CANYON | As the elevated Kaibab Plateau slopes westward atop gently inclined strata, both Grand Canyon rims descend from thickly vegetated heights. Near Jumpup Point, upstream from a tributary called Kanab Creek, a different appearance emerges. Most notable among the changes, perhaps,

is the stark absence of stately conifers. When the trees fade away, only naked rock is exposed in the gorge, and the scenes of blinding white Kaibab limestone make viewers wonder if this is the same Grand Canyon that exists farther east, or upstream.

The central and western parts, the region I call Wilderness Grand Canyon, comprise by far the largest and most remote expanse of the Grand Canyon's immense length. Very few roads invade this rocky wilderness, and the ones that do seldom are traveled. With the exception of two significant attractions on Indian lands (the Havasupai Tribe's turquoise blue waterfalls and the Hualapai Tribe's Grand Canyon West with its Skywalk looming over the gorge), the region seldom is seen or even known by the Canyon's many pilgrim faithful. Wilderness Grand Canyon is thus a very appropriate moniker.

Besides the disappearance of conifers from its rims, many other Canyon aspects have changed. For

one, the vegetation besides trees.

Mohave Desert plant species have expanded into the Canyon's interior at the expense of Great Basin species living farther east. Ocotillo, creosote bush, barrel cactus, and cholla cactus are common throughout Wilderness Grand Canyon and have replaced a host of other species. Piñon and juniper only cap the rims. To those who need a lot of green in their views, the Mohave vegetation may make the Canyon appear more raw and less approachable. To me, the change represents one of the many moods that the Canyon takes on, neither good nor bad, just different.

Besides the flora, the Canyon's shape has changed dramatically.

The broad Esplanade, the uppermost layer of the Supai group of rocks, has grown into an imposing platform that makes its appearance at the expense of the Tonto Platform. The Tonto exists in Classic Grand Canyon as a major horizontal break

sitting atop Tapeats sandstone in the otherwise steep Canyon profile and is positioned about three-quarters of the way down toward the river. In Wilderness Grand Canyon, the Tonto fades into obscurity, and a more reddish platform emerges much higher in the Canyon's profile. The Esplanade appears as a graceful landform—broad and colorful and decidedly more expansive than the Tonto Platform.

A hike I once completed with friends across the Esplanade on the North Rim illustrates the expansive nature of the Esplanade. At the start of the hike a National Park Service ranger told us that a herd of cows had somehow gotten through the park boundary. Knowing that they were there illegally, he jokingly mentioned that we should chase them away. We later found the bovines grazing on the Esplanade and quite spontaneously began to chase them with the intention of running them off a cliff

Tips of agave poke through the snow in the "wilderness" portion of the Grand Canyon.

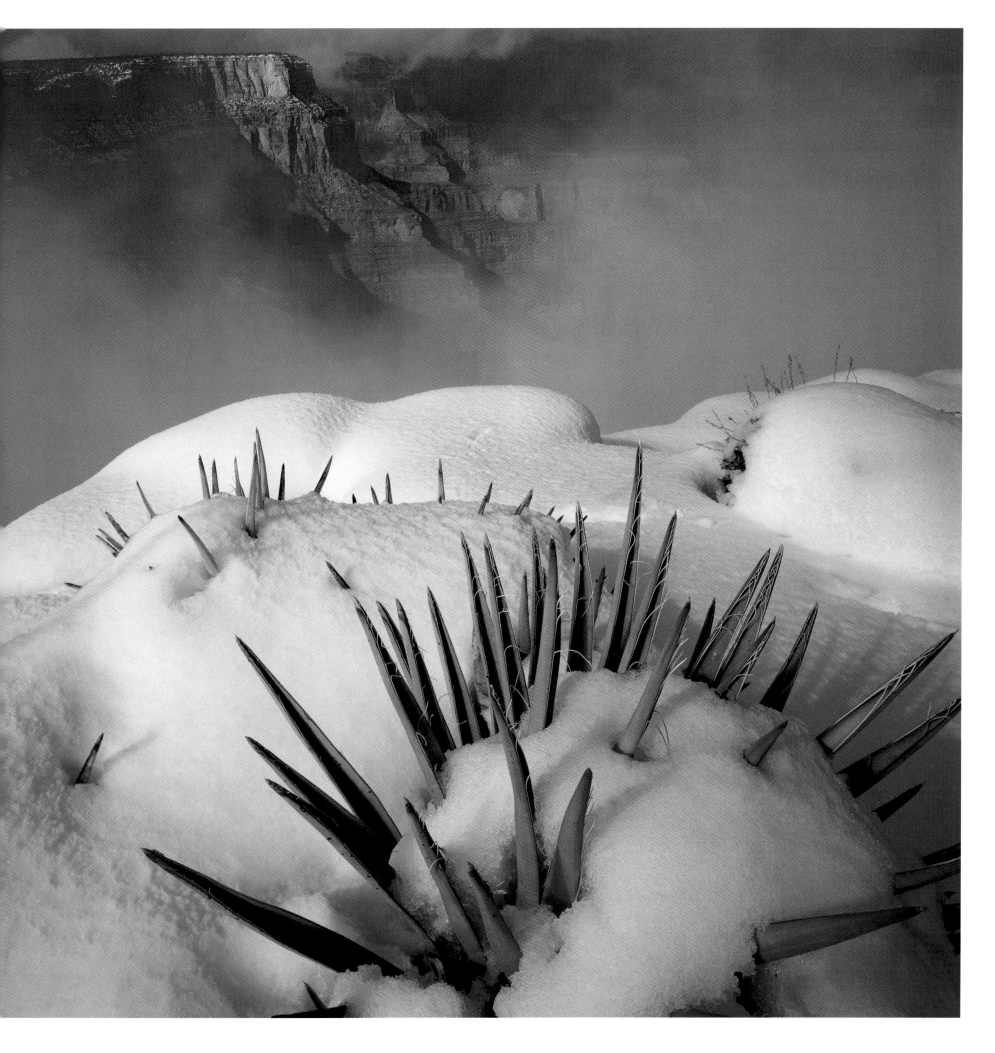

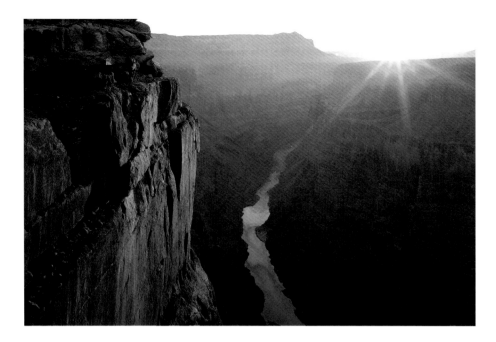

(á la Archaic peoples who did run buffalo off of "jumps" elsewhere in the Rocky Mountain region). The chase was unsuccessful as far as the meat-gathering goes, but we nevertheless ran with the small herd for almost a mile, such was the ease with which the Esplanade unfurls. It's hard to imagine many places in the Grand Canyon where people could run so far without encountering rock walls.

Such broad platforms come about because all of the Grand Canyon's variable strata are eroded at quite different rates. Rocks like shale and mudstone, once exposed by the river's scouring, will retreat from its edge at a much faster rate than harder rocks like limestone and sandstone. These softer rocks actually work to undercut the harder rocks that lie above them causing the otherwise indestructible rocks to collapse. Such processes are important in making the Canyon's stair-step profile. The Esplanade has formed as a result of the relatively soft Hermit shale eroding back at a relatively quick rate, which undercuts the Coconino sandstone and other higher layers in the process. The Esplanade Platform exists throughout more than half of the Canyon's entire length.

At Toroweap Overlook the red Esplanade is "flavored" by another completely unexpected type of rock–black volcanic basalt. This stupendous perch reveals evidence for a remarkable extrusion of lava within the Canyon beginning almost three-quarters of a million years ago. As many as 13 different lava dams may have once blocked the Colorado River during this interval, only to be catastrophically destroyed by time and the unflinching power of the river. Imagine red-hot lava pouring into the Grand Canyon. Imagine it creating a dam across the river, whose reservoir may have inundated many upstream portions of the Canyon. Imagine the day when water started to pour over the top of these dams—one which was documented to have been more than 2,000 feet high within the Canyon. And imagine the day when a dam was undercut by the power of the very waterfall that crashed at its base, releasing a giant torrent of water downstream in the Canyon. Such scenes have occurred here. Wilderness Grand Canyon is certainly a land of extremes.

Kelly Point, located on the North Rim's Shivwits Plateau in the far western part of Wilderness Grand Canyon, is perhaps one of its most remote and difficult-to-reach viewpoints. A seemingly never-ending dirt road must be traversed starting from St. George, Utah, and very few people have actually ever seen the Canyon from this vantage. The promontory sits above a giant 180-degree arc in the Colorado River and takes in an encircling view of the Canyon. Fossil crinoids (a type of ocean creature related to starfish) may be a bit of a surprise on this lonely desert roost, but they attest to the persistent nature of the strata within Grand Canyon. For its entire length, Kaibab limestone has been the cap rock of Earth's grandest canyon. Here too it rises to "hold up" the landscape within. Seeing it so far from more well-known locales makes me wonder what factors have come together to produce such a spellbinding landscape? How did all this beauty come about in the first place?

In the course of my musings on the Canyon's origin, I have identified five rather independent factors that are part of the Canyon's long heritage and have acted in concert to produce it. The first of these is the existence of a widespread extent of sedimentary rock or strata. Some formations found within Grand Canyon can also be found in adjacent states and although the names geologists give to them may be different, the rocks are essentially of the same age and rock type. Second, this extensive stack of layered rock is variably and brilliantly colored. This is the result of the layers being deposited in shifting, mostly terrestrial environments— desert dunes, river floodplains, and the shores of shallow tropical seas. Each gives rise to a different color. Next, this colorful expanse has been uplifted en masse without the layers being broken or deformed to any great degree. Usually rock uplift involves the crashing of crustal plates, but this region escaped much of that. Fourth, very large rivers

The cliff face at Toroweap, above, shows evidence of volcanic activity some 750,000 years ago. At Jumpup Point, right, lichen-covered fossils cover the rimrock on slopes dotted with amber grasses.

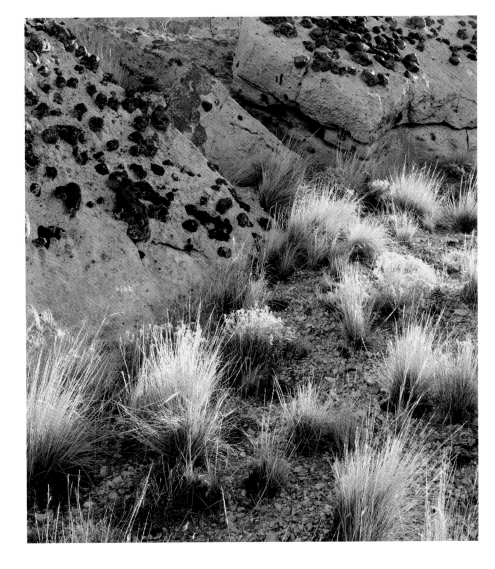

have carved into this uplifted plateau and have revealed its great, colorful depths. Lastly, and seemingly out of place with large rivers, is that the modern climate is arid, which leaves the spectacle relatively uncovered by vegetation for all to marvel at. Five factors: flat-lying strata, vividly colored, elevated without crushing, cut by large rivers, and all within an arid environment. These are the ingredients that have combined to make Grand Canyon and the Colorado Plateau such a sumptuous delight.

At first, it might seem contradictory to have large rivers and an arid environment. But the Colorado River draws 70 percent of its water from the high Rockies to the northeast. Thus a large volume of water flows through this parched landscape. There are two other places that come to mind with these two factors in place, Iraq and its Tigris and Euphrates rivers, and Egypt with the Nile. But these places lack one of the other elements—crustal uplift, which brings rocks into a position where they can be carved. The Tigris, Euphrates, and Nile rivers are generally at sea level by

the time they reach their arid reaches and so have not cut great canyons.

Other places, like the Himalayas or parts of the Alps, may reveal a history of uplift. But these areas do not always have the colorful sedimentary rocks that can be found in the canyon country. Some places, like Iran or other portions of the Alps, have thick stacks of sedimentary rocks and uplift, but they are not vividly colored to any great degree. Only the Grand Canyon and the vast Colorado Plateau reveal all of these five properties together. And this makes the area unique upon our planet.

Looking out upon the Canyon from lonely Kelly Point provides a fitting end perhaps to this geologic understanding of the Grand Canyon masterpiece. From this perch, a vast swath of the Canyon is revealed. To the west are the Grand Wash Cliffs where the Colorado River (actually the head of Lake Mead, as Hoover Dam blocked the river in the 1930s and inundated as much as the lower 35 miles of the Grand Canyon) exits the Canyon in surprisingly swift fashion. For 277 miles, the Colorado has been trapped in a canyon of its own making. Suddenly, the river takes

a left turn to the west and within a quarter-mile has gone from being enclosed within the stratified walls of the Canyon, to the low-lying, joshua tree-covered hills of the Mohave Desert. A giant fault has broken the strata of the Grand Canyon, creating a basin that contains evidence for the birth of the Colorado River as we know it today.

In this basin a fresh-water lake existed at the foot of the Grand Canyon as recently as 6 million years ago. And then it was gone. No younger deposits of this "pre-Grand Canyon" landscape have been found and that is why most geologists will give an age of 6 million years when pressed for an answer to the age of the Canyon. It's possible that an arm of this lake extended up into an early incarnation of the

Canyon, but we cannot know for sure. All that is left is too few clues and one very large question: How and when?

It is ironic that such a world-renowned landscape should escape even rudimentary understanding of its origins. Usually, well-known features receive such close scrutiny that the basic questions of "How" and "When" can be answered to satisfaction. But the Grand Canyon is simply too big to be known easily by us. As we consider the many moods and variables in this wondrous gorge, it is hard not to consider the fascinating geologic story of the Grand Canyon.

Do all stories that are profoundly moving require "answers"? Or are some of the best stories those that remain a mystery to us? ▥

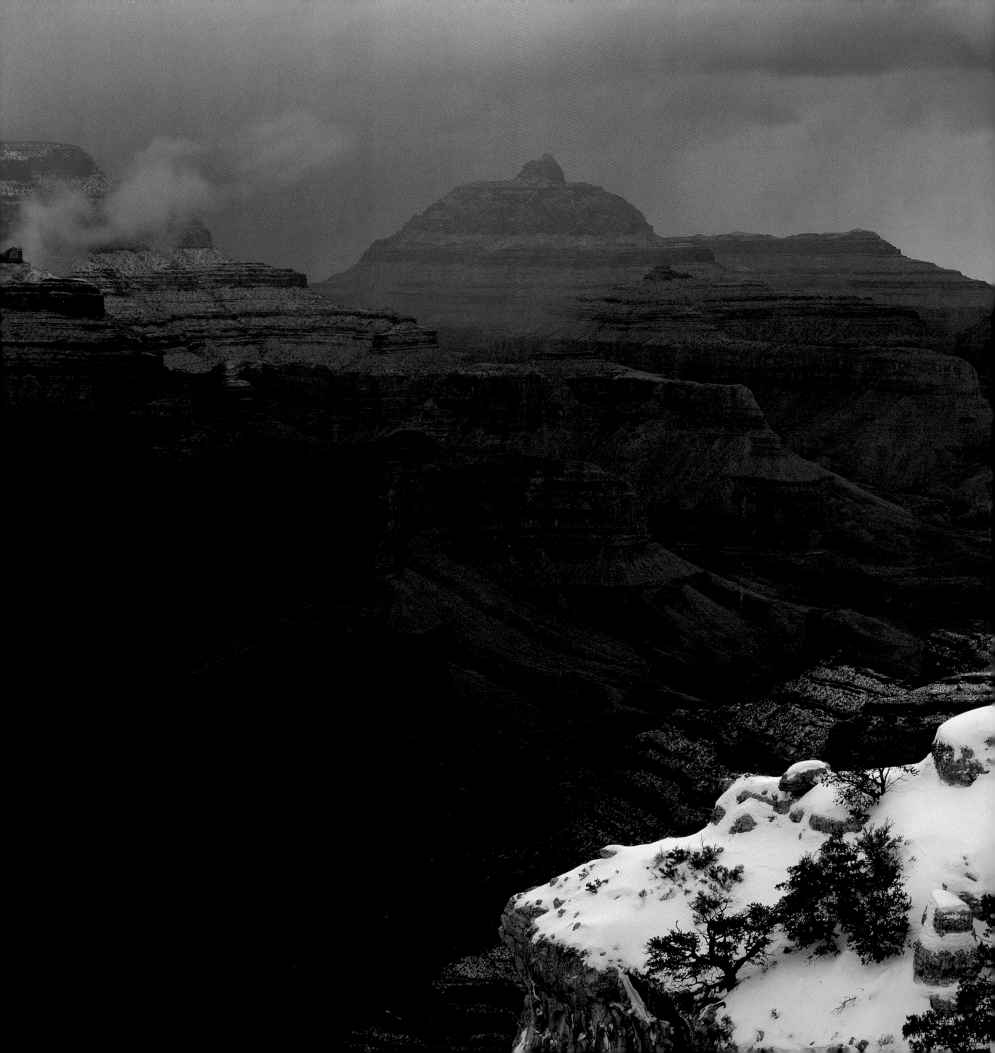

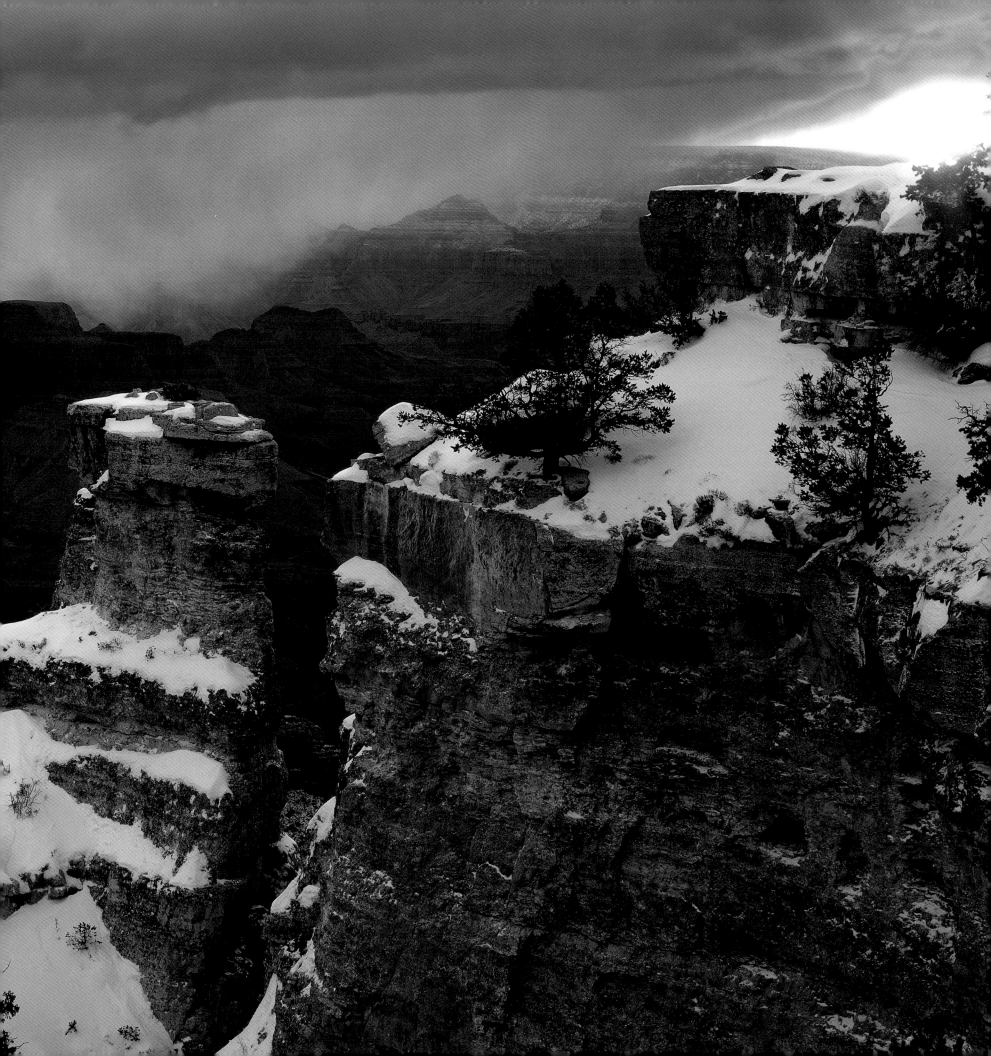

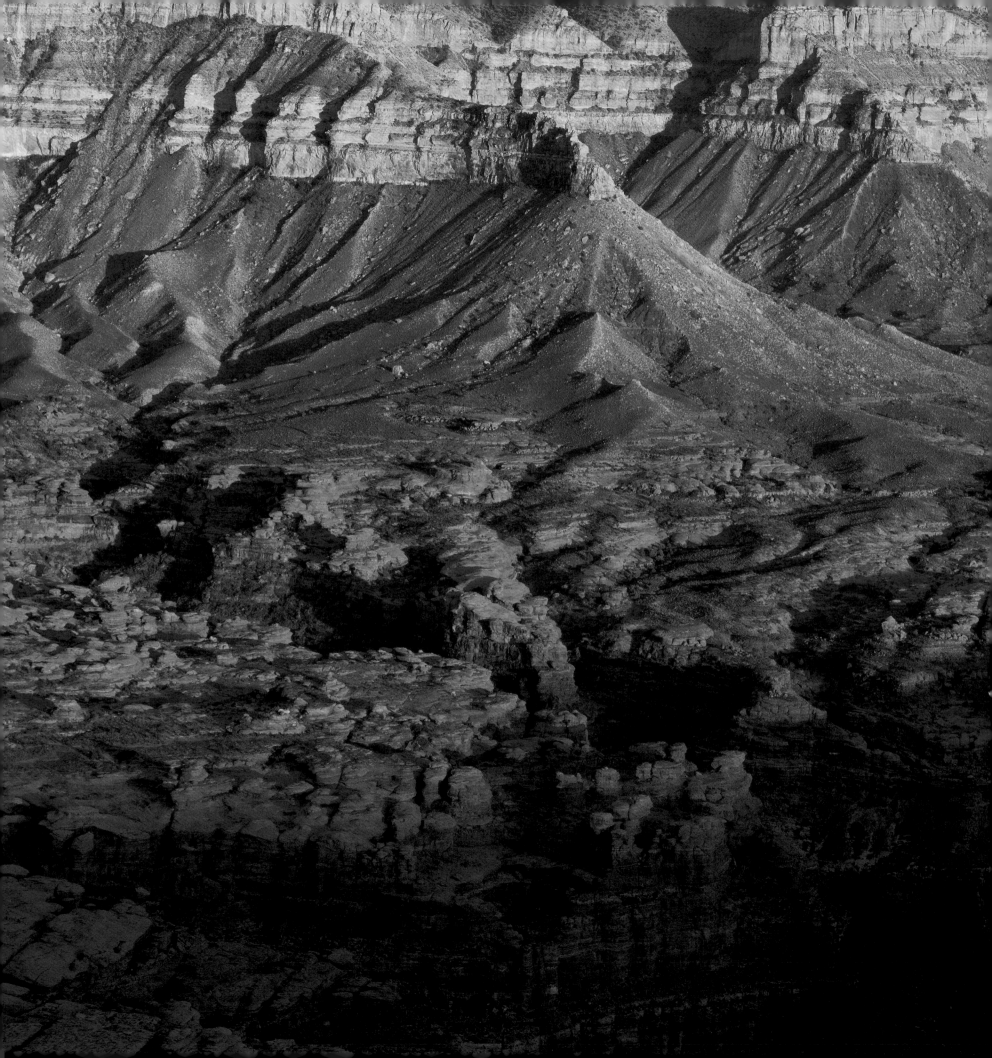

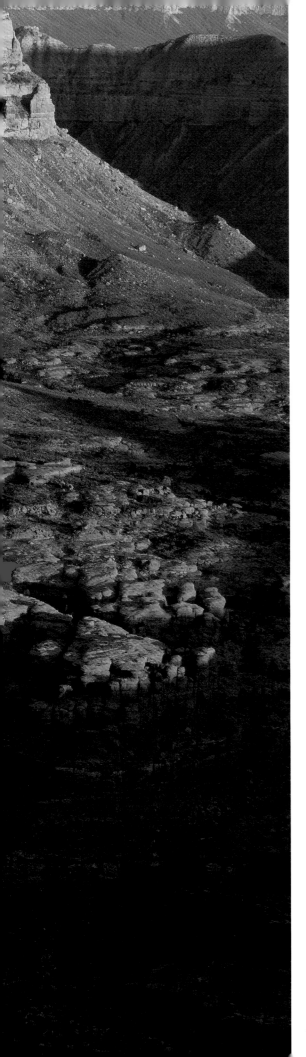

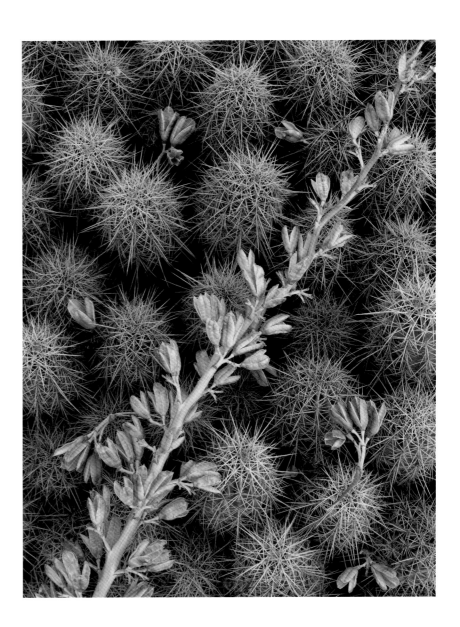

Peering across the Canyon from the South Rim's Yaki Point (preceding spread, pages 104-105), one can easily discern the distinctive Vishnu Temple.

A setting sun, left, puts a red glaze on sandstone hoodoos in the Kwagunt and Indian Hollows beneath the Kaibab Plateau on the North Rim.

Above, a fallen agave stalk lies across a bed of claret cup cactus on the Shivwits Plateau.

The polished Granite Gorge (following spread, pages 108-109) contrasts with a wild garden of crumbling stones and scrub plants at Havasupai Point on the South Rim.

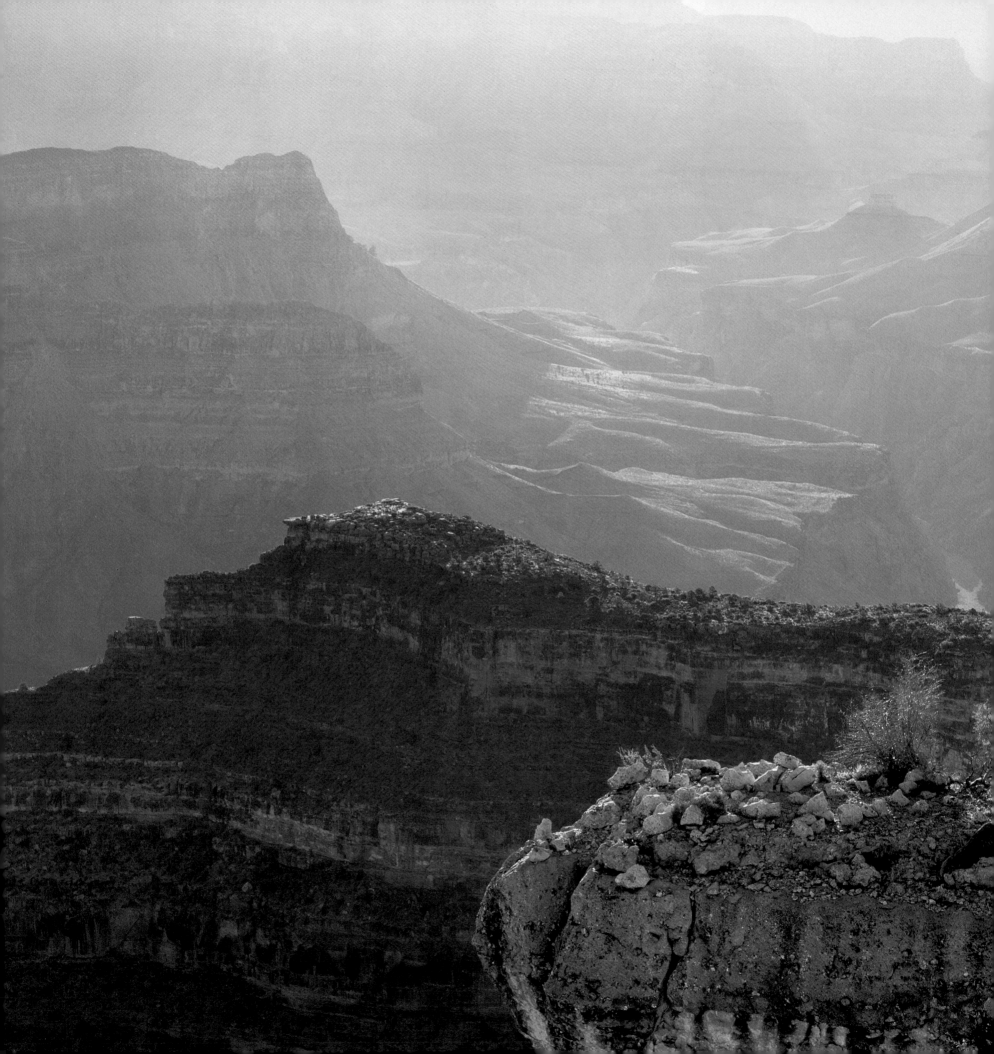

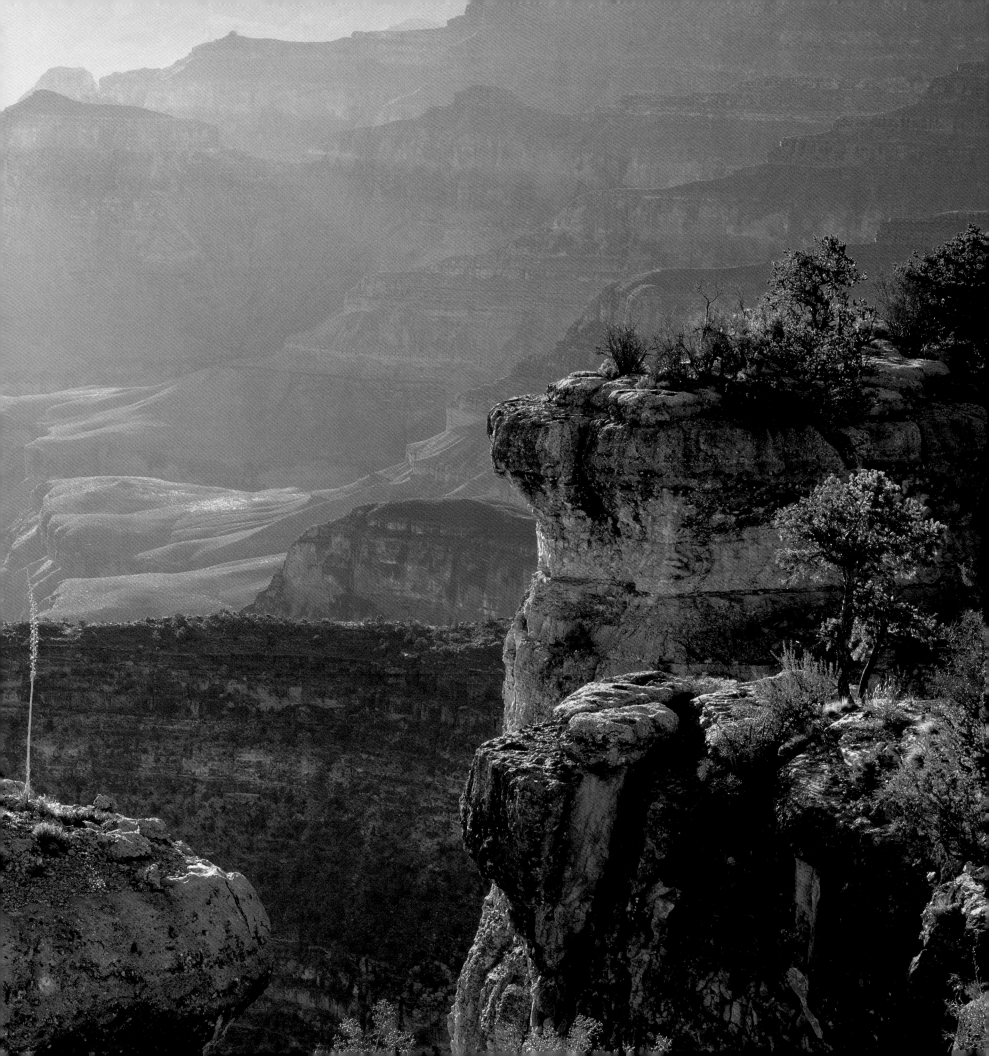

INDEX

Spiny blades of an agave, right, jam together to make radiating patterns of green.

Compare this view of Yaki Point and Vishnu Temple (Page 112) with the one on pages 104-105, and you'll better understand why photographer Jack Dykinga says that light, weather conditions, and perspective alter the Grand Canyon's appearance.

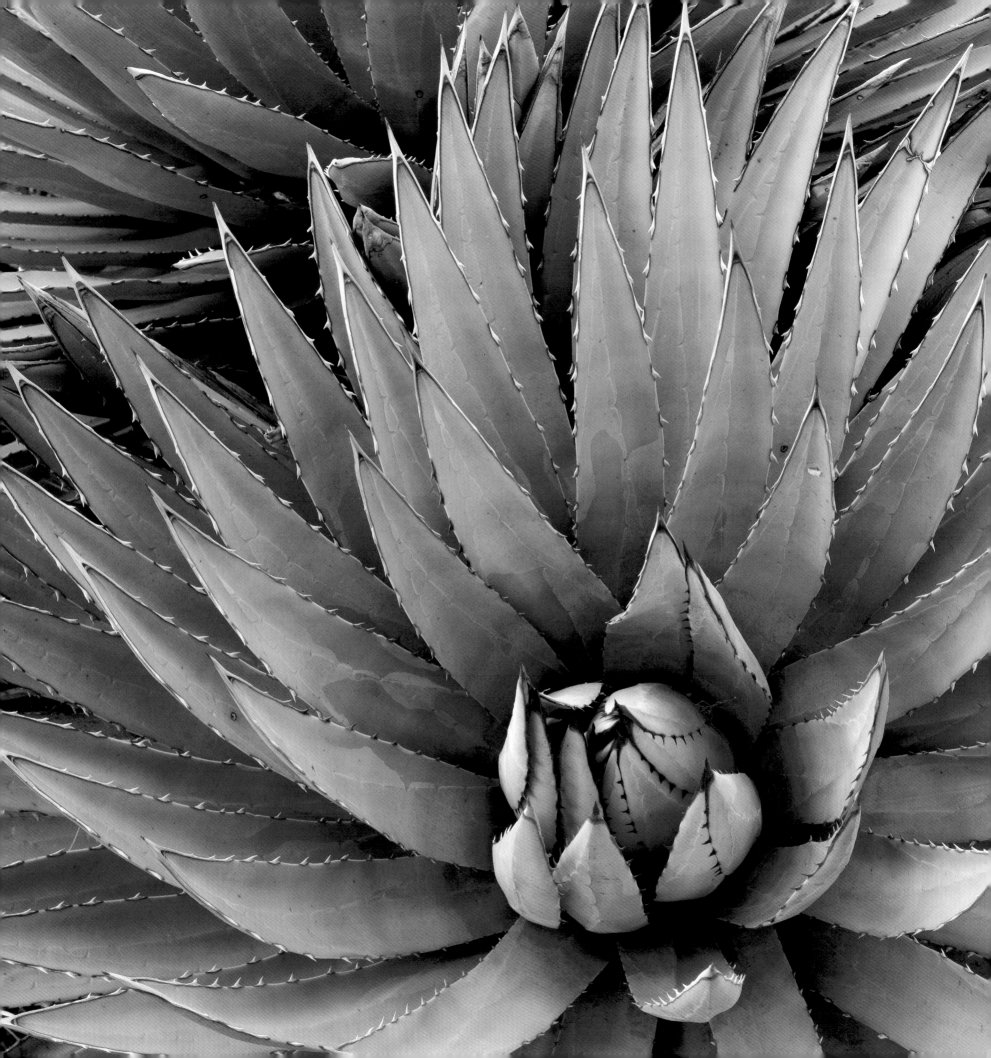

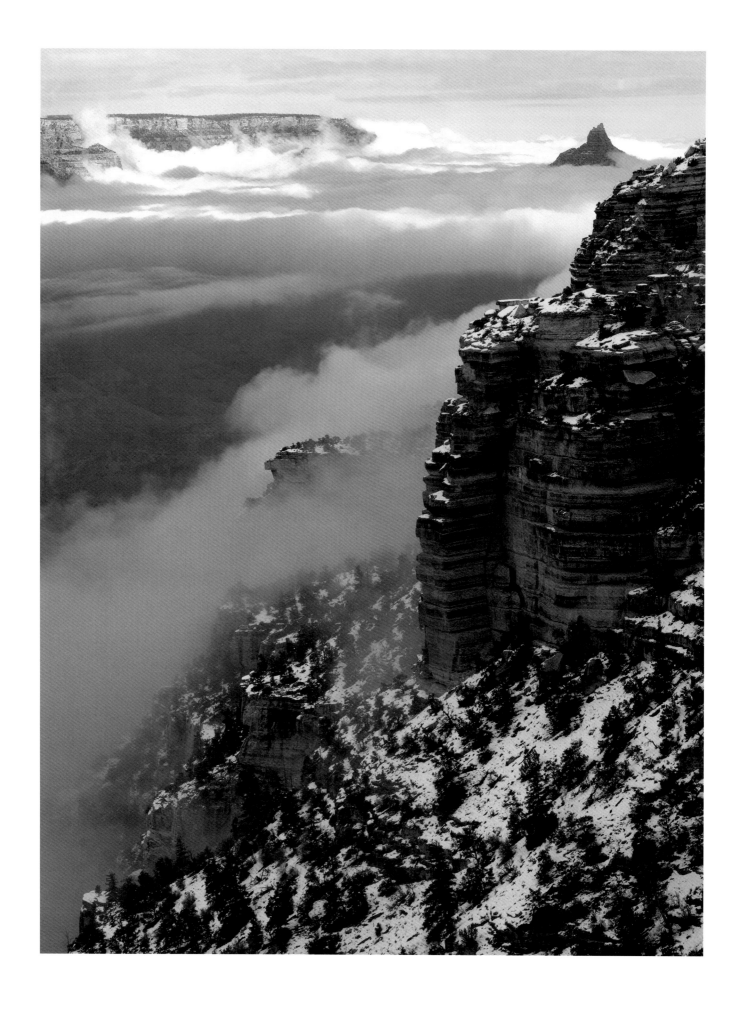

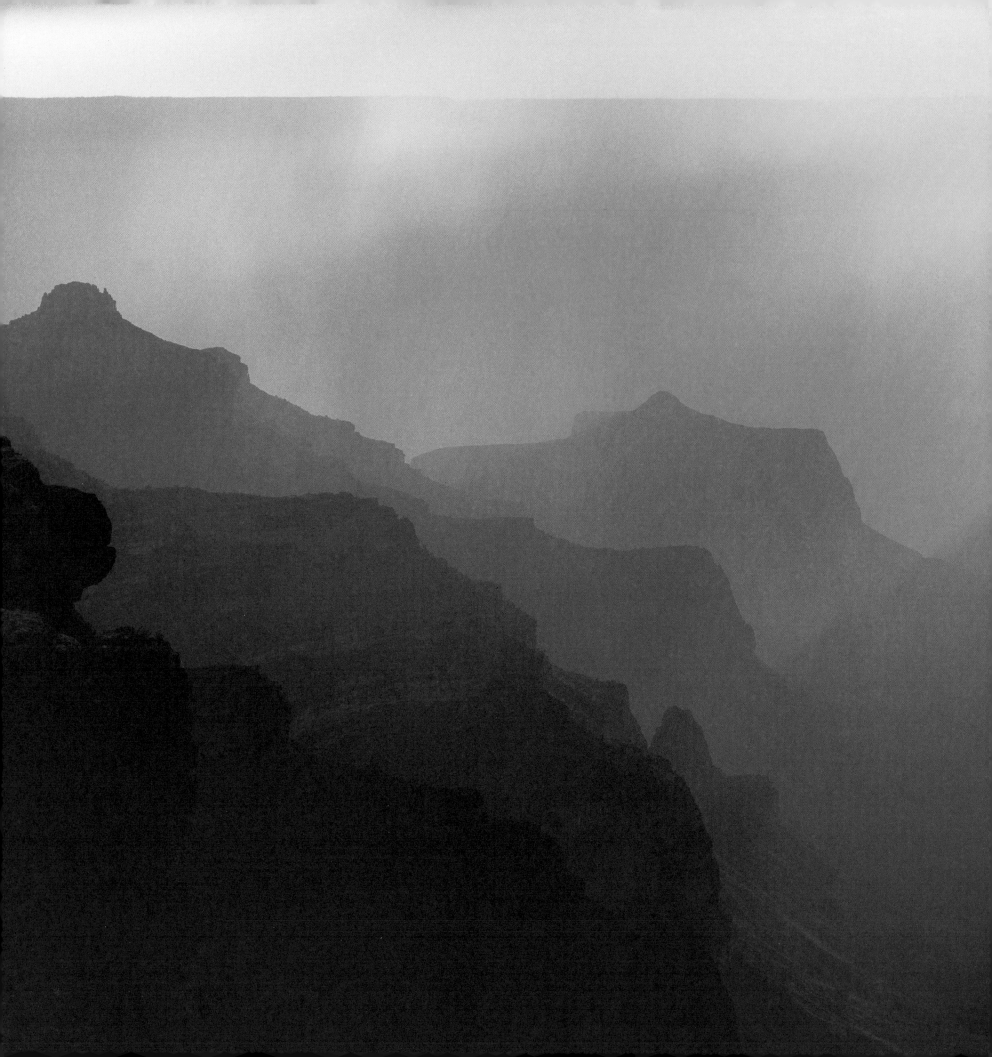